Digital Travel Photography Digital Field Guide

Digital Travel Photography Digital Field Guide

David D. Busch

WILEY

Wiley Publishing, Inc.

Digital Travel Photography Digital Field Guide

Published by
Wiley Publishing, Inc.
111 River Street
Hoboken, N.J. 07030
www.wiley.com

ISBN-13: 978-0-471-79834-7

ISBN-10: 0-471-79834-7

Manufactured in the United States of America

10 9 8 7 6 5 4 3 2 1

1K/RZ/QV/QW/IN

For general information on our other products and services or to obtain technical support, please contact our Customer Care Department within the U.S. at (800) 762-2974, outside the U.S. at (317) 572-3993 or fax (317) 572-4002.

Wiley also publishes its books in a variety of electronic formats. Some content that appears in print may not be available in electronic books.

Library of Congress Control Number: 2006922422

WILEY

About the Author

David D. Busch was a roving photojournalist for more than 20 years, who illustrated his books, magazine articles, and newspaper reports with award-winning images. He's operated his own commercial studio, suffocated in formal dress while shooting weddings as a photographer-for-hire, and shot sports for a daily newspaper and an upstate New York college. His photos have been published in magazines as diverse as *Scientific American* and *Petersen's PhotoGraphic*, and his articles have appeared in *Popular Photography & Imaging*, *The Rangefinder*, *The Professional Photographer*, and hundreds of other publications. He currently reviews digital cameras for CNET.com and *Computer Shopper*.

Busch's *Digital Photography All-in-One Desk Reference For Dummies* and *Mastering Digital Photography* occupied the top two slots when About.com recently listed its top five books on Beginning Digital Photography. His 80 other books published since 1983 include bestsellers *The Nikon D70 Digital Field Guide*, *Digital SLR Cameras and Photography For Dummies*, *The Official Hewlett-Packard Scanner Handbook*, and *Digital Photography For Dummies Quick Reference*.

Busch earned top category honors in the Computer Press Awards the first two years they were given (for *Sorry About The Explosion* and *Secrets of MacWrite, MacPaint and MacDraw*), and later served as master of ceremonies for the awards.

Credits

Acquisitions Editor
Michael Roney

Project Editor
Cricket Krengel

Technical Editor
Michael D. Sullivan

Copy Editor
Kim Heusel

Editorial Manager
Robyn B. Siesky

Vice President & Group Executive Publisher
Richard Swadley

Vice President & Publisher
Barry Pruett

Business Manager
Amy Knies

Project Coordinators
Adrienne Martinez
Jennifer Theriot

Graphics and Production Specialists
Jennifer Click
Lauren Goddard
LeAndra Hosier
Lynsey Osborn
Amanda Spagnuolo

Quality Control Technicians
Amanda Briggs
Brian H. Walls

Proofreading
Debbye Butler

Indexing
Stephen Ingle

For Cathy, my traveling companion.

Acknowledgments

Thanks to Mike Roney, who moved quickly to get this exciting project in the works, for his valuable input as this book developed; to Cricket Krengel for keeping the project on track; and to tech editor Mike Sullivan, whose more than a decade of experience shooting digital cameras proved invaluable. Mike also contributed some of the best travel photos in the book. Finally, thanks again to my agent, Carol McClendon, who once again found me a dream job at exactly the right time. I'd also like to thank contributor Felix Hug.

Felix Hug is a travel photographer based in Sydney and works throughout the Asia-Pacific region. He believes that positive images and compassion will inspire and change the way we look at things. Diversity, beauty, and humanity are what impress him the most.

His book titles, published by Marshall Cavendish Singapore, include: *Journey through Sydney* (2004) and *Journey through Yangon* (2005).

Among Felix's photographic awards he counts The PDN Travel & Landscape "World in Focus" contest—Winner in the section "Human Condition" (2005/06); Australia's Top Travel Photographers 2006 (nominated by the Industry); The Canon Australian Professional Photographer Awards APPA—Gold Award & selected "Best of Show" (2005); The Asian Geographic Nikon Grand Prize (2004); International Photography Awards (IPA), Award for "Travel and Tourism" (2005); "Travel Photographer of the Year TPOTY" awards for 3rd prize portfolio "The Essence of Travel" and the "Judges Favorite Images" Award (2004); and "Travel Photographer of the Year TPOTY" award for 3rd prize portfolio "The Human Spirit" (2005).

Michael D. Sullivan is a veteran photographer (in the military sense of the word!); he contributed some of the fine travel images in this book. Mike began his photo career in high school where he first learned the craft and amazed his classmates by having Monday morning coverage of Saturday's big game pictured on the school bulletin board. Sullivan pursued his interest in photography into the U.S. Navy, graduating in the top ten of his photo school class. Following Navy photo assignments in Bermuda and Arizona, he earned a BA degree from West Virginia Wesleyan College.

He became publicity coordinator for Eastman Kodak Company's largest division, where he directed the press introduction of the company's major consumer products and guided their continuing promotion. Following a 25-year stint with Kodak, Sullivan pursued a second career with a PR agency as a writer-photographer covering technical imaging subjects and producing articles that appeared in leading trade publications. In recent years, Sullivan has used his imaging expertise as a technical editor, specializing in digital imaging and photographic subjects for top-selling books.

Additional figure credits...

Figure 6.1 — Corbis Digital Stock
Figure 6.42 — Digital Vision
Figure 6.29 — © IT Stock
Figure 6.30 — © IT Stock
Figure 6.38 — Purestock
Figure 6.61 — Flat Earth

Contents at a Glance

Contents

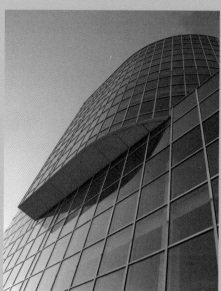
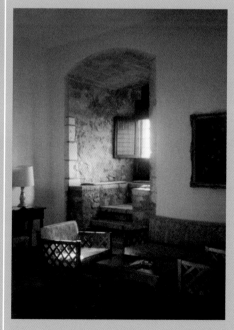

Chapter 2: Prepping Your Digital Camera for a Smooth Trip 25

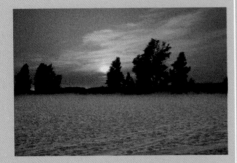

Part II: Taking Great Travel Photographs 39

Chapter 3: Photography Basics 41

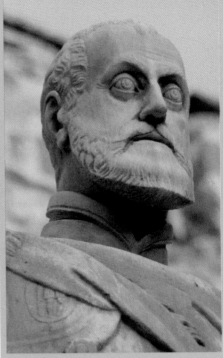

Chapter 4: Working with Light 59

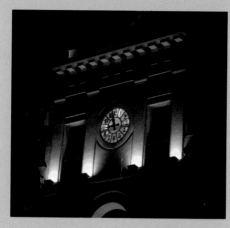

Chapter 5: Accessories for Digital Travel Photography 73

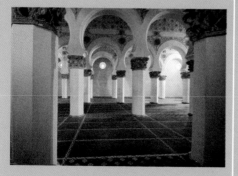

Chapter 6: Techniques for Great Travel Photos 89

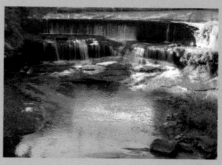

Chapter 7: Backing Up and Sharing Your Images 201

Digital Travel Photography

Congratulations! Whether you're ready to embark on the trip of a lifetime or setting out on one of your frequent, if well-deserved vacations, the fact that you're thinking about digital travel photography now shows that you're thinking ahead.

After all, they say travel is broadening, and photography provides a way for you to make that newfound breadth part of your life forever. The places you visit, the new friends you make, and the experiences you accumulate all have value. Yet, when you get home, the best way to keep your travels fresh in your memory isn't through that pile of souvenirs you pick up along the way. Your photographs help you relive your most enjoyable moments and let you share those memories with friends, family, and colleagues who didn't have the good fortune to travel with you.

Travel photography is much more than a way of preserving in pictures your investment in a journey overseas or commemorating those three weeks in which you hauled the entire tribe across the country in a crowded RV. For those who enjoy photography for its own sake, travel is a great way to explore new picture subjects, try out creative imaging techniques, or document the activities, dress, cuisine, and culture of those with interesting or exotic lifestyles.

Planning Your Trip from a Photo Perspective

One of the most enjoyable parts of any trip is the anticipation. The days and weeks leading up to your departure can be delightful, especially if you spend some of that time planning your trip. Part of your planning should include a photographic perspective so you'll be prepared to get the most from your

digital camera during your travel. It doesn't matter whether your trip is by guided motor coach with a full slate of activities scheduled down to the minute, or a self-navigated walkabout with an itinerary that can change as the mood strikes you. Planning, even if only for the broad spectrum of *possibilities,* can make your photo safari that much more successful.

Five things you must take with you

Chapters 1 and 2 cover selecting equipment and accessories in more detail, but if you learn nothing else from this Quick Tour, you should know about the five most important things that absolutely must go into your luggage, camera bag, purse, or other carry-all.

A camera and a spare

Don't laugh. People have been known to climb into the minivan and get partially out of the driveway without one of the kids. Inadvertently leaving the camera behind is within the realm of possibility. While you can certainly purchase a replacement camera anywhere you go (there are even single-use *digital* cameras now), you'll take your

best pictures if you have your familiar, full-featured digital camera with you. Don't forget it!

A spare camera is something that many travelers forget about. Within a family or group, one member is often the most enthusiastic or skilled photographer, and given that there's so much else going on during a typical trip, it's easy to anoint that person (probably you) as the official (and only) photographer.

In practice, though, it's usually a good idea to have a second person with an additional camera to serve as a backup should the main camera become broken, lost, or stolen, and, most importantly, to provide another perspective. You'll find that your photographic second unit may capture pictures that you miss or even include you in a few shots so you're not relegated the invisible person of the trip. This additional camera (or two) needn't be as sophisticated as yours.

Of course, travel photography is so much fun that backup photographers may not be a problem. It's likely that everyone in your group will want to have a camera of his or her own.

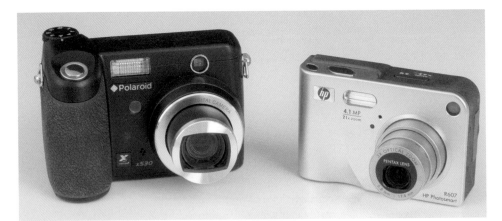

QT.1. Your backup camera can be a simple point-and-shoot model like these.

Plenty of digital film cards

Back home, you probably find that as your digital memory card fills up, it's easy to copy all the pictures to your computer to make room on the card for more. As you travel, you find that your cards seem to fill up much more quickly. And your computer, which you probably left behind, can't be used to offload your shots (unless you take a laptop computer with you.)

Cross-Reference *If you are gone long enough to fill up your memory card and spares, you need some way to empty your cards onto other media. I offer tips for doing this in Chapter 7.*

Note *Label your film cards (and your camera, too!) with your home phone number or e-mail address, so if they're mislaid a good Samaritan can contact you and return them. Some folks are leery of putting their home address on personal items while traveling (perhaps on the theory that it's not a good idea to alert a stranger that one's home is currently unoccupied), so the phone number, e-mail address, or perhaps an office address may be the most suitable identification.*

You'll need to have *a lot* more digital film. So, plan on buying one or two extra memory cards for your trip. That way you have spares as well as enough capacity for a day or two of shooting as a bare minimum.

How much memory is enough? If you were shooting with film, it wouldn't be uncommon for you to shoot two or three rolls of 24- or 36-exposure film a day. Because you won't be paying for film processing and need to make prints only of the shots you want, you'll probably shoot more digital pictures. If you have enough memory cards, it

costs no more to shoot 10 shots than it does to shoot 1,000. It's wise to plan to have enough digital film to shoot *at least* 100 pictures a day — more if you're a dedicated photo buff. Even if you find yourself in a seeming photo wasteland and discover something interesting enough to snap off two or three photos every 15 minutes or so, that's still more than 100 pictures in a typical day.

The size and number of memory cards you need varies depending on the resolution of your camera and the capacity of the cards you choose. Insert a blank card in your camera, and set the camera for the resolution you'll be using. Note the number of pictures possible (it will appear on the status LCD of your camera), and divide your daily target shooting goal by that figure to arrive at the quantity of cards you'll need. A photographer with a 5- to 6-megapixel digital camera typically needs two or more 512MB film cards to handle a day's shooting.

QT.2. Be sure to take enough memory cards to hold your photos until you can copy them to other media.

Extra batteries and/or a charger

If your digital camera uses AA batteries, you'll be able to find fresh replacements nearly anywhere in the world. But if your camera uses an oddball lithium or alkaline battery, you might find yourself far from a camera or electronics store when your old one fails. Should your camera use rechargeable batteries, make sure you take your

charger and that it's physically and electrically compatible with the power system at your destination. It's not a bad idea to have an extra rechargeable battery along, both as an emergency backup and as a pop-in replacement if your original battery tires out during a long shooting day.

 Cross-Reference *For more information on compatible power systems, see Chapter 2.*

A one-gallon zippered plastic food storage bag

Sometimes the simplest must-haves can be lifesavers. This all-purpose storage container can hold your memory cards, batteries, and other accessories separate from your other personal items in your luggage, purse, or camera bag. This extra protection can shield your gear from moisture—or worse. In a pinch, a zip bag can function as a raincoat for your digital camera. Don't leave home without one.

Your camera manual, this book, and a travel guide

Okay, that's three items—but one of them (your camera manual) might not be necessary if you've absolutely memorized how to use each and every feature of your digital camera. If not, it's a good idea to take along your manual so you can quickly look up—if necessary—how to operate that self-timer you almost never use so you can get into a picture yourself, or how to set your camera for shooting rapid sequences. Or, perhaps you'd like to add a special effect or, for the first time, use your camera's facility for slimming down big pictures to e-mail size.

This Digital Field Guide is also useful to refresh your memory on some technical points such as use of flash or focus settings, plus it's packed with ideas for special shoot-

ing situations and recipes for getting great pictures in those situations. A field guide serves you best *in the field.*

A good travel guide, such as those from Frommer's, not only helps you find places to stay and things to do, but can also spark ideas on the most interesting photo opportunities. I took along one of Arthur Frommer's "$5 a Day" books on my first trip overseas (yes, it was *that* long ago), and liked the way it provided me a key to each city's and region's primo sights and sites.

Tip *For a complete listing of all the Frommer's guides and great tips and travel suggestions, visit www.Frommers.com.*

Choose interesting and photogenic sites

It's a smart strategy to think about the photographic possibilities that may unfold as you plan your trip. I recognize that the main goal of your travels may be sightseeing, business, or something other than photography. But it's even more likely that taking pictures will be an important part of your experience. If you're a very serious photographer, picture-taking may be your primary motivation.

Six weeks prior to beginning this book I spent seven full days of a 10-day solo visit to Spain in a pilgrimage to the magical medieval city of Toledo. I allotted that much time specifically to take pictures of a town I'd visited more than a dozen times before and knew well enough to want to document its people and sights. In this particular case, my destination was chosen specifically for its photographic possibilities.

You probably won't go that far, but you may want to keep photographic interests in

mind as you plan your itinerary. Here are some things to think about:

✦ **Get lost.** Be alert for off-the-beaten-path photo opportunities along your planned route. Perhaps the world's biggest ball of twine isn't your cup of tea, but you might be passing by the birthplace or former home of a president or of some other person you admire. A little-known glacier formation or an unusual monument might yield an interesting picture quite different from that with which everyone else ends up. Don't forget out-of-the-way places found in larger cities, too. In Paris, you'll certainly want a photo of the Eiffel Tower, but you might get a better picture in a secluded little park you discover a few blocks from the Seine.

✦ **Plan for festivities.** Local events, fiestas, fetes, and celebrations can provide memorable photo opportunities, but only if you are at the right place at the right time. Holy Week in Spain, Cherry Blossom Time in Washington, D.C., the annual Chicago Bluesfest or Carnaval in Rio de Janeiro can be once-in-a-lifetime photographic treasures for travel photographers. You might plan your trip around one of these major events or simply do some research to see what other things are going on during your visit.

✦ **Explore the quirky.** Some of your favorite photo opportunities can turn up in places you'd ordinarily never visit. You might not think of journeying, say, to Fairmount, Indiana (population 3,300), because it's a mundane and quiet rural community most of the time. But late in September each year it's invaded by hordes of fans for the annual James Dean Festival, thus qualifying for both my off-the-beaten-path and festivities guidelines. The town's most famous native son (although Garfield creator Jim Davis might beg to differ)

QT.3. Out-of-the-way places can make some of the best travel photos.

transforms this destination into a prime photo opportunity complete with look-alike contests, 1950s-era automobiles, and much more.

✦ **Plan for the weather.** Some destinations are a lot of fun, no matter what the weather. For example, Europe can be spectacular and uncrowded during the winter months. However, if photography is high on your list of priorities, keep the limitations and advantages of rainy seasons, gusty weather, and the possibility of scorching days in mind. Some times of year are better than others for certain types of photography. You might want to shoot surfing pictures when the seas are a little rough and the waves high, or tour New England during the fall when the changing colors of the leaves are breathtaking.

✦ **Choose your sites.** On a typical trip there are more than enough interesting things to see and visit. Plus, if you're a typical traveler, you'll want to spend time actually doing things such as scuba diving,

QT.4. High-contrast lighting shows off the stark qualities of Rodin's *Thinker* in this garden location.

windsurfing, rock climbing, or enjoying local foods (even dedicated tourists do more than *tour*). So, it's important to choose your photo opportunities carefully. Mix in some particularly photogenic stops along with those that are important for other reasons. For example, the Louvre in Paris prohibits photography in certain parts of the museum (generally the busiest areas). Those same galleries contain some of the most important works, so you'll want to visit them even if you can't take pictures. Instead, try a visit to, for example, the gardens of the Musée Rodin, where the photographic possibilities are spectacular.

Shooting a Set of Travel-Style Images

I provide more information on trip planning in Chapters 1 and 2, but as you become immersed in your preparations, one important thing you can do is have a real, live photographic dress rehearsal — a practice session or two under simulated travel conditions that lets you exercise your skills and spot potential kinks in your technique.

If you have sufficient time before you leave, work through the list of photo assignments in the sections that follow. Go out and actually take some photos in each environment, come home, load them on your computer, and evaluate how you did. Review Chapter 6 for hints on how to take pictures in each of these situations. You'll learn how you react to particular challenges and probably discover ways to improve your work. You might even discover that you really need an extra gadget or two (perhaps an external electronic flash) to get the kind of photos you want. It's better to uncover flaws and deficiencies now than after you've left!

Practicing close to home

Pretend that your hometown or a nearby city is a major tourist destination — especially if they really are! (Those of you who live in New York City, San Francisco, or Chicago, for example, have a major advantage.) If your town is small, pretend that it's a tiny European village or some other hamlet on your itinerary. Should you have a larger city available, go out and take some photos as if you were shooting in New York, Miami, Paris, or Tokyo. Look beyond the familiar for interesting things to photograph. Such an excursion is good practice for your trip, and you may even discover something new in your own backyard.

Interesting architecture and monuments

A great deal of travel photography involves pictures of buildings, monuments, and structures. In North America, good examples are the St. Louis Gateway Arch, the Golden Gate Bridge, Toronto's CN Tower, or the Lincoln Memorial. Overseas, the Eiffel Tower, Roman Coliseum, the Great Wall of China, and the Taj Mahal are iconic subjects.

But don't forget that some interesting photos can be taken of lesser-known homes and buildings, particularly if you travel in a country where structures that are 200 or 300 years old are common. Practice at home taking pictures of buildings and monuments that may not seem exotic to you,

QT.5. Local architecture, like this tower at an Ohio university, can fill in for more exotic locales.

but which offer the kind of picture-taking practice you need. Wide-angle lenses or the widest zoom setting on your camera serve you best for these kinds of photos, so learn how to use them. Looking for interesting angles and architectural detail can be a good approach to take when a well-known monument isn't available.

Lively street scenes

Street life is always fascinating. Take some time now to explore photography of people, pets, vehicles, and other elements of street life. Your assignment is not only to find and photograph interesting subjects, but also to become comfortable shooting photos of strangers in a way that is friendly and non-threatening. Remember that if you are photographing individuals rather than just crowd scenes, it's a good idea to at least ask if you can take a photograph.

Learn how to use wide-angle lenses and zoom settings. Ways to steady your camera and how to shoot discreetly — but not sneakily — are all good skills to master.

Including your family in candid shots

I'm always amazed when folks journey off to strange and exotic places, and then pose friends or family in front of truly breathtaking sights so they can mug for the camera. I'm even more amazed when I do it myself. However, there's nothing really wrong with taking a photo of your spouse posing in front of the Great Pyramid at Giza to prove that you've actually been there — as long as you don't limit yourself to those kinds of photos.

Practice taking a few candid shots that let you position your loved ones in a way that doesn't obscure the interesting portions of the scene in the background. Grab a couple of family members, and go out into your community and practice arranging warm bodies and posing them in a relaxed manner so your photos won't look like the moments just before a firing squad took aim.

Family portraits on-location

Rather than pose your gang on the front steps of the U.S. Capitol, why not choose another, less dramatic backdrop for a group or individual portrait? Find a location that sets the mood for the place you're visiting, but which can form a more low-key background. In Washington, D.C., that might be the Mall; in New York, it might be a quiet corner of Central Park, perhaps with some buildings showing above the trees in the background.

To practice for these sorts of images, locate a suitable place nearby, take a family member or two out, and shoot some informal portraits. You'll sharpen your portrait photography skills so you can better apply them during your travels. Avoid lenses and zoom settings that are either very wide or very telephoto in their effects, and try out some of the tricks in Chapter 6.

QT.6. You'll find many opportunities for shooting informal portraits of family and friends on your trip.

Wide-angle landscapes in parks or rural areas

Unless you'll be spending all your time in cities, you'll be shooting lots of scenics, so practice photographing nature and environs in your own area prior to leaving on a trip.

Find a park with a lake or rolling hills, or visit a rural area. Take lots of photos of Mother Nature at her finest. Work with wide-angle lenses and zoom settings, polarizing filters, and try to find the most colorful subjects possible.

Museums and indoor locales

One of your most challenging photo environments will be indoors at museums, cathedrals, exhibit halls, and similar venues. Some prohibit photography entirely, while others discourage flash photography. You might have to brace your camera to take a good shot, or if permitted, use a monopod. Above all, be unobtrusive.

 Cross-Reference *For more about monopods and other accessories, see Chapter 5.*

This is a good time to learn about shooting indoors, using your camera's slow shutter speeds (which increase the amount of exposure), and ISO settings (which make your digital camera more sensitive to the available light. Visit your local art museum, shopping mall, or sports arena where picture-taking is permitted, and practice some indoor photography.

Close-ups

Don't neglect the up-close and personal looks at the things around you on your trip. That scrumptious meal may be worth a picture, whether you know exactly what is in the dish or not. Flowers, insects, coins, or the weathered hinges on a 500-year-old door may be fodder for some interesting pictures too.

Find the local equivalent of any of these, and see just how easy your digital camera's close-up or macro capabilities are to use. You can get some ideas about what kinds of things to photograph from this category in Chapter 6.

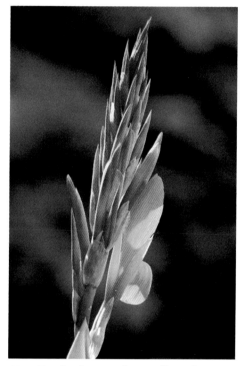

QT.7. Exotic plants make excellent photo subjects as you travel. Just make sure you learn how to use your camera's close-up features.

Becoming Familiar with Your Traveling Camera

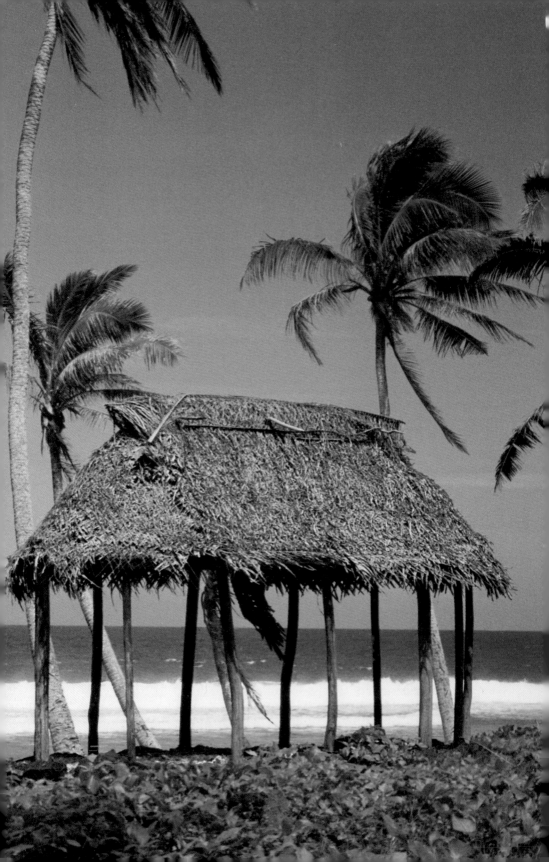

Exploring the Digital Camera

The digital camera you own right now is probably the perfect tool to capture memories of your trip. All you may need are some accessories that can give you some extra capabilities or will make your photography a bit easier. If that's the case, you'll find some suggestions for equipping yourself in Chapter 2, and some accessorizing tips in Chapter 5.

This chapter is aimed at familiarizing you with digital camera features that are most useful when taking travel and vacation pictures. If you're thinking of upgrading to a newer or better camera, you'll find some information on the various categories available today, and what they have to offer.

Although it's a safe assumption that as readers of this book you already own the digital camera you'll be using on your travels, it's still worth devoting a few pages to the ideal features and capabilities you'll need. After all, a very special journey may prompt you to buy a new, very special camera. Or, you might find that several members of your traveling party want their own digital cameras so they can capture their own memories.

For most of us, a digital camera isn't a lifetime investment. It's something we buy in the same way we purchase a computer, as a tool that gives us the advantage of current technology, but with the full expectation of replacing it somewhere down the road with a smaller, better, more powerful, more flexible device, at a lower cost. No matter what type of digital camera user you are — veteran, beginner, or someone who hasn't dipped a toe into the digital waters yet — and whether or not you're thinking about upgrading, this chapter will help you.

Digital Camera Categories

Until recently, most digital cameras could be neatly classified solely by the number of megapixels, or *resolution*, they offered, because all the other useful features and prices often followed in lock step with the camera's resolution. Today, however, you find cameras with around 6 megapixels ranging from simple point-and-shoot models to advanced SLRs with interchangeable lenses. You can't tell the players without a program, but you can discern their differences by their features and layouts. Your digital camera will be one of these types:

✦ **Basic point-and-shoot models.** You frame the picture through a simple optical viewfinder or a small LCD screen, press the shutter release, and these cameras make all the other decisions for you. Generally priced in the $100-$200 range, these basic 4- to 6- (or more) megapixel (millions of pixels, or picture elements) models have a 3X zoom lens that may not be quite wide enough for photographing interesting buildings and monuments in tight quarters, nor have enough telephoto magnification to capture distant subjects. The built-in flash unit may be good for shots from 5 to about 11 feet. Focusing is automatic, with no options other than a close-up mode.

✦ **Intermediate point-and-shoot cameras.** Most travel cameras sold today fall into this category, with models having 5 to 7 megapixels and prices in the $200-$400 range. They appeal to casual and slightly more serious photographers who want sharp, clear pictures, and a bit of versatility in their cameras. Zoom lenses range from 3X to 6X. In addition to automatic focus and exposure, there may even be a few manual settings. These can include the ability to choose the shutter speed or lens opening , exposure adjustment for photos taken facing the sun, or full manual control. Anyone who is not a dedicated photo buff can probably take any travel picture he or she cares to create with a camera of this sort.

✦ **Advanced point-and-shoot models.** More advanced models attract travelers who want more options and features. Those with $400-$600 can buy an 8- to 9-megapixel (or more) camera with a 6X to 12X or longer zoom (magnification) range, more manual controls, and interesting bonus features. These cameras appeal to those who realize they can take better and more interesting pictures with a digital camera that has more options. Such cameras are stuffed with multifunction buttons and dials, lots of modes, dozens of menus, and thick manuals. You'll find goodies like time-lapse photography, burst modes that can squeeze off six to 10 shots at 2 frames per second or faster, and in-camera editing/ image-enhancing features. These extra features can be very handy while traveling without a computer.

✦ **Photo enthusiast models**. These are sometimes called "prosumer" cameras, and include non-interchangeable lenses with generous zoom ratios (often extending from true wide angle that's the equivalent of 24mm for those of you familiar with 35mm camera lenses) to ambitious telephoto (up to the

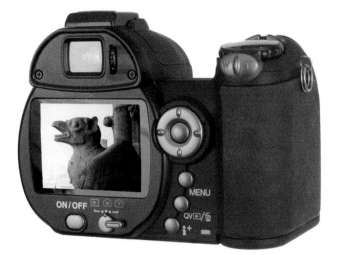

1.1. An enthusiast camera may have both a large back-panel LCD as well as an internal electronic viewfinder (EVF).

equivalent of 300-360mm — truly a long reach). You can spend $600 to $1,000 for an 8- to 10-megapixel camera that probably has a large back-panel LCD (up to 2.5 inches) and a second, internal LCD (called an electronic viewfinder, or EVF) that shows you almost exactly what the lens sees. These are the cameras that advanced amateur photographers favor, because their lower cost frees up money to purchase extra accessories. They are also the cameras that pros sometimes use on weekends for their personal photography or which they purchase as cheap, extra cameras to supplement their good equipment.

✦ **Digital SLRs.** The digital SLR (single lens reflex) is the camera of choice for serious photo hobbyists and professional photographers. They offer unlimited optical flexibility because the lens can be removed and replaced with another lens that is wider, longer, focuses closer, or has the ability

to shoot in lower light levels. The dSLR also has faster performance, with little of that frustrating lag that delays the actual picture-taking once you press the shutter release button. Digital SLRs cost around $700 to $1,300 (add another $100 to $300 and up for a lens) for the prosumer models, and $1,300 to $5,000 or more for those suitable for advanced amateurs and professionals. Resolution for dSLRs ranges from 6 to 16 megapixels.

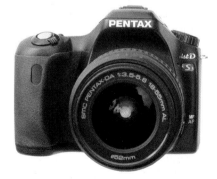

1.2. Digital SLR cameras feature interchangeable lenses, excellent performance, and lots of extra features.

Working with what you have

Even if you've been using your camera for awhile, it's a good idea to explore the typical features as they relate to travel photography. This section helps you refamiliarize yourself with your own camera from a travel photography perspective.

✦ **Resolution.** Resolution expresses the number of individual picture elements, or pixels, a camera can capture, usually specified in megapixels. The resolution determines the maximum size of the prints you can make from your digital camera's images or whether you can crop out a small section of an image and enlarge it. If you're just going to make small prints of your travel pictures you don't need as many megapixels (4 to 5 megapixels is plenty), and being frugal with resolution allows your memory cards to hold more images before they fill up.

✦ **Lens.** The lens mounted on your digital camera determines the relative magnification of your image. Most digital cameras use zoom lenses that can be adjusted to make the image larger or smaller, so you can shoot different subjects without the need to get closer or back away. This quality is usually described in terms of *focal length*, expressed in millimeters, and almost always given as the equivalent focal length if the lens were mounted on a 35mm film camera. Equivalent focal lengths of 35mm to 40mm or less are considered *wide-angle* lenses; those from 40mm to about 55mm are considered *normal* lenses, and anything

with a longer focal length is referred to as a *telephoto.* Digital SLR (single lens reflex) cameras have the ability to substitute a different lens for the one mounted on the camera. The range of your lens is important for travel photography. You frequently need to use a wide-angle setting to take in all of a building or monument, while a telephoto setting brings you closer to a distant subject.

✦ **Focus.** Another characteristic of the lens and the camera it is mounted on is the ability to focus sharply at a given distance. All digital cameras and their lenses can focus from a few feet to the horizon (*infinity*), but some can focus closer, down to an inch or less from the front of the lens. This gives you the ability to shoot close-up, or *macro*, pictures. The simplest digital cameras use a full-time autofocus system to set the focus point for you. More advanced cameras let you specify the zone within your picture frame to be used for focus or to focus manually. Travel photos can vary from distant subjects to fine details, so a good focus range and efficient autofocus system are desirable.

✦ **Exposure.** An autoexposure system keeps your photos from being too light or too dark. The system sets the amount of time the sensor is exposed to light (the shutter speed) and how much light is admitted through the lens (the *aperture* or *f-stop*.) Such exposure systems may use a complicated matrix of zones within your image area to determine ideal exposure or let you opt to measure exposure from a smaller area of your choice. A good exposure system allows

you to expose your travel photos flexibly, say, to create a silhouette or other effect.

✦ **Viewing System.** Digital cameras have one of four kinds of viewfinders: an LCD that shows an image as currently captured by the sensor; an optical window you can use when the light is too bright to view the LCD on the back of the camera; an electronic viewfinder (EVF) inside the camera that is similar to the back-panel LCD, but shielded from external light; and a through-the-lens optical viewfinder (found in dSLRs) that uses a mirror to present an image to you before exposure. The mirror flips up to allow the image to continue to the sensor during exposure, and then returns to its original position to restore your view in a (literal) blink of an eye. Some cameras may have only a back-panel LCD, or may include the LCD plus an optical

window or internal EVF. With digital SLRs, viewing is always through the optical viewfinder; the back LCD is used only for reviewing photos. Because so many travel photos are taken outdoors, digital cameras with an LCD as their only viewfinder are often less desirable.

✦ **Performance.** Your camera's performance can be measured by how quickly it operates, which can be crucial in travel photography because you often don't have a lot of time to waste. In some situations, you need to take the photos you want and then move on. In others, you see a fleeting moment and want to capture it instantly without waiting. Important performance parameters can include how long you must wait after you turn on your camera before you can take a picture (3 seconds or more is probably too long in most travel settings), and how quickly

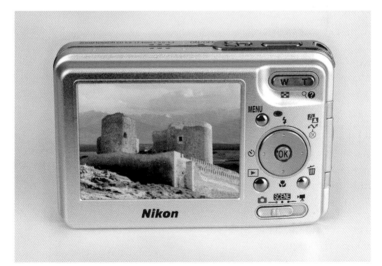

1.3. A camera that has a large LCD on the back, but no optical viewfinder, is great for reviewing your photos but may be difficult to use in bright sunlight.

you can take your next picture (anything more than 2 or 3 seconds will become frustrating). Fast exposure measurement and auto-focus, speedy electronic flash recycling, and quick storage of images to your memory card (so you can keep taking many pictures in sequence) are all important when you're in a hurry — or sometimes even when you're not.

✦ **Flash Range.** Electronic flash needs little explanation. The image of the tourist wandering around, flashing a camera incessantly, is one of the reasons why electronic flash is banned from so many venues. Flash pictures rarely provide the best image of your subject in any case. Even so, there are times when flash is useful, particularly to fill in dark shadows outdoors in full daylight. For those times when you do need to use flash, you'll want a flash that has enough power to illuminate your subject at a decent distance (12 feet at the minimum.) Generally, the smaller the camera, the more puny the output of its flash. That's not because powerful flash tubes won't fit in tiny cameras. The real reason is that an electronic flash uses a lot of power, and small cameras usually have correspondingly small batteries. That's another reason why you should try to rely on flash as little as possible for your travel photos. Naturally lit pictures are...more natural...and should be your first choice.

Simple enhancements to improve your travel hardware

Here are some things you can do to upgrade the capabilities of your digital travel camera. I list five easy ways to improve your travel photos here, but there are more suggestions in Chapter 5.

✦ **Wide-Angle/Telephoto Attachments.** Point-and-shoot cameras don't have interchangeable lenses, but many of them can be fitted with wide-angle and telephoto attachments that provide a broader or longer perspective. These fasten to the front of the lens and may cost $100 or less. If you don't own one of those "superzoom" (8X to 12X zoom) cameras, an attachment of this sort can be a good investment, perhaps even postponing the need to replace your camera for a few years.

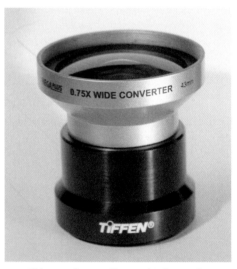

1.4. This attachment fits on the front of a point-and-shoot camera's fixed lens and increases its wide-angle perspective.

✦ **External Flash.** An external flash unit (if your digital camera can use one; digital SLRs and many advanced point-and-shoot cameras have the correct connectors, while others can use a "slave" flash

that has its own triggering unit) provides more power and lets you use creative techniques.

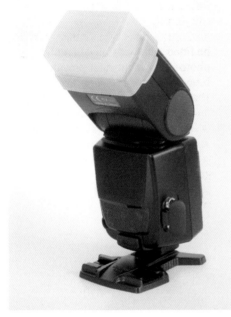

1.5. An external flash can be attached to the camera, or it can be removed and used while attached to the camera with a cord to allow lighting your subject from a different angle.

✦ **LCD Hood.** If you have difficulty viewing your back-panel LCD under bright light, a custom-fitted hood can shield your viewfinder from ambient illumination. Hoodman (www.hoodmanusa.com) has easy-fasten hoods for most digital cameras and video camcorders. If your camera has only an LCD with no optical finder option, this may be the best investment you can make.

✦ **Beanbag.** Sometimes you need to steady your camera to shoot at a slow shutter speed under dim illumination. Other times you just want your camera to stay put as the self-timer ticks off while you frantically run to get into the picture. If you don't want to take a tripod on your trip, a soft beanbag (like those your kids toss around at a school carnival) may be the next best thing. Plop the bag down on a suitable surface, nestle your digital camera into the beanbag's embrace, and then proceed to take your picture. Just be sure to keep a lookout for dishonest folk who may cast a covetous eye on your beanbag and unattended camera!

✦ **Lens Hood.** One way to dramatically improve the quality of your images when shooting images in the direction of the sun or other bright light is to mount a hood on your lens. Most digital SLR camera lenses are furnished with a hood, but you can usually find one to fit many intermediate point-and-shoot or advanced digital cameras, too. The hood reduces flare and improves the contrast of your pictures, and serves as a modicum of protection should you accidentally swing your camera into an object.

Considerations for a New Camera

The ideal camera for travel photography varies, depending on who is doing the shooting. Some travelers want the smallest camera possible, something that can be slipped in or out of a pocket on the spur of the moment to photograph an interesting monument or unexpected scenic wonder. Others prefer a camera with maximum megapixels, because the extra detail all that resolution supplies makes it possible to enlarge the very best shots to sizes suitable

for framing and display in a personal photo gallery, or to crop out all but a tiny portion of the image, creating a whole new photograph from the contents of your original shot.

Or, you might simply want a digital camera that has features that make sharing your pictures easier. There are cameras that make e-mailing photos back home as easy as connecting the camera to a computer in an Internet café and pressing a few buttons.

Tip

Because deciding on the ideal digital camera for travel can be daunting, it is a good idea if you can narrow the field a bit. Or, if you are just looking to upgrade, and you want recommendations for specific models, you can read the evaluations found on the most highly regarded Internet review sites, such as www.dpreview.com *or* www.cnet.com.

To arrive at the ideal digital travel camera, the first step is to decide exactly what you want to accomplish with your travel photography. This section explains some things to consider. If any of the features listed are unfamiliar to you, you'll find an explanation earlier in the chapter.

✦ **Is size important?** Travel books always advise you to pack light, and the same goes for photo gear, within limits. If you truly want to carry only the minimum amount of photo equipment, there are some tiny full-featured cameras that are smaller than your passport and not much thicker. Or, you may want a camera with a longer zoom lens, more powerful electronic flash, interchangeable lenses, or other features that call for a larger package. Evaluate the importance of size and weight when choosing the best camera for your travels.

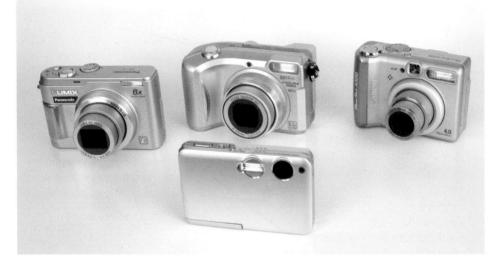

1.6. Small digital cameras can fit in any pocket, ready for use on a moment's notice.

✦ **How will you be using your pictures?** Some travelers make lots of standard sized (4- × 6-inch) prints, but few enlargements. Others want to display their best work at large sizes, as framed prints. Many distribute their snapshots by e-mail or display them in slide shows on their computer screens. Your intended use for travel photos can impact your choice of a camera. For example, if you rarely make enlargements, you don't need a camera with extra-high resolution (more megapixels.)

✦ **Do you plan to edit your images?** Many folks like to use their photos just as they come from the camera with little or no manipulation in the computer. Indeed, these no-fuss folks place a high premium on getting usable pictures right out of the camera. Others find that playing with the pictures in image-editing software — even if it's just to crop the photos to remove extraneous subject matter or to remove "red-eye" effects — is part of the fun. Some cameras do a better job than others in giving you finished images that are ready to go. They may even provide in-camera fixes to improve exposure, color, and other aspects after the picture is taken. Other cameras offer better, sharper raw material that you can tweak to perfection in your favorite image editor.

✦ **Is photography a creative outlet for you?** You might be someone who wants little more than sharp, clear pictures that accurately represent a memorable scene or experience. Or, you might see travel photography as a creative outlet and want special features such as extra-long or extra-wide zoom lenses, sequence shooting or time-lapse photography modes, super-close focusing, and other options.

✦ **How many pictures do you take?** The economy of digital photography makes it easy to take many more pictures than you might have had when you were paying for film and processing. Even so, some photographers tend to view the picture-taking part of their trip as a sideline activity, while others enjoy immersing themselves in capturing every possible scene and event in a photograph. If you belong in the latter category, pay special attention to how many pictures will fit on a single memory card, and explore your options for stretching and augmenting your camera's picture capacity.

✦ **Is your camera a long-term investment?** The amount invested in a digital camera today can depend on whether you plan on buying a new model in a year when spiffy new features are available at an even more attractive price, or whether you plan on using your current camera for two, three, or more years. Unless you have unlimited funds to spend on a digital camera, you might want to pay a little less for a camera you'll be using for only a few trips, and a little more for a camera that you'll use over a longer term.

✦ **Do you want to share accessories?** The accessories you purchase for your digital camera may include memory cards, external electronic flash units, or, in the case of digital SLR cameras, lenses

(which can add up to an expenditure equal to the camera itself). If you want to share these accessories among several family members or use the same accessories with the next camera you buy, it's a good idea to stick to one camera vendor's line of compatible products. That means fewer items to buy, and, when you're sharing, fewer to carry along on your trip.

Prepping Your Digital Camera for a Smooth Trip

Digital photographers need to be prepared. Even if your trip is an impromptu visit with no set itinerary, you find that you come home with better photographs if you prepare ahead of time. And if your travels are tightly scripted with each stop planned in advance, a little work before you leave lets you get the most from the time you have available for taking pictures.

Try all the key features on your camera to make sure it's operating properly, work through a check list to ensure that you're toting along everything you need, and then finish with a pretrip familiarization (or re-familiarization) tour of your camera's key features so, on arrival, you can literally hit the ground running.

Your Pretrip Checkout

Check out your camera and other equipment before you leave to make sure everything is working as it should. You may snap more pictures in the week or two after departure than you take the rest of the year, so make sure that your digital camera is up to the task. This next section lists some things to consider.

Cleaning house

The first thing to do is clean and adjust your camera inside and out. A clean camera operates smoothly and produces the best picture quality.

Lenses

The front surfaces of both fixed lenses and interchangeable lenses are cleaned in exactly the same way. Inspect the lens and make sure no smudges, fingerprints, or grit has adhered to the glass. On many point-and-shoot digital cameras, a cover automatically hides the lens when the camera is turned off. If your camera doesn't have that feature you might want to use a lens cap to protect the front glass. But while you're actually taking pictures it's easy for a stray finger to leave a print on the lens. Shooting in moist weather can result in tiny deposits of rain or mist. Dust is almost certain to settle on the lens at some point. You might not even notice any difference in your pictures due to this moisture, dirt, and grime, but eventually your lens accumulates sufficient amounts of artifacts to affect the quality of your images. Your pictures may be less sharp or plagued by glare that reduces the contrast and may even affect your colors.

If you are using a camera with interchangeable lenses, dirt may reside on both the front and back surfaces of your optics. Dust and smudges can pile up on the front and backs of filters you've attached to the front of the lens for protection. You'll want to clean any part of the lens that has picked up dust, oils, or other contaminants.

Use a soft cloth to clean the outside, non-glass surfaces of your lenses. If sand or grit has found its way onto the lens, use an air blower (canned or a bulb/aspirator-type device) to eliminate the dust, being careful not to whisk it toward any joints that lead to the interior of the lens. Sometimes a little lens cleaning fluid and lens cleaning tissue can be used on the outside of the lens.

The glass of the lens (or filter) is cleaned using a bulb blower, a soft lens brush, or other tool designed for cleaning lenses as your first line of defense. Some people roll up a piece of lens tissue, tear off one end, and use that as a nonabrasive brush.

Caution *Be extra careful when cleaning your lenses to avoid scratching them. Touch the lens only with a cloth or brush designed for that purpose. Use extra caution when using compressed air cans to clean your lenses. When tilted the wrong way these cans can emit a fine white powder from the propellant that can coat your lens.*

For stubborn spots that can't be blown or brushed off, you might have to turn to liquid cleaning. It's important to remember that some dust particles are hard and have rough edges, so you definitely don't want to try to rub them off with a dry cloth or piece of lens tissue. A single drop of fluid designed for cleaning lenses may dissolve stubborn smudges enough so you can wipe them off. Place the fluid directly on the lens tissue. Don't use so much fluid on the tissue that it spreads onto the glass and drips down to the edges of the lens surface. Sometimes, just the moisture deposited from breathing on the lens can be enough.

Exterior

It's a good idea to remove dirt and grime from the exterior of your camera, too. Hard-edged dirt can scratch the surface of your camera, get inside the memory card slot, or gum up the works of rotating dials. With digital SLR cameras, exterior dust can make its

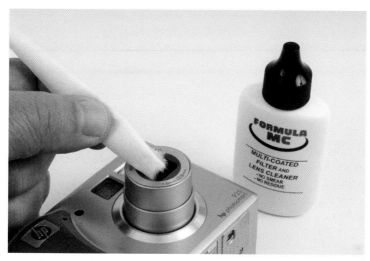

2.1. Clean your lens carefully before leaving on your trip.

way into the mirror box area and, eventually, onto the sensor. Smudges can obscure your camera's optical viewfinder window.

Use the same techniques for cleaning the exterior of your camera as you did for cleaning your lenses. Pay special attention to the back-panel LCD and (if your camera has one) the protective cover over the LCD.

Digital SLR interior

Each time you remove a lens, dust finds its way inside your digital SLR. Some of it settles on the mirror, where it is mostly invisible, and a bit may land on your focusing screen where it is, at best, annoying. In neither case can this dust in your camera's viewing system actually affect your photos, however. Eventually, though, some of this dust moves past the shutter while it is open and settles on the sensor.

Sensors can be affected by dust particles that are virtually invisible to the naked eye, so over time, any dSLR owner is forced to deal with the accumulation of dust. There's no better time for this than just before you leave

on a trip to do a thorough cleaning. Although many approach sensor cleaning with trepidation, the filters that cover sensors tend to be fairly hard compared to optical glass, so there is little danger of damaging the camera. The tricky part comes in cleaning a component that measures 24mm (about 1 inch) or less in one dimension.

You can tell if your sensor is affected by dust particles by taking several photos of a blank area (a plain white wall or the sky will do) using a small f-stop (such as f/16 or f/22.) Throwing the image out of focus eliminates the texture of your test subject. Then compare the pictures in an image editor and see if a spot shows up in the same place in both. The small f-stop helps bring the dust into sharp focus; indeed, you might not even be able to see dust on your sensor in photos taken at larger f-stops (which is why dust on the sensor may not even be a problem much of the time).

There are three ways of removing dirt from your dSLR's sensor, all of which must be performed with the shutter locked open (check your camera manual to learn how to do this).

✦ **Air cleaning.** This process involves squirting blasts of air inside your camera and works well for dust that's not clinging stubbornly to your sensor. Several firms make bulb devices suitable for cleaning sensors.

✦ **Brushing.** A soft, very fine brush designed especially for sensor cleaning is passed across the surface of the sensor's filter, dislodging mildly persistent dust particles, attracting them to the bristles via a charge of static electricity, and sweeping them off.

✦ **Liquid cleaning.** A soft swab dipped in a cleaning solution such as ethanol is used to wipe the sensor filter, removing more stubborn matter. You should use only an ultra pure, highly filtered alcohol approved for sensor cleaning, such as Eclipse Solution (from Photographic Solutions, www. photosol.com).

There are many commercial kits available to clean sensors, and you can use the air cleaning and brushing components to dust off the mirror and focus screen parts of your digital camera, too. Work slowly, make sure you have plenty of light available so you can see what you're doing, keep a steady hand, and you'll be successful.

Usually, it's not necessary to take your complete sensor cleaning kit with you on a trip. Indeed, it's not even legal to take certain cleaning liquids on airplanes or to send them via the United States Postal Service. If you clean your sensor well ahead of time, you might want to take only your air cleaning bulb for emergencies. If you do unknowingly pick up some dust inside your camera, it's usually possible to remove it from your final pictures in an image-editing program when you get home and found you've picked up a few specks in some of your images.

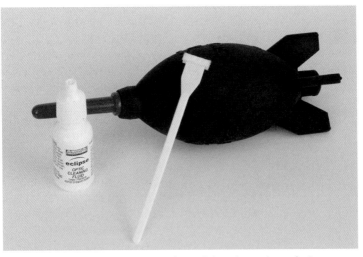

2.2. Digital SLR owners may need special tools to clean their camera's sensor.

Simple adjustments

There are simple adjustments you may want to make to ensure that your camera is operating smoothly and efficiently. While these adjustments aren't all crucial, it's wise to make them if you can.

Banish hot or dead pixels

From time to time, a pixel in your sensor fails, leaving a *hot* (permanently bright) pixel or *dead* (permanently black) pixel at the same location in all your shots. You can test for dead pixels in much the same way as outlined earlier for sensor dust testing. Take photos of plain white and plain black surfaces, and then examine your photos at high magnification in an image editor. As with dust on the sensor, bad pixels can be easily retouched out in an image editor most of the time. However, unlike sensor dust, hot/dead pixels are visible at any f-stop.

Many cameras — both dSLR and non-dSLR models — include a feature called *pixel mapping*, which hunts for hot/dead pixels and programs them out of all future pictures. Your camera then replaces those pixels with information from surrounding pixels, so the image looks natural and doesn't have a bright or dark spot in those locations. If your camera doesn't have a pixel-mapping feature, you can often have those bad pixels wiped out by the camera vendor with a quick (and usually free) trip to the repair shop.

Exposure and contrast tweaking

Serious photographers often make adjustments to their exposure as they take pictures to account for varying lighting conditions. However, if your camera consistently underexposes, overexposes, or produces images that are not pleasing from a contrast standpoint, you can often make an adjustment that can be applied automatically to all the photos you take.

The easiest way to do this is to make an EV (exposure value) change, and then leave that adjustment in place for all the photos you take. Some cameras have banks of settings you can create as presets and use a particular group of settings any time you want. Advanced cameras, particularly digital SLR models, have the ability to use custom curves, which tell the camera how to expose the bright and dark areas (highlights and shadows) and midtones. Creating these curves and uploading them to the camera can require a great deal of knowledge of how exposure works — which is why many intermediate-level photographers rely on custom curves created by others. You can search the Internet for custom curves and locate predesigned settings for your camera and instructions on how to upload them to your particular dSLR.

Cross-Reference *For more information on using EV, see Chapter 3.*

Diopter adjustments

It's easy to forget about adjusting your digital camera's eyepiece for comfortable viewing. Before you leave on a trip, check the diopter adjustment (if available) on your

2.3. A hot pixel shows up as a bright spot in an image.

camera's viewfinder so you have the sharpest view possible. Proper diopter adjustment enables you to see the view through the finder comfortably without the need to wear your glasses or to see the viewfinder better while wearing your glasses. This adjustment makes it easier to focus dSLRs and cameras with electronic viewfinders (EVFs), but even owners of point-and-shoot cameras with simple optical viewers will be more comfortable if the diopter setting has been made properly.

Diopter
adjustment control

2.4. Many digital cameras have a diopter adjustment for sharpening the view through the finder.

Neckstrap

Yes! Even a small detail like how your neckstrap fits you can make a difference. Make sure your camera's neckstrap (if you use one) is adjusted so the camera doesn't hang too low around your neck or swing about in such a way that it can bang into something. You might even want to replace a worn neckstrap with a new one, or buy one that has a wider or more comfortable pad. Your camera store probably has a full range of straps and pads, including those designed to prevent the camera from slipping off your shoulder. If you're going to be carrying a

camera for days or weeks, you want it to feel comfortable.

A trial run

The only way to know that your digital camera is operating at peak efficiency is to take it out for a test run. I recommend using the trial run described in the Quick Tour. By taking practice shots in typical travel situations, you sharpen your skills and at the same time test some of the following parameters:

✦ **Battery life.** If your digital camera uses rechargeable batteries, you should know that batteries begin to lose their ability to hold a charge after a certain number of uses. If you find that yours need to be recharged more often than they used to, it's time to buy new batteries.

✦ **Exposure consistency.** Does your camera provide consistent exposures in similar situations? If the answer is no, find out why not. Perhaps your camera needs a trip to the repair shop, or you need to learn to make some adjustments as you shoot.

✦ **Focus consistency.** Does your camera accurately focus automatically? Some cameras and interchangeable lenses have a tendency to focus behind or in front of the actual point of true focus. The camera vendor can usually fix this at little or no charge.

Packing Your Gear

When I travel, I actually create a Microsoft Word packing checklist and place it on my desktop. As I think of things I absolutely must remember to take along, I open the checklist and add those items. Then, when I'm ready to go, it's a simple matter to

double-check and be certain nothing has been left behind. There's nothing worse than arriving at the airport without your passport — unless you forget the charger that keeps your digital camera's battery working throughout your trip. (Okay, a missing passport *is* more serious.) Here are some things that should go on your personal to-do list.

Essential equipment

The most important gear should be packed in a camera bag or other carry-on luggage (if you're traveling by plane), so you have it — without fail — when you arrive. If you're flying and are a minimalist packer, you won't have any checked luggage at all and will be able to fit both your camera equipment and personal clothing and other items in your carry-ons.

✦ **The basics.** Cameras, lenses, and external electronic flash (if you use one) go in this category. Ideally,

you pack one camera and a spare, and, if using a digital SLR camera, the minimal number of lenses to get the job done. I discuss these lens minimums in more detail in Chapter 5.

✦ **Batteries and chargers.** Always have enough batteries for at least one day of shooting, assuming you spend the night at a hotel where the batteries can be recharged. Make sure you pack the chargers for each type of battery you'll be rejuvenating. If your digital camera and other electrical devices use AA batteries, so much the better, because you might be able to get along with a single charger for all of them; purchase lithium or alkaline AA batteries at your destination if your rechargeables need additional backup. Don't forget to check the battery life of your current batteries as discussed previously.

2.5. Small external hard drives with built-in card readers can be used to offload pictures from your memory cards so the cards can be reused.

✦ **Alternate storage.** Unless you have enough memory cards to last for your entire trip, take along some sort of alternate storage device. This can be a laptop computer that can offload images from your memory cards, a stand-alone CD or DVD burner, or a portable hard drive. I describe your options in more detail in Chapter 5.

✦ **Cleaning and emergency fix-it kit.** Your photographic safari shouldn't be spoiled because you don't have some small item handy. At the very least, have a lens cleaning kit (liquid and lens tissue or a cloth), an air bulb for cleaning lenses or your sensor, a small screwdriver or two, some rubber bands, a zip-closure plastic bag (which can double as a case for your emergency kit), a small roll of tape, and maybe a plastic canister of the type film is sold in.

Use this kit to tighten loose things, tape up looser things, and store things that are so loose they fall off and must be reinstalled later. You can clean what's dirty or use the plastic bag to keep things from becoming dirty in the first place.

The how-to

Learn to pack your camera equipment in two different configurations. One packing configuration can be used for heavy travel legs of your journey when you won't need much (or any) of your gear on the spur of the moment. This setup should be oriented toward carrying your stuff in a compact way that protects everything. For example, I am able to fit all the photo equipment I take on a typical trip, including a spare dSLR body, all lenses, flash, and portable storage device, into a tightly packed, padded camera bag.

This configuration is useful for traveling by plane, then going through customs and riding in a taxi, bus, or subway to my hotel. I really don't take many pictures in any of those situations, and, actually, was once asked to cease taking pictures within a concourse at Heathrow Airport in London. Once I arrive, I switch to a second, looser, packaging arrangement. The electronic flash, portable storage device, some other accessories, and, much of the time, the spare camera body, go into a carry-on bag, leaving my main camera and its equipment in the camera bag ready for an impromptu shot. While visiting a particular city, the extra equipment often remains in the hotel room or is toted along by a companion.

If you don't burden yourself with excessive camera gear, you'll find you can pack light and tight for travel, and loose for use when you're ready to take photos.

How to get through security, Customs, and on the plane

Although security measures are constantly changing, and, in recent months, have become less stringent, you still need to deal with airport and customs personnel if you're not traveling by ground transportation. Here is some advice to keep in mind.

✦ **Know what's allowed – and what is not.** Flammable fluids — including liquids used to clean sensors — may not be carried on planes. Many things that can be used as weapons may be questioned by security personnel,

although small sets of scissors (not a photographic essential in most cases, anyway) are now once again allowed. I've had no trouble carrying tripods and monopods on-board planes in the U.S. or Europe, particularly if they are small units that fit neatly inside carry-on luggage or strap to the bottom of a camera bag. The only time I've been questioned recently was in regard to a quick-release clamp affixed to the top of a monopod that may (or may not) have looked like some sort of mount for a firearm.

✦ **Dealing with Customs.** At the entry points to most countries, Customs seems to display little interest in equipment carried by traveling photographers. If you have nothing else to declare and don't otherwise look like a suspicious person, you're safe going through the nothing-to-declare lines.

✦ **Airlines and carry-ons.** The rules for carry-on items, in terms of number, weight, and size, can vary from airline to airline, but complete specifications are available at your airline's Web site. Most allow one carry-on bag, plus one personal item, which can be a purse, briefcase, laptop computer, or camera bag. All must be of a size that fits in the overhead compartment or under the seat in front of you. International flights and domestic flights at certain times of the week are busiest, but there is usually no problem finding room for one of your bags in the overhead bin. Most camera bags fit under the seat in front of you if the overhead area is full. Those who want to bring carry-on luggage, a camera

bag, and a briefcase or laptop computer might need a little luck.

Features and Settings Check

Before you leave, check your camera's basic settings to make sure you're set up to take typical photos without needing to make special adjustments. Here are some of the things you need to learn now rather than when you're in the middle of your trip, trying to enjoy your surroundings and take good pictures at the same time.

Viewing and playback on the road

It's surprising how many people don't understand all the options available to them for viewing and reviewing images in their cameras. When you travel and are far away from your desktop computer, some of these features can be especially handy. Before you leave, take out your camera and its instruction manual, and make sure you're comfortable with all these options.

✦ **Learn how to review images quickly.** Most cameras can switch from a single-image view on the back-panel LCD to a view that shows four or nine images simultaneously. These multi-image thumbnails make it easy to browse among dozens of images quickly to find the set of pictures you want to look at in more detail.

✦ **Big review.** Your camera probably came with an AV cable that you might be able to connect to a TV to review images on a large screen. You might have to switch your

camera from NTSC output (used in the U.S., Japan, and some other countries) to PAL (used in much of Europe and elsewhere in the world). However, be prepared for locations which use neither; digital cameras are generally able to handle only NTSC or PAL.

✦ **Understand how to zoom in and out.** When you don't have a large computer screen to use to examine your photos up close, your camera's LCD can help you check focus or search for artifacts (like dust) in your images, simply by zooming in and out. Many cameras have a frame that can be moved around within the image and used to zoom in or out for a specific part of the image. Today, many point-and-shoot cameras and digital SLRs are equipped with LCDs that measure up to 2.5 inches in size, which makes review of picture details more practical.

✦ **Delete the real duds.** Unless your storage space is severely limited, I don't recommend going through and culling bad photos based on the view provided by your camera's LCD. You might find later that a seemingly defective image can, in fact, be rehabilitated, or that, a slightly out-of-focus shot is the only one you have of your tour guide wearing a lampshade on his head. But as you review photos, if you see black or white frames, shots of your feet, and images that you can't even tell what is pictured, those are good candidates for deletion. That saves some time later when you review your prize photos at home, and it stretches your storage space a little more.

✦ **Mark photos for printing.** Many digital cameras are compatible with PictBridge and DPOF (digital print order format), so you can tag pictures now for printing later.

2.6. Learn how to zoom in and out during picture review so you can evaluate your travel photos in your camera during your trip.

These are standardized ways of embedding picture order information in an image file so the pictures you want can be printed out to your specifications with no additional input from you. Marking an image now may be a good idea, because when faced with a couple thousand shots later on, you may find it difficult to decide which photos are the most important. In addition, if you mark photos as you shoot, you can stop by a retailer with a photo kiosk or digital printing lab and order a few prints of your designated pictures while you're still traveling. It's easy to immediately print a few shots for sharing with your touring companions or those you've photographed.

✦ **Add voice annotations.** Many cameras allow adding voice annotations to your shots after the picture is taken. These voice notes serve as excellent reminders. One castle or cathedral looks like another after a long tour, and your voice notes help you remember what's important about each picture or picture set.

✦ **View or share a slide show.** Most digital cameras let you display slide shows of selected shots. A few let you create PowerPoint-like transitions between the shots or even assemble — right inside the camera — HTML Web pages to showcase your photos. Even if you've left your computer at home you may be able to create and upload Web pages for viewing by family, friends, and colleagues who don't accompany you on a trip.

Cross-
Reference *More tips on photo sharing can be found in Chapter 7.*

Basic settings

It's no fun taking your first travel photos on a trip and then discovering when you get back to your hotel room that most of them are spoiled because your camera is still set up to take some specialized type of photo (a close-up, for example) that you were working on before you left. Check your camera's basic settings using the following checklist:

✦ **ISO.** This should be set to Auto in most cases. ISO determines the sensitivity of the sensor to light. Lower values require more exposure, but often produce better results. Higher values let you take pictures in dimmer conditions, but may reduce quality and increase the noise levels in photos. As you travel you may need to adjust ISO up or down manually to improve your results, but the Automatic setting found on most cameras does a good job much of the time. If you're very concerned about the grainy noise that results from high-sensitivity settings, you can manually set your camera to a lower ISO, recognizing that you might not be able to take certain pictures in dim light (or the exposure will have a shutter speed that is too slow to stop action or camera motion) unless you are alert enough to adjust the ISO manually.

✦ **White balance.** Your camera generally does a good job setting the color balance for you automatically. White balance is an adjustment for the relative color relationships in an image. Indoor illumination tends to be warmer or redder, and outdoor illumination is cooler or bluer. What you *don't* want is a

manual setting that produces large numbers of off-balance photos until you notice your mistake. Setting the camera manually for Daylight or Incandescent or Fluorescent light (if your camera has those options) is not a good idea unless you are certain you'll be taking your photos under those conditions. Even if you have an advanced camera that can shoot in the unprocessed RAW mode (which means you can adjust the setting when the image is imported into your image editor), nobody wants to have to make manual adjustments on a large group of travel photos. It's better to have white balance automatically or properly set by manual methods.

Cross-Reference *More information on coping with White Balance can be found in Chapter 4.*

✦ **Autofocus mode.** Your digital camera may offer several autofocusing modes to choose from. You might be able to select the zone used to focus the image and switch between Single Autofocus (the camera locks focus when the shutter release is partially depressed) and Continuous Autofocus (the camera sets focus when the shutter release is pressed, but continues to refocus if the subject moves or the image is reframed). If you want to simplify things, set the focus zone for the center of the image, and use Single Autofocus. The Continuous mode is better for action and sports photography,

but uses up your battery more quickly.

✦ **Metering mode.** Your camera may allow you to choose from Matrix, Center-Weighted, or Spot metering. Usually, Matrix metering — which evaluates many different areas of your image to intelligently choose what exposure to set — is best for most travel photography. Center-weighted and Spot metering are more specialized options that are useful when you want to zero exposure in on specific parts of the image.

2.7. Exposure modes include Scene modes optimized for Landscapes, Night Scenes, and other picture-taking situations, represented on the mode dial by pictographs similar to those shown here.

✦ **Exposure mode.** Use Programmed exposure for most of your shooting. Your camera will use the matrix metering mode and match up the exposure results with a built-in database of picture types and arrive at the best combination of shutter speed (to stop action) and aperture (to provide a

sufficient zone of sharp focus). Your camera might also have Scene modes geared toward specific shooting situations (such as Landscape, Night Scenes, Night Portraits, Museums). If you are a serious photographer, you'll find applications for Shutter Priority and Aperture Priority modes, too, which are covered in more detail in Chapter 3.

The common way to use EV settings is to take a picture, review it on your camera's LCD, and then decide whether it is too dark or too light. EV adjustments are represented by plus (+) and minus (-) signs, signifying that you can add or subtract exposure from the value your camera determined automatically with its metering system. Choosing +1 EV doubles the amount of exposure; selecting −1EV cuts the exposure in half.

Usually, though, whole increments are too much unless your picture is drastically overexposed or underexposed. (This can happen when a bright light source is included in the frame and your camera doesn't automatically compensate for that.) Digital cameras often allow you to change EV values in one-third or one-half EV increments over a range of plus/minus 2 EV, a total of 4 EV— two more and two less from the camera's original exposure. Some cameras have a 3EV to 5EV adjustment in either direction. However, even a small change can make a difference, as you can see in figure 3.1, which shows the same photo as it would look when underexposed by half an EV,

overexposed by half an EV, and, on the far right, at an optimum exposure.

Once you make an EV change, most cameras continue to use that extra or reduced exposure for subsequent shots, so it's important to change back to the default value (0 EV) when the exposure change is no longer required.

A second way of adjusting exposures in simple cameras may be found in what many cameras call *scene* modes, which are preset programs in your camera for specific shooting situations, with names like Landscape, Museum, Architecture, Portrait, Night Scene, and so forth. Some cameras have several dozen scene modes. Each mode includes basic settings for electronic flash, exposure, and how focus should be applied, and may include other parameters, including saturation (richness of the color) or contrast. If you find scene modes that work for you in particular photo environments, use them.

Focus with a simple digital camera is equally easy: You may have few options to worry

3.1. One-half EV in either direction — under (left), over (center) — can make a difference when compared to an optimized exposure (right.)

Photography Basics

You're on a trip, spot a perfect picture-in-the-making, and want to apply a little creativity to make it extra special. Then you realize that you've relied on your digital camera's automated features so much that you haven't taken the time to learn the photography basics you need to tweak your picture in a creative direction. Or, perhaps you have some experience with more advanced features, but you're a little rusty on some of the techniques you need to apply. Don't panic! In this chapter, you find a quick refresher in some photography fundamentals. Spend a minute or two boning up on exposure, depth of field, and a few other topics, and then capture that award-winning shot!

If you have a simple point-and-shoot camera with few adjustment options, most of what you need to know is in the next section. Those with digital cameras that have manual controls for exposure and focus can apply the techniques described in the rest of this chapter.

Exposure and Focus Adjustments with Simple Digital Cameras

With simple cameras, exposure adjustments are usually accomplished by making a change using a control called EV, or *exposure value*, settings. Virtually all digital cameras have an EV control, either in the form of a button or two on the back of the camera or as a choice found in your camera's menus. More advanced cameras also have EV settings.

Taking Great Travel Photographs

about. Your camera may have full-time automatic focus and no way to set focus manually, except, perhaps, when shooting close-ups. Some cameras may allow you to choose the zone used to calculate focus, whether or not the camera focuses continually while you compose the photo, or lock the focus (and exposure) in only at the last instant when you press the shutter release to take the picture.

If your camera has other settings for manipulating focus or for adjusting exposure, including shutter-priority, aperture-priority, and manual exposure, you'll want to read the following sections, too.

Exposure and Focus Adjustments with Advanced Digital Cameras

Digital cameras with their light-sensitive *sensors* (the high-tech replacement for film) are so automated and easy to use today, that you may not be totally familiar with the elements of photography that affect your exposures—which contribute to whether your image is too dark, too light, and with sufficient detail in both the dimly lit areas (*shadows*) and bright areas (the *highlights*). These elements are

✦ **Aperture.** The *aperture* (or *f-stop*), is the size of the opening in the lens that determines how much light is admitted.

✦ **Shutter speed.** The *Shutter speed* is how long the light is admitted into the camera.

✦ **ISO setting.** Both the shutter speed and the aperture have to do with the *ISO setting*. The ISO setting means how sensitive the sensor is.

A digital camera does such a good job of calculating exposure on its own whether you use one of the canned scene modes, programmed exposure, or even aperture- or shutter-preferred modes. Your camera doesn't necessarily leave you entirely on your own in manual shooting mode, either, because the indicators in the viewfinder may show you when your manually selected settings are more or less correct.

Creative photography often calls for an even deeper understanding of how exposure works. The next section includes a quick explanation of exposure to bring you up to speed.

What affects exposure?

Digital cameras, like film, react to light passing through the lens and form an image when sufficient illumination reaches the sensor. If not enough light strikes the sensor, the picture will be too dark (underexposed). If too much light reaches the sensor, the photo will be too light (overexposed). The amount of light received by the sensor varies in several ways, depending on how much light is reflected or transmitted by the subject and how much actually makes it through the lens.

The amount of light can be too much, too little, or just right. Proper exposure results when the light that reaches the sensor is just right and provides detail in the darkest areas of your image, while avoiding excessive illumination in the brightest areas

(which cause them to wash out). Four things affect exposure:

✦ **Light reaching the lens.** Your subject may reflect light (for example, the outside of a cathedral or other monument in sunlight), transmit light (the stained glass windows of the cathedral shot from inside), or be a light source on its own (for example, the flame of candles). To change the exposure, you can try to increase or decrease the amount of illumination coming from the light source, but that isn't always an option. However, consider, for example, waiting until the sun moves behind a cloud which reduces the light bouncing off or passing through a translucent object. You can also adjust the light reaching the lens through the use of reflectors that bounce additional light onto your subject or objects used to block some light, including filters placed over the lens. However, all these methods are usually used for creative effects. Exposure adjustments are generally made using one of the three parameters listed next.

✦ **Light passing through the lens.** The amount of light that makes it through the lens to your sensor is limited by a number of factors, the most important of which is the size of the lens opening, which is a circular, hexagonal, octagonal, or some other shape rather than circular. Except for a few specialized optics for cameras that allow interchangeable lenses, the lens for your digital camera includes a *diaphragm* that can be adjusted, usually through an arrangement of thin panels that shift to enlarge or reduce the size of the lens opening, as shown in the simplified image in figure 3.2. The relative size of the aperture (opening) is called the f-stop. Many digital cameras allow you to specify this f-stop manually, or at the very least, choose an aperture while the camera selects the shutter speed automatically. The simplest point-and-shoot cameras may have only one or two f-stops that are always chosen automatically by the camera.

✦ **Light passing through the shutter.** The amount of light admitted by the lens is further adjusted by the duration of the exposure, as determined by the shutter. This can be an electronic feature that sensitizes and desensitizes the sensor for a brief period, or a mechanical device that covers the sensor, then exposes it to light for the required length of time. With a digital camera, shutter speeds can be as brief as 1/8000 second or as long as many seconds.

✦ **Sensitivity of the sensor.** The sensor, like film, has a certain sensitivity to the light that reaches it. This sensitivity is measured using ISO (International Organization for Standardization) ratings, much like film is. ISO settings can range from about ISO 50 (not very sensitive to light) to ISO 400 (very sensitive to light) in point-and-shoot cameras, all the way up to ISO 1600 or ISO 3200 with more advanced cameras. Each time the ISO setting is doubled, the sensor seems to become twice as sensitive to light. However, the sensor's absolute sensitivity actually remains the same. What really happens is that the electrical *signal* the sensor produces is amplified when requested by the user (just as when your

stereo system amplifies the signal from your CD player when you turn the volume up), creating the same effect as a higher-sensitivity sensor.

3.2. The diaphragm controls the size of the lens opening.

All four factors described here work together to produce an exposure. Most importantly, they work together *proportionately* and *reciprocally* (with some exceptions involving very long and very short exposure times). In practice, doubling the amount of light reaching the lens, making the lens opening twice as large, leaving the shutter open for twice as long, or boosting the ISO setting 2X all increase the exposure by the same amount.

Exposure adjustments

From an exposure standpoint, if you need more or less light falling on the sensor to produce a good exposure, it doesn't matter which of the four factors you change. However, that's seldom true, because each of these factors affects the picture in different ways, whether you are adjusting the exposure yourself or letting your camera make the settings for you.

Adjusting the light reaching the lens

The lighting of your scene has an effect on both the artistic and technical aspects of your photograph. The quality of the light (soft or harsh), its color, and how it illuminates your subject determine its artistic characteristics. In exposure terms, both the

quantity of the light and whether your subject is illuminated evenly have a bearing on the settings. That can have a major impact on how your picture looks, whether you're shooting a landscape photo of a distant vista, capturing street life in a city you're visiting, or trying to picture the interior of an interesting building. You can do one of these things:

✦ **Increase or decrease the total amount of light in the scene.** Of course, if you're taking pictures of a castle while on a tour, you can't move the castle or turn the light levels up or down. Instead, you can find an angle where the sun is at your back, or the sun moves behind (or out from behind) a cloud. If you have flexibility on subject placement, move your subject to an area within the scene that's better illuminated or that has less light. Add lights or flip up your camera's electronic flash. Bounce illumination onto your subject using a reflector. Simply having one person in your party who is wearing a light-colored shirt or blouse stand off to one side to reflect light onto the person being photographed can work wonders.

✦ **Increase or decrease the amount of light in parts of your scene.** If there is a great deal of contrast between brightly lit areas and the shadows of your picture, your camera's sensor will have difficulty capturing the detail in both. If you're looking for creative effects, your best bet is usually to add light to the shadows (only) with reflectors, fill flash, or other techniques, or move your subject to an area that has softer, more even lighting. Figure 3.3 shows a close-up of a stone detail

made with soft, even illumination. In figure 3.4, the light comes more from one side and has more contrast and appears to be more dimensional. The shadows are darker, but the overall image is more interesting.

3.3. Light that is soft makes for an even exposure...

3.4. ...however, letting the shadows go dark often makes a more interesting, 3-D image.

Adjusting the aperture

Changing the f-stop adjusts the exposure by allowing more or less light to pass through the lens. If your camera offers manual or aperture priority modes you can change the aperture independently. The f-stop you choose appears in the viewfinder or on the LCD. You may need to check your camera manual to learn how to adjust the aperture if this feature is available. You might have to press a button or select a menu option, then change the aperture by pressing a pair of cursor control keys (up/down or left/right). More advanced point-and-shoot cameras and digital SLR cameras offer control over the aperture using command dials on the front or back of the camera. There are several considerations to keep in mind when changing the lens opening:

✦ **Depth of field.** Larger openings (smaller numbers, such as f/2.8, f/3.5) provide less depth of field at a particular zoom setting. Smaller openings (larger numbers, such as f/16 or f/22) offer more depth of field. When you change exposure using the aperture, you're also modifying the range of your image that is in sharp focus, which you can use creatively to isolate a subject (with shallow depth of field) or capture a broad subject area (with extensive depth of field.)

Note *Note that this depth-of-field control may be less significant with point-and-shoot digital cameras than with digital SLR cameras. You might find that your digital camera makes almost everything in your picture sharp, regardless of f-stop, and at most shooting distances other than close-ups. That can often be a good thing for most travel-type photography, except when you want to use depth-of-field as a creative effect.*

✦ **Sharpness.** Most lenses produce their sharpest image approximately two stops less than wide open. For example, if you use a zoom lens

with an f/4 maximum aperture, it probably achieves its best resolution and least distortion at roughly f/8.

✦ **Diffraction.** Stopping down further from the optimum aperture may create extra depth of field, but you also lose some sharpness due to a phenomenon known as *diffraction.* Avoid f-stops like f/22 unless you must have the extra depth of field or need the smaller stop so you can use a preferred shutter speed. Most point-and-shoot cameras don't have such small apertures, so diffraction is generally a problem only with dSLR owners.

✦ **Focal length.** The effective f-stop of a zoom lens can vary depending on the focal length used. That's why some lenses are described as, say, an f/3.5-f/4.5 optic. At the wide-angle position, the largest lens opening is equivalent to f/3.5; at the telephoto position, that same size opening passes one stop less light, producing an effective f/4.5

f-stop. At intermediate zoom settings, an intermediate effective f-value applies. Your camera's metering system compensates for these changes automatically, and, as a practical matter, this factor affects your photography *only* when you need that widest opening.

✦ **Focus distance.** The effective f-stop of a lens can also vary depending on the focus distance, but is really a factor only when shooting close-ups. A close-focusing lens can lose a full effective f-stop when you double the magnification by moving the lens twice as far from the sensor. The selected f-stop then looks half as large to the sensor, which accounts for the light loss. Your camera's exposure meter will compensate for this.

✦ **Rendition.** Some objects, such as points of light in night photos or backlit photographs, appear different at particular f-stops. For example, a streetlight, the setting sun, or other

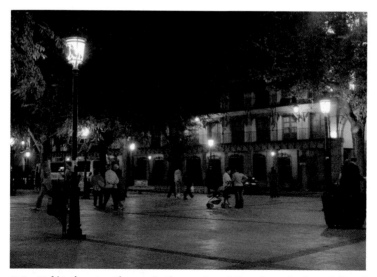

3.5. At f/4, the streetlamps in the center of the photo look undefined and globular.

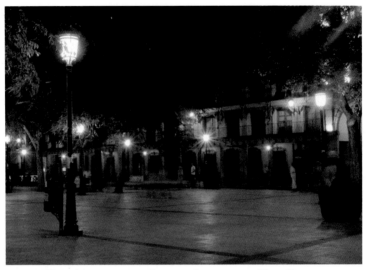

3.6. At f/22, the same streetlamps take on a star-like effect.

strong light source might take on a pointed-star appearance at f/22, but renders as a normal globe of light at f/8. If you're aware of this, you can avoid surprises and use the effect creatively when you want.

Adjusting the shutter speed

Adjusting the shutter speed changes the exposure by reducing the amount of time the light is allowed to fall on the sensor. In manual and shutter priority modes, you can change the exposure time by using your camera's shutter speed control. On some cameras, you may need to press a button or access a menu selection, and then change the shutter speed by pressing a pair of cursor keys (up/down or left/right). Digital SLRs may use a command dial on the back or front of the camera. The speed you select appears in the viewfinder and LCD status panel on top of the camera. Here are the considerations involving altering shutter speed:

✦ **Action stopping.** Slow shutter speeds allow moving objects to blur and camera motion to affect image sharpness. Higher shutter speeds freeze action and offer almost the same steadying effect as a tripod. If you're photographing street scenes with fast-moving people or shooting other photos of subjects that are in motion, you'll want to take advantage of the action-stopping ability of higher shutter speeds. Or, you might want to use a slower shutter speed to create blur, as in figure 3.7.

✦ **Reciprocity.** Shutter speeds that are very long may produce exposures that aren't equivalent due to a phenomenon known as *reciprocity failure*. That is, a 30-second shot at f/2.8 could provide less light than one at 1/2 second and f/22, even though the exposure settings are equivalent. Reciprocity also applies to very short exposures, but the top speed of most digital cameras is unlikely to generate much in the way of exposure failure. However, an electronic flash's 1/50000 second (or shorter) burst just might.

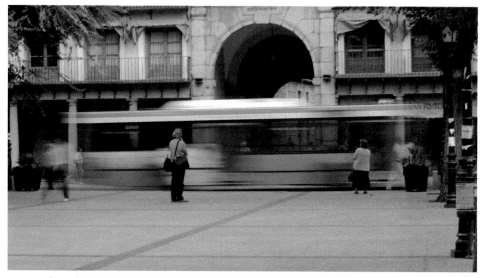

3.7. A slow shutter speed allows for the creative application of subject blur — but you may have to mount your camera on a tripod to keep the rest of your photo sharp.

Changing ISO

You can produce the same effect on your exposure as opening up one f-stop or doubling the shutter speed, by bumping up the ISO setting from 200 to 400. When photographing inside a museum that prohibits flash and tripods, but allows non-flash photography, this ability can be quite useful. However, there is at least one side effect to boosting the camera's ISO setting. Noise artifacts, those multicolored speckles that are most noticeable in shadow areas but which can plague highlights, too, appear more numerous and dense as the ISO setting is increased.

Point-and-shoot digital cameras tend to be the worst offenders in this regard, which is a primary reason why their ISO settings seldom go above 400. Their smaller sensors have electrical properties that accentuate noise levels, and a few of these cameras actually have objectionable levels of noise at relatively low ISO settings. Digital SLR cameras perform very well in this regard, fortunately. You probably won't notice much more noise at ISO 400, and ISO 800 can produce some very good images indeed. While ISO 1600 or higher may be still quite usable with many digital SLRs, you can expect noise to be visible.

Your camera manual will tell you how to adjust the ISO setting of your camera. You may have to press a button or access a menu selection to switch from Automatic to a manually specified setting.

Cross-Reference *I cover another basic of photography — composition — in Chapter 6.*

3.8. At ISO 800 (left), sensor noise is obvious. Reduce the ISO to 100 (right), and noise is almost invisible.

Getting the Right Exposure

If you're already serious about photography, you may already know that good exposure involves much more than keeping your picture from coming out too dark or too light. That's because no sensor can capture all the details possible in an image at every conceivable light level. Some details are too dim to capture, and others overload the photosensitive sites in the sensor and don't register at all, or worse, they overflow with light from overexposed areas that spills into adjoining pixels and causes an effect called *blooming*.

Like film, digital sensors can't handle large variations between the darkest and lightest areas of an image, so the optimum exposure may possibly be one that preserves important detail at one end of the bright-ness scale while sacrificing detail at the other. That's why you — the photographer — are often smarter than your camera's exposure meter. You know whether you want to preserve detail in the shadows at all costs or are willing to let them fade into blackness in order to preserve the lightest tones.

Perhaps you've found a perfect forest location for some nature shots, but want the exposure fine-tuned for the shadowed areas under a canopy of leaves. You don't care about bright spots of light where the sun makes its way through the foliage. Or, you're shooting an interesting building and want to preserve the detail on the sunlit side, and let the shadows go black for dramatic contrast. You — not the camera — must make these decisions by selecting the optimum exposure.

Left to their own devices, many digital cameras have a tendency to allow the highlights to be clipped (blown out) in order to preserve

3.9. Only you can decide whether the detail in the highlights or the detail in the shadows is more important for the image you're trying to take. Here, the interior of the gateway is more important than the scene outside its archways.

shadow detail. New users of these cameras often think their cameras underexpose most pictures (until they begin making adjustments on their own), when, in fact, they're rescuing those parts of the image that are most easily corrected. You can often boost detail in areas that are underexposed, whereas there's not much that can be done with blown highlights.

Understanding tonal range

The number of light and dark shades in your image is called its tonal range, and many digital cameras provide several tools to help you manipulate that range. If you have a digital SLR, you might be able to program your camera to use something called *custom curves*, which you can upload to the camera's internal settings.

A more accessible tool for the average advanced digital camera user is the *histogram.* This tool is available in many fixed

lens cameras and all digital SLR cameras. Fixed lens cameras may show histograms live in the LCD preview image, which means you can use it to adjust exposure before you take the shot (you usually turn this feature on or off using the display info button or a menu choice). For digital SLR owners, histograms are generally an after-the-shot tool used to improve the *next* exposure, because digital SLRs are unable to provide a live preview of the image you are about to take.

A histogram is a simplified display of the numbers of pixels at each of 256 brightness levels, producing an interesting mountain-range effect, as you see in the upper-right corner of figure 3.10. Each vertical line in the graph represents the number of pixels in the image for each brightness value, from 0 (black) on the left and 255 (white) on the right. The vertical axis measures the number of pixels at each particular brightness level.

The sample histogram in figure 3.10 shows that most of the pixels are concentrated

3.10. A histogram of an image with correct exposure and normal contrast will show a mountain-shaped curve of tones extending from the shadow areas (left) to the highlight areas (right.)

roughly in the center, with relatively few very dark pixels (on the left) or very light pixels (on the right). Even without looking at the photo itself, you can tell that the exposure is good, because no tonal information is being clipped off at either end. The lighting of the image isn't perfect, however, because some of the sensor's ability to record information in the shadows and highlights is being wasted. In a perfect histogram, the toes (edges) of the tonal curve snuggle comfortably with both the left and right ends of the scale.

Sometimes, your histogram shows that the exposure is less than optimal. For example, figure 3.11 shows an underexposed image; some of the dark tones that appear on the histogram in the original exposure are now off the scale to all the way to the left. The highlight tones, which normally would be toward the right, have moved toward the center, and there's a vast area of unused tones at the right side where the highlights *should* be. Adding a little exposure by using the +EV control moves the whole set of tones to the right, returning the image to the original, pretty-good exposure.

In the overexposed image shown in figure 3.12, highlight tones are lost off the right side of the scale. Reducing exposure by using the –EV control can correct this problem. As you work with more histograms and learn to understand the information they provide, you can use that information to fine-tune your exposures.

3.11. In an underexposed image, dark tones are lost at the left end of the scale.

3.12. In an overexposed image, tones are lost at the right end of the scale.

Fine-tuning

There are several ways you can fine-tune your exposure and the tonal range of your images. Here's a quick checklist:

✦ **In manual mode.** Adjust the aperture or shutter speed to add or subtract exposure.

✦ **In program, shutter-priority, or aperture-priority modes.** Perhaps you feel that choosing a different metering mode lets your digital camera choose an appropriate exposure more easily. Many digital cameras offer a choice of modes used to calculate exposure. These include *matrix* (the camera looks at many different areas of your image and uses a built-in database to determine what exposure might be best); *center-weighted* (most of the exposure is calculated from the information in the center of the image); or *spot* (exposure is calculated exclusively from a very narrow area in the center of the image). While matrix metering generally does a great job, sometimes you want to add emphasis to subject matter in the middle of the frame using center-weighting, or meter from one precise area in the frame, using the spot-metering capability.

✦ **Use tone compensation.** Some digital cameras allow you to specify what kind of image you have so it can apply its own specialized tonal adjustments to the image as it is shot. Your choices may range from automatic, to normal, low contrast, high contrast, and custom (which applies a tonal curve you've created yourself).

✦ **Apply EV settings.** Use your camera's EV control, and apply up to plus or minus five stops worth of exposure in one-half or one-third-stop increments (depending on how you've set up your camera). As mentioned earlier, EV controls actually add or subtract exposure from the camera's default meter reading using aperture or shutter speed changes.

✦ **Bracketing.** This is a tool for taking several successive pictures at different exposures (or with changes made to other settings). Your camera may allow taking three or more pictures, each with a little more or less exposure. Exposure bracketing may be performed in whole EV settings, but, like EV, can be more effective if smaller increments (that you select) are used. Advanced cameras may also allow you to bracket flash exposure or white balance. Bracketing doesn't fine-tune an individual exposure but, rather, lets you take a series of pictures, one of which, you hope, is optimal.

Focus Controls

More advanced digital cameras, particularly digital SLRs, give you a great deal more control over what's in focus and what is not. You need to understand how to fine-tune your camera's automatic focus features, use manual focus, and apply that range of sharpness called depth of field.

What's depth of field?

It's difficult to talk about depth of field in concrete terms because it is, for the most part, a subjective measurement. By definition, *depth of field* is a distance range in a photograph in which all included portions

of an image are at least acceptably sharp. What's acceptable to you might not be acceptable to someone else and can even vary depending on viewing distance and the amount the image has been enlarged.

Strictly speaking, only one plane of an image is in sharp focus at one time. That's the plane selected by your digital camera's autofocus mechanism, or by you (if you've manually focused). Everything else, technically, is out of focus. However, some of those out-of-focus portions of your image may still be acceptably sharp, and that's how we get depth-of-field ranges.

The DOF range at a particular zoom setting and focus position extends one-third in front of the plane of sharpest focus, and two-thirds behind it. So, assuming your depth of field at a particular aperture, focal length, and subject distance is 3 feet, everything 1 foot in front of the focus plane and objects 2 feet behind it appear to be sharp. You can see an example of depth of field in figure 3.13, which shows some ceramic pieces I picked up on a recent trip.

3.13. When you focus on the jug in back, the cup in front is out of focus.

Most of the time, DOF is described in terms of the size of the *circle of confusion* in an image. A portion of an image appears sharp to your eyes if fine details seem to be sharp points. As these sharp points are thrown out of focus, they gradually become fuzzy discs rather than points, and when that happens you deem that part of the image unacceptably blurry. The closer you are to the image and the more it has been blown up, the larger its circles of confusion appear, so DOF that looks acceptable on a computer display might be unacceptable when the same image is enlarged to poster size, hung on the wall, and examined up close.

To make things even more interesting, some of these out-of-focus circles are more noticeable than others and can vary from lens to lens. This particular quality is called *bokeh*, after *boke,* the Japanese word for blur. (The *h* was added to help English speakers avoid rhyming the word with *broke.*) The bokeh qualities of a particular lens are determined by factors like the evenness of its illumination and the shape of the diaphragm.

Lenses with good bokeh produce out-of-focus discs that fade at their edges, in some cases so smoothly that they don't produce circles at all, as in figure 3.14. Lenses with intermediate bokeh qualities generate discs that are evenly shaded or perhaps have some fade to darkness at their edges. The worst lenses create discs that are darker in the center and lighter on their edges, as in figure 3.15. You've probably seen the "donut hole" bokeh that result from catadioptric or "mirror" lenses, which is either the most atrocious bokeh possible or else a creative effect, depending on your viewpoint.

3.15. Individual discs with dark centers and bright edges call attention to out-of-focus areas of your image.

3.14. When the out-of-focus discs blend together smoothly, they are much less distracting.

Using focus controls

Your digital camera's focus controls may range from the nonexistent (your camera always calculates focus automatically), simple (you may be able to adjust how your camera applies its mandatory autofocus), intermediate (there may be a mode that lets you set focus within a limited range), to advanced (you have extensive control over automatic and manual focus).

If your camera allows manual focusing, you might have to use an on-screen adjustment with cursor keys, often using an enlarged view on the LCD of the central area of your image (because small LCDs are rather difficult to use to achieve accurate focus). Or, if you're using a digital SLR, you may focus by twisting a ring on the lens while the image pops in and out of focus in your SLR viewfinder.

Here is a more complete discussion of some of these focus controls and what they can do.

✦ **Basic full-time autofocus.** In this mode, the camera adjusts focus all the time, with no input from the user. Many point-and-shoot cameras have only this option, and it actually works quite well for most kinds of pictures. The autofocus mechanism is usually as accurate as a human and often much faster in locking in the correct focus. Autofocus generally kicks in when you press the shutter-release button halfway, locking focus at a single point until you continue to press and take the photo. Many digital cameras also have a *macro*, or close-up, mode that uses autofocus to ensure sharp pictures of subjects that are only a few inches from the camera lens.

✦ **Autofocus modes.** More advanced cameras up to and including digital SLRs may offer a choice of autofocus modes. In *continuous autofocus,* the camera sets sharp focus when the shutter release button is partially depressed, but continues to adjust focus if the subject moves or the camera reframes. This mode is good for action photography. With *single autofocus*, the camera locks in a focus point when the shutter release button is pressed down halfway and doesn't change. Use this mode if the distance between you and your subject remains the same and you don't want the camera to change focus if you reframe the image in the viewfinder, or some intervening object intercedes, (for example, a pedestrian walking by as you are taking a photo of a family member in front of a monument). A few advanced cameras analyze your scene and switch between continuous and single autofocus as appropriate.

✦ **Autofocus zones.** Simple digital cameras may adjust focus based on a fixed central area of your image. More advanced cameras may use from four to 12 different zones (or even more), either selecting which zone to use automatically (for example, the one that includes the subject nearest the camera) or one that you choose by pressing a cursor control key to highlight the zone you want in the viewfinder.

✦ **Autofocus override.** If your camera has this feature, it may focus for you automatically but allow you to fine-tune the focus using a control such as a cursor key or lens focus ring. Your lens or camera has this feature if it has a switch like the one shown in figure 3.16, which allows you to change from manual focusing mode to automatic/manual.

3.16. This override switch lets you change from automatic to manual focus.

✦ **Manual focus.** With manual focus, all focus decisions are up to you, although your camera may be equipped with something called an electronic rangefinder that is a signal that flashes in the viewfinder or next to the eyepiece when correct focus, as judged by the camera's focus system, is achieved.

✦ **Depth-of-field preview.** Digital SLRs let you view your image with the lens at its largest aperture. But it may include a button called the *depth-of-field preview* that closes the lens down to the actual f-stop that you use to take the picture, so you can get a more accurate look at the depth of field you'll get (even though this preview lens may be quite a bit darker).

Depth of Field and Your Camera

As I mentioned earlier in the chapter, DOF may be a non-issue for those with point-and-shoot cameras, which often make everything in an image sharp because their lenses, mated with small sensors, have bounteous depth of field at any f-stop and most shooting distances. That's because digital snapshot cameras have much smaller sensors that require lenses with shorter focal lengths to achieve the same image size, and depth of field is determined by the focal length of the lens and the distance from the camera to the subject. So, that 7mm to 21mm 3X zoom lens on your point-and-shoot camera may have the same field of view as a 35mm to 105mm zoom on a full-frame film camera, but the depth of field is much greater. The telephoto position, for example, has the same depth of field as a 21mm wide-angle lens on a film camera.

If you own a fixed-lens camera with a super zoom lens (the equivalent of around 300mm or longer with a 35mm film camera), you'll find that this long focal length makes depth of field something that you want to pay attention to. This is also the case with digital SLR cameras because they have larger sensors and correspondingly longer focal lengths at a particular magnification. With a dSLR, even a wide-angle lens has depth-of-field issues.

Working with Light

A s you take travel photos, you'll find that light is a basic tool and can be one of the things that sets your photos apart from countless others taken by picture-taking travelers who've also passed that way. The quantity and quality of the light you work with has an effect on every other aspect of your photography. The amount of light available controls whether you can make an exposure at all inside a dimly lit museum, how well you can stop action or slow down a shutter enough to use movement blur and other creative techniques at a bullfight, and how you apply selective focus to isolate an ancient artifact from its modern surroundings. The distribution of light affects the tonal values and contrast of your photo. The color of the light determines the hues you see.

In many ways, photography (*light writing* in ancient Greek) depends as much on how you use light as it does on your selection of a composition or a zoom setting. Great books have been written on working with lighting; for this field guide, I concentrate on some of the nuts and bolts of using the lighting tools available for your digital camera.

Light falls into two categories: continuous light sources, such as incandescent, daylight, and fluorescent light; and electronic flash. Both forms are important.

Conquering Available or Continuous Light

Most of your travel pictures will use available light sources (the light that is already present in the scene), which, in contrast to the brief, almost instantaneous blip of an electronic flash, are continuous. These sources can include daylight, moonlight, lighting fixtures indoors, light streaming through windows, and any other sort of nonintermittent lighting.

The term available light is sometimes confusing because, after all, any light you have at your disposal (including electronic flash and lights mounted on stands) is, by one definition, "available." Photographers have traditionally used available light (or existing light) to mean any preexisting light, but I want to go beyond that to include impromptu lighting adjustments you might make using reflectors or even additional non-flash sources. So, I use the term continuous lighting throughout this chapter so you'll know what I mean.

Continuous lighting has some advantages over electronic flash. You always know what lighting effect you're going to get. Any such light automatically shows how it affects your scene (electronic flash requires a modeling light as a preview) and how it interacts with other continuous lighting in use. If you're grabbing a shot of a traveling companion posing in front of a notable landmark, it's good to know exactly how the light falling on both looks, even before you take the picture. If you were to take a similar picture at night using a flash, predicting how it might look can be tricky. Certainly, you can review your photo on the LCD and reshoot, but isn't it better to do it right the first time?

A final advantage of continuous lighting is that it makes it easier for you or your digital camera to measure exposure with daylight/incandescent/fluorescent-style lighting, than it is with electronic flash.

On the other hand, continuous lighting doesn't have the built-in, action-stopping capabilities of electronic flash, which can freeze an instant in time by virtue of its very short duration. It provides the same effect as a brief shutter speed like 1/500 or 1/1000 second (if the flash is the main source of illumination). Nor is continuous lighting always as intense. You might need a tripod with continuous lighting, where electronic flash would allow handholding the camera under the same conditions.

When shooting travel photographs, there are four things about continuous lighting that you need to manage:

✦ Intensity (how bright or dim the light is)

✦ Quality (how harsh or soft the light is)

✦ Direction (where the light is coming from)

✦ White balance (the light's color tinge).

Coping with Intensity

The brightness or dimness of your light determines the exposure, but intensity has practical aspects, too. If there's not enough light, you might not be able to take a photo at all; the same thing can happen if there is too much light, for example, on a beach or at a ski resort. Fortunately, there are things you can do to remedy insufficient or excessive light levels.

Night photography

One common travel scenario is night photography, especially in picturesque villages or bustling cities. A town changes its character as night falls, and many of the business people retreat to their homes to reemerge for socializing or recreation. Others go to work at nighttime jobs. There are lots of opportunities for great photos at night.

Although I'm sure you've all visited sleepy little towns (or even metropolises in certain parts of the U.S.) that seem to close down at 9 p.m., the largest cities in the United States and towns of all sizes in Europe and Asia tend to bustle at all hours, making for some interesting photo opportunities. (That's not to say you won't find things to photograph in tiny hamlets in the evening, too.) Your digital camera is probably well equipped to handle night photography in these situations. Here are some things to think about:

✦ **Check out your camera's night scene modes**. These modes allow longer shutter speeds to allow dim light to register (often in conjunction with electronic flash, so the available light and your flash balance out). When using lengthy shutter speeds, steady your camera to avoid blur. Look for a spot to brace yourself or your camera against (a pillar, a wall, a lamppost) or somewhere you can set down the camera and use the self-timer to trigger the exposure.

✦ **Try a tripod.** There are lightweight tripods that travel well. They might not be as sturdy as you like, but most can be used for longer exposures at night if you let the camera settle by using a remote release or the self-timer to take the picture.

✦ **Incorporate movement into your photos.** If you use slow shutter speeds, try to use the blur of objects that move as a creative tool. Headlights of cars may make interesting streaks. Pedestrians

4.1. A tripod made it possible to capture this dramatic view of a European town's clock tower at night.

may blur in ways that suggest movement.

✦ **Use higher ISO settings with caution.** Unless you use a digital SLR, your camera's ISO sensitivity settings probably top out at around 400. No matter what kind of camera you have, the very highest ISO settings will probably result in *digital noise,* a grainy effect produced by amplifying the signal from the sensor. Learn how to use your camera's noise-reduction feature (if it has one) to counter this effect. Some digital cameras may automatically switch noise reduction on for any exposure longer than one-half second, for example.

Low-light indoors

Indoor photography in museums, cathedrals, and other dimly lit locations offers challenges similar to those found in outdoor environments at night with a couple exceptions:

✦ **Beware of night scene modes that use available light in conjunction with flash.** Many museums and other venues prohibit flash photography indoors. So, if your night scene mode combines a long available light exposure with a flash, you may get in trouble. Instead, see if your digital camera has a Museum mode (found in many of the latest models) that locks out your flash entirely so you can be confident that the photo is taken using only available light and your flash won't get you in a bind.

✦ **Working without a tripod.** You may find that the majority of indoor tourist attractions prohibit

the use of tripods (although they may make exceptions when asked ahead of time in writing). The main objection to tripods is that they get in the way of other visitors and may even become a hazard to those who aren't paying attention. These same venues may look the other way at discreet use of a compact monopod that looks like a walking stick. Buy a quick-release plate set (available from any camera store). Half attaches to the bottom of your camera, the other half fits on your tripod, and the two are quickly and unobtrusively mated when you want to take a quick picture. You find more about monopods in Chapter 5.

✦ **Find brightly lit corners.** If you're having trouble shooting indoors, find a more brightly lit area, perhaps near a window with daylight streaming in, or in an area that is showcased by auxiliary lighting.

Extra-bright environments

Relaxing on the beach is a favored activity for many travelers, and so is visiting snow-covered mountains for skiing or snowboarding, or ice-covered lakes and arenas for skating. All these situations can lead to a lot more light than you really need for your picture. High light levels are great when you want to freeze a speedboat or stop a ski jumper in midflight, but too much of a good thing can be a problem. Here are some things to consider when photographing outdoors in bright light:

✦ **Use your camera's lowest ISO setting.** Some digital cameras set ISO automatically, with no user options, but others may have

4.2. When indoors, look for a brightly lit corner or corridor with plenty of artificial lighting or daylight streaming in from a window or open area.

manual ISO settings as low as ISO 50 or ISO 64. A reduced setting prevents your camera from being overwhelmed by excessive light levels, and if you're a more advanced photographer, gives you the option of using a larger f-stop to reduce depth of field for creative purposes. For example, at ISO 200 on a brightly lit beach, a typical exposure might be 1/400 second at f/16 — and not all fixed-lens digital cameras have an f-stop of f/16 even available! But at ISO 50, a more reasonable exposure of 1/400 second at f/8 could be used.

✦ **Use a filter.** Many digital models can be fitted with an add-on filter. One kind is called a *neutral density* filter, which can be used to cut down on the amount of light used

to take your photo. A 2X ND filter cuts the light in half (one f-stop), while a 4X ND reduces the light by 75 percent (two f-stops).

✦ **Cut down harsh light with reflectors or fill flash.** In beach or snow scenes, the light may not only be too bright, but also too harsh with strong shadows. Simple reflectors (try using a discarded pizza box) or turning on your camera's electronic flash can fill in the shadows when photographing subjects up close in harsh lighting conditions.

✦ **Check out Beach/Snow scene modes.** If you like letting your camera make most of the decisions, see if it has a beach or scene mode (or both) and use that.

Coping with White Balance

Another problem with non-flash illumination is the color of the light itself, called *white balance*. All light sources, including electronic flash, can vary in the relative color balance of the light they produce. Your digital camera has the ability to adjust for this variation using the white balance feature built into it.

Most of the time, you can leave white balance set on Auto and let your camera make an educated guess about the color of light you're currently shooting under. However, sometimes the camera is fooled and you get photos taken outdoors that are too blue in color or indoor pictures that are too orange (or even vice versa.) In those cases, manually adjust the white balance setting to one of the presets available through your menu system. These presets have names like Daylight, Cloudy, Shade, Fluorescent, or Incandescent.

These changes are needed because each individual type of light source has its own particular color, and this color can be partially specified using a scale called *color temperature.* For example, an incandescent light might have a warm color temperature of 3200 or 3400 degrees Kelvin (which is the scientific scale used to describe the color of a mythical object called a *black*

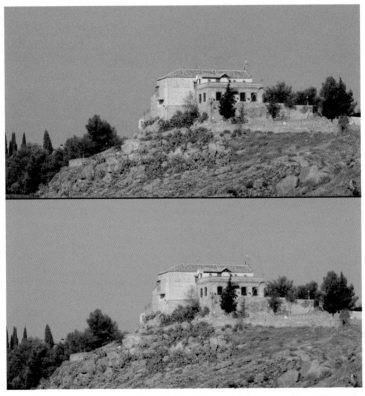

4.3. Getting the correct white balance (bottom) can make a dramatic difference in your final photo.

body radiator as it heats). Daylight might have a "cooler" 5500K color temperature. That might seem paradoxical, because the reference object is getting hotter as the color temperature becomes cooler, but humans tend to associate blue with cold things, including colors, and red with warm things, so that's the way it is.

> **Tip** *Kelvin and color temperature are complex topics, but if you'd like to learn more, just Google "color temperature" to locate pages and pages of explanation.*

Things get a little complicated when fluorescent lights are introduced into the mix, because such lights don't produce illumination from heat but, rather, from a chemical/electrical reaction. So, fluorescent light can't be measured precisely on the color temperature scale. Nor do such lights necessarily produce proportionate amounts of all the colors of light in the spectrum, and the color balance of fluorescents varies among different types and vendors.

That's why fluorescents and other alternative light technologies such as sodium-vapor illumination can produce ghastly looking human skin tones. Their spectra can be lacking in the reddish tones normally associated with healthy skin, and emphasize the blues and greens popular in horror movies and TV procedural investigation crime shows.

If none of the presets on your camera seems to work (reviewing your picture on the LCD shows a continuing colorcast), you can use the Custom setting found in many advanced digital cameras. To use this feature, set the camera to measure light balance, and then point the camera at a neutral gray or white object, and take a picture. The camera calculates white balance from this sample. Also, some models allow using the white balance already established in a picture you've taken previously that's still on your memory card.

Working with Flash

When it comes to digital cameras, electronic flash units are like opinions — just about everybody has one. Except for some high-end pro cameras, all digital models include a built-in electronic flash that may reside on the front of the camera or flip up from the top when you're ready to use it.

Electronic flash illumination is produced by accumulating an electrical charge in a device such as a capacitor, and then directing that charge through a glass *flash tube* containing a gas that absorbs the electricity and emits a bright flash of photons. If the full charge is sent through the flash tube, the process takes about 1/1000 second and produces enough light to properly illuminate a subject 10 to 20 feet away, depending on the power of your camera's flash and the ISO setting in use.

The chief drawback of flash is that light diminishes sharply as distance increases — much more quickly than you might guess. It actually falls off with the square of the distance, meaning an object that is 4 feet from the flash receives four times as much illumination as one that is 8 feet away. Photographers call this the *inverse square* law.

The simplest digital cameras use their autofocus systems to determine how far your subject is from the camera and use that information to determine the correct exposure for flash shots. That works fairly well but takes into account only the distance, and not how well your subject reflects light. A white marble statue 6 feet away requires less illumination than, for example, a cute burro laden with pottery at the same distance.

Techie Flash Stuff for dSLRs

No matter what the duration of the flash, it generally occurs only when the digital camera's sensor is exposed and fully sensitized. The process is a little more complicated with digital SLRs, which always have a shutter in front of the sensor until the moment of exposure. With most SLR cameras, this mechanical focal plane shutter consists of two curtains that follow each other across the sensor frame. First, the *front curtain* opens exposing the leading edge of the sensor. When it reaches the other side of the sensor, the *rear curtain* begins its travel to begin covering up the sensor. The point in time when the full sensor is exposed is when the flash is tripped. If the flash goes off sooner or later, you see a shadow of the front or rear curtain as it moves across the frame.

In the typical digital SLR, the sensor is completely exposed for all shutter speeds from 30 seconds (or longer) to a top speed of about 1/180 to 1/500 second. The maximum top shutter speed that can be used with electronic flash is called the camera's *sync speed.*

More advanced cameras measure the amount of light reflecting back and use that information to determine exposure. A common system is to use a preflash that you probably won't even notice to determine the reflectivity of your subject an instant before the actual picture is taken. The flash then varies the *amount* of light issued by the flash tube to reduce the illumination reaching subjects that are closer to the camera.

Shooting considerations

What does all this mean to the travel photographer? Here are the key points to think about:

✦ **Flash stops action.** Because the flash occurs for a brief time only when the shutter is completely open, the actual shutter speed has no effect on the flash's action-stopping power. A 1/1000 second flash freezes action at 1/2 second in exactly the same manner as at 1/500 second, because only the flash itself is used for illumination.

The actual shutter speed doesn't matter. If you shoot moving subjects by flash (for example, some swirling Gypsy dancers) your flash freezes them in their tracks.

✦ **High light levels produce "ghosts."** If the shutter is open long enough to produce an image from the continuous, non-flash (available or existing) light in a scene, you get a second exposure in addition to the flash exposure. If your subject is moving, this second exposure appears as a blurry ghost image adjacent to the sharp flash image. Always take into account the fact that you're taking two exposures, not one, when shooting with flash. If your Gypsy dancers are also illuminated with a spotlight, you may find blurry trailing edges of their costumes visible (which might be a good thing, if done creatively). Those colorful carousel horses may be followed or preceded by ghost horses if you're not careful.

✦ **Allow for delays.** Once an exposure is made, it takes a short time for the flash to recharge to full power, usually 1 to 2 seconds. If your photo doesn't require the full capacity of the flash, you may be able to take another picture more quickly, however.

✦ **Watch light "fall-off."** Because of the effects of the inverse square law, strictly speaking, electronic flash produces a correct exposure only at one distance. Objects that are farther away or closer to the flash will be a little (or a lot) under- or overexposed. For example, if you're shoot a person in your traveling group standing 8 feet away, someone positioned 4 feet behind your main subject receives about one f-stop less exposure; a bystander 8 feet farther away receives two less f-stops' worth of light. Someone in the foreground 4 feet from the camera will be overexposed by two full stops. You can think of this phenomenon as *depth of light*, although the distribution is the opposite of depth of field. On a foot-by-foot basis, there's a longer range of acceptable light behind the main subject than in front of it.

Flash modes

Even relatively simple digital cameras have optional flash modes that control how and when the electronic flash is triggered. Most of the time you can use the default mode (usually called Automatic), but it's smart to know about the others in case you have need of them. The flash modes include:

✦ **Always On/Fill Flash.** In this mode, the flash always fires, whether it is needed for the exposure or not. This allows the flash to fill in shadows in indoor and daylight pictures. Some cameras have a separate fill flash setting that sets the flash to a lower level to ensure that shadows aren't completely washed out.

✦ **Slow-sync.** This mode is available with many cameras, sometimes only when the camera is set to Night Scene or Night Landscape modes. It combines slow shutter speeds with flash to produce two different images (one from the flash, the other from the ambient light) so that your flash pictures have a background that isn't completely black. It's best to use a tripod and avoid moving subjects when

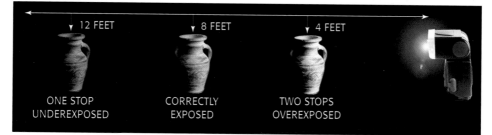

▼ 12 FEET ▼ 8 FEET ▼ 4 FEET

ONE STOP UNDEREXPOSED CORRECTLY EXPOSED TWO STOPS OVEREXPOSED

4.4. When a subject 8 feet from the light source is properly exposed, a subject 4 feet closer receives four times as much exposure (two f-stops more), but a subject 4 feet farther away receives only half as much exposure (one f-stop less.)

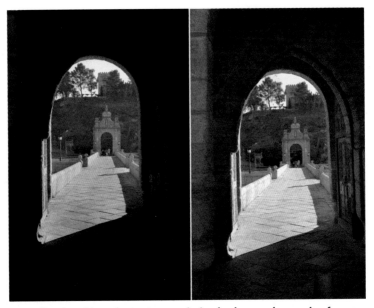

4.5. Allowing the archway to remain in shadow makes a nice frame for the bridge on the other side (left), but using a little fill flash reveals detail in the stonework. Either approach works.

using slow sync, because many cameras program exposures up to 30 seconds long, and you're likely to get ghost images otherwise.

✦ **Red-Eye mode.** When set to this mode, your digital camera uses a preflash of the focus assist lamp (if present) or, more commonly, the main flash itself to reduce the chances of red-eye effects. Supposedly, the preflash causes your subjects' irises to contract and stifle some of the reflection. You'll know when this mode is in use.

✦ **Front sync.** Digital SLRs have a mode called front sync, which is usually the default setting. In this mode, the flash fires at the beginning of the exposure when the first curtain reaches the opposite side of the sensor, and the sensor is completely exposed. The sharp flash exposure is fixed at that instant. If the exposure is long enough to allow an image to register by existing light as well as the flash, and if your subject is moving, you end up with a streak that's in front of the subject in the direction of the movement.

✦ **Rear sync.** In this optional mode for digital SLRs, the flash doesn't fire until the end of the exposure. The ghost image registers first and terminates with a sharp image produced by the flash at your subject's end position, providing a ghost streak behind the subject, similar to the streaks you see in comic books and movies about superheroes. If you must have ghosts (or want them for creative effect), rear-curtain sync is more realistic.

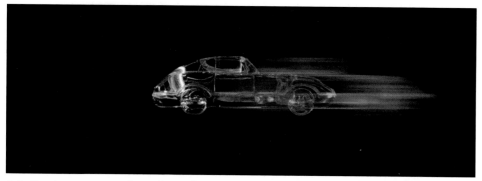

4.6. Front sync can produce ghosts that appear ahead of the direction of movement.

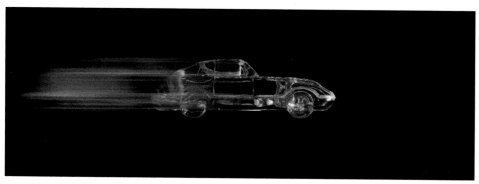

4.7. Rear sync creates more realistic trailing ghost images.

Flash exposure modes

As previously mentioned, your digital camera may determine the correct exposure simply by measuring the distance between your camera and your subject. More advanced cameras, including dSLRs, determine the correct exposure by emitting a preflash just prior to the actual exposure, then measuring the amount of light reflected from the subject. The preflash occurs almost simultaneously with the main flash, so you probably won't even notice it.

But wait, there's more! The typical dSLR gives you several different ways to calculate exposure:

✦ **Advanced TTL.** Through the lens (TTL) exposure measurement in its advanced form is known under various names, depending on the vendor. But what generally happens is that exposure is based on a complex set of factors, including information supplied by the lens' autofocus system (which tells the camera both the focal length of the lens and distance of the main subject) combined with the measured light reflected during the preflash. The camera then attempts to balance the flash illumination with the ambient light to produce the best exposure. This mode is found in built-in flashes and add-on units.

✦ **Standard TTL.** In standard mode, TTL calculates only the exposure needed to properly expose the subject and does not try to balance the flash with ambient light. This mode is also found both in built-in flashes and add-on units.

✦ **AA (Auto Aperture).** This mode is found only in external add-on, dedicated flash units built specifically to communicate with the cameras they are used with. It was most popular before cameras became capable of measuring flash illumination through the lens. The AA mode takes some of the control from the camera and calculates exposure in the flash itself. The camera tells the flash the ISO and aperture settings, and a sensor on the front of the flash measures light reflected by the subject and shuts off when the correct amount of light is emitted.

✦ **A (Automatic).** This mode, similar to AA, is the simplest automatic exposure mode of all. There is no communication between camera and the external flash. The aperture and ISO setting must be entered into the flash manually, and the flash measures the amount of light reflected by the subject and shuts off at the appropriate time.

✦ **Manual.** With both internal and external flash units, you may be able to set the power of the internal flash manually using the menus or set the power output of an external flash on the speedlight itself. This mode, used by advanced photographers, is useful when you have a handheld electronic flash meter or want to set the flash level yourself for other reasons.

Flash exposure compensation

If you want to tweak the exposure set for you by your flash, you can use the flash exposure compensation system found in many digital cameras. It's similar to the EV settings provided for nonflash exposures, but applies to flash pictures instead. To make this adjustment, hold down your camera's flash exposure compensation button (or summon this feature from the menu system), and then set the +EV or –EV setting you want. This feature is especially useful when trying to use fill flash to brighten up shadows and your camera's flash exposure modes provide either too much or too little fill.

Using Built-In Flash

As you work with your digital camera, you may find yourself constrained by the limitations of the built-in flash. There's a lot to like about the internal flash. It's always there when you need it, requires no extra batteries, and it's well integrated with the camera's exposure system. The built-in flash is more or less a no-brainer accessory.

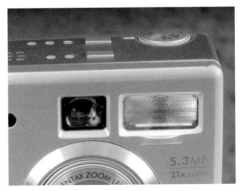

4.8. The best thing about an internal flash is that it's always there, ready for use.

Unfortunately, the internal flash is usually limited in output, so your effective range may be 10 to 12 feet or even less. The typical location so close to the lens tends to exacerbate red-eye problems, even with a red-eye preflash in use. The flash's position also means it's not very useful when shooting close-up photos or some wide-angle shots. If you're using a digital SLR, the lens or its lens hood can cast a visible shadow on your subject. There's no way to re-aim an internal flash to bounce it off the ceiling, walls, or reflectors. Finally, a lot of light is wasted by the internal flash, which keeps the same coverage area whether you use a wide-angle or telephoto zoom setting.

Using External Flash

Intermediate and advanced digital cameras may be able to use an external flash unit that slides onto a hot shoe or plugs into a special connector on the camera. Tiny external flash units that provide a little extra light, as well as huge monsters that can fill a room with their illumination, are available.

An external flash unit, especially one designed for your particular digital camera, solves many other problems. Even mounted in the camera's hot shoe, an external flash is much farther away from the lens, reducing red-eye problems. You can remove the flash from the camera, while keeping it connected to the camera with an extension cable, and point it any way you like for bounce flash or close-ups. The flash coverage can sometimes be adjusted narrower or wider to better suit the focal length of the

lens being used. Some dedicated external flash units can receive information such as current focal length of the zoom lens, so this coverage adjustment is automatic.

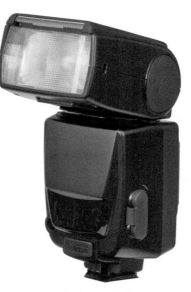

4.9. An external electronic flash can provide you with more power and flexibility.

You can connect an external flash by sliding it into the hot shoe or by connecting its cord to an adapter offered by your camera vendor or an adapter like the Wein Safe Sync. This kind of adapter isolates the camera from the triggering voltage of your flash unit.

Caution *If the flash you try to use is not made by your camera manufacturer or made specifically for your make and model of camera, the triggering voltage might be too high for your camera's internal circuitry.*

You can also trigger an external flash by equipping that flash with a light-sensing slave unit (some have them built in) and using the camera's internal flash to trigger the external unit. Some digital SLRs allow wireless operation, with no connection between the camera and flash at all. You can actually use several different external flashes in this way.

4.10. The Wein Safe-Sync isolates your external strobe's triggering voltage.

Accessories for Digital Travel Photography

A camera properly equipped with its lens and a memory card is all you need to shoot great-looking travel photos, right? Oh, wait. Your camera must be powered, so throw in extra batteries and/or a battery charger, too. Hmm...maybe you should include a rain poncho to keep you and your camera dry during those misty (or rainy days). Some sort of camera support would be nice to hold your camera steady for long exposures or for when you want to include yourself in a picture of your entire group.

If you use a more advanced camera, you probably want an electronic flash for pictures at night, and at least one or two interchangeable lenses to give you a different perspective on your travel subjects. Now you need a bag to carry all that junk in. It looks as if you're going to have to take a serious look at the accessories you take with you on your trip — so you know what you absolutely must have and what you can get along without.

If you've read the Quick Tour and the first two chapters of this book, you already know the basic items that are essential for anyone traveling as light as possible: a camera, a spare camera (usually happily put to use by another member of your party), lots of memory card space, and sufficient power to keep your equipment operating for the length of your journey.

While I always recommend traveling with a minimum of gear so you have more time to enjoy your trip and take photos without being bogged down with gadgets, there are certain

items that are certainly worth their weight in your take-along kit. This chapter outlines some of the less-essential essentials so you can make an informed decision about what to take along, and what to leave behind based on your specific trip and photography goals.

The Simple Life

The journeys of many travelers don't revolve around the photos they take. If you're one of those who craves the simple life when on the road, then you want to take along only what you absolutely must have. You want to take great photos, but don't want photographic activities to dominate your trip.

This section details the accessories needed for those who are traveling as simply as possible. You probably use a fixed-lens camera, perhaps one with a very long zoom lens range so that a single lens can accommodate just about every type of picture you're interested in taking. You prefer not to pile in a lot of gadgets. Here is a minimalist's take on what to take.

Storage

If you want to rely on your memory cards and not drag along some sort of device for off-loading the photos you take to another device, you have two choices: plan on taking only as many pictures as you have storage space for in your memory cards, or find a service at each of your destinations that can handle this chore for you. In most parts of the world, that's not a particularly daunting task. Many camera stores and souvenir shops in tourist towns are equipped to copy images from your memory cards onto a CD or DVD while you wait. Internet cafés or public libraries may provide you with online access so you can upload your pictures to a safe Web space.

Cross-Reference *You'll find tips on using services for downloading and creating CDs when traveling in Chapter 7.*

Even if you plan on dumping your memory cards at regular intervals, you'd still be smart to have enough memory card space to handle at least two days of shooting.

Staying powered

Earlier in this book I mention the importance of having enough battery power for your camera, and recommend having at least one set of spare batteries. Those leading the simple life may be able to squeeze by with nothing more than extra batteries if their camera uses AA or common lithium types. Otherwise, you need to add a battery charger to your traveling kit, so you can charge your batteries each night in your hotel room.

The good news is that if you travel outside your home country, you probably don't need to bring along one of those bulky power converters that used to be essential for travel overseas. Most electronic devices manufactured in the last five years or so accommodate multiple voltages (usually 90/100 volts to 240 volts) and both 50/60Hz frequencies. All your camera battery chargers, devices like electric razors and hair dryers, and a host of other gadgets should work just fine no matter where you go. When I first began traveling, it was necessary to take along two converters, one with a high wattage rating for heating devices and other equipment that wasn't sensitive to frequency fluctuations, and a second, lower-capacity converter with precise

frequency control for anything with an electric motor.

Today, converters may no longer be necessary. Just check your equipment's label or instructions to see if it automatically switches among various types of power. Some older gadgets may have a switch you need to throw to alternate between 110/120 and 220/240 volts. You will need an adapter to convert the type of plug on your device to the sort used at your destination, but these are cheap, small, and even readily available when you arrive if you forget to take one along. Your local electronics store can sell you one of these adapter plugs and may have a chart showing exactly what types of prongs are needed where you're headed.

5.1. Check the specs on your charger and other electronic components to see if they are compatible with power at your destination.

Stuffing a camera bag

Many digital cameras are small enough that they can live happily in a pocket or purse until needed. Or, if you take many photos, you may discover that your camera rarely leaves your hand while you're actively touring. But, if you have a larger digital camera (especially a digital SLR) or want to tote

along a few accessories, you'll need some sort of pouch or small camera bag to hold your camera, extra batteries, memory cards, and some identification so the bag can be returned to you if it's mislaid.

Just about any small bag will do for those traveling on the simple plan, especially if you follow my advice from earlier in this book to include a zipper-seal bag that can protect the contents of even a simple bag from the elements. If you have a lot of junk to carry along, you'll want to read the camera bag advice later in this chapter.

Cleaning kits

Those traveling light don't need much in the way of cleaning utensils, but a soft, lint-free cloth intended for cleaning lenses and, perhaps, some lens-cleaning fluid, come in very handy when a fingerprint or unexpected drip lands on your lens. If you use a digital SLR, you might want to take along a blower to remove dust from your sensor, lens, or viewfinder.

Rain poncho

I can't count the number of times when an unexpected shower (possible in all but the driest of locales) sent me hunting for a shop that sold *parapluies, paraguas,* or even an old-fashioned *brolly.* In tourist areas, street vendors hawking umbrellas seem to appear by magic as soon as the first raindrop falls, but if you are smart enough to include one of those compact, ultralight rain ponchos in your gear, you can keep yourself and your camera equipment safe and dry. I saved the raincoat supplied for a voyage on the *Maid of the Mist* on a photo trip to Niagara Falls, but you can find foldable rain ponchos at travel stores, your local auto parts store (our

Maximizing Your Battery Life

✦ **Minimize LCD use:** The LCD viewfinder is a real energy hog, but most digital cameras let you specify how long the LCD stays on for picture review after a shot is taken. If you use a camera that also has an optical viewfinder, choose the briefest setting. Should your camera offer only an LCD viewfinder, leave the LCD switched on for a longer period so you can frame your next shot. A power-off delay of perhaps 2 minutes should be adequate. The brightness of your LCD's backlight can also be adjusted: Use the dimmest setting that still allows you to view your image adequately. The brightness used indoors can be lower than what you need outdoors.

✦ **Use flash sparingly:** Built-in flash units can reduce the life of your camera's batteries by as much as half. Use flash only when there isn't enough illumination for available-light shooting or when you want to fill in dark shadows with the flash in contrasty lighting, say, outdoors.

✦ **Choose beefier batteries:** Sometimes you have a choice of battery types, particularly if your camera uses AA cells. AA lithium batteries tend to last longer than other nonrechargeable battery types, such as alkaline cells, so if you use these, you can extend the active life of your shooting session. Lithium cells handle cold weather better, too. Nickel metal hydride (NiMH) and Lithium-ion batteries have more juice than nickel-cadmium (NiCad) batteries.

local shop offers ponchos with the store's logo for free), or your favorite professional sports venue.

When folded in their original packaging, these indispensable aids are pocket-sized, or fit in one of the compartments of your camera pouch. Don't leave home without one.

More Advanced Add-Ons

If your photographic pursuits while traveling tend to be a little more involved, you'll want to add a few gadgets to your traveling kit. The sections that follow describe some of the more advanced add-ons to consider, starting with a utilitarian camera bag. You may also want to consider storage needs for longer trips, external flash units, and the one

accessory that really shows your commitment to travel photography excellence: the tripod.

No excess baggage

If you plan on toting around a few lenses and other accessories, make sure you have a bag that allows you to carry what you need without it becoming a burden. Camera bags should follow the "large enough, but no larger" rule. You don't want everything crammed into your bag in a way that makes an item difficult to extract when you really need it, nor do you want to be lugging a huge bag that imposes a weight burden on your shoulder or back muscles.

In practice, it's not uncommon for serious photographers to have several camera bags so they can select the one that best fits the gear they need to take for a particular trip. I

own a large one that holds two digital SLR camera bodies and five or six lenses, plus electronic flash, and a monopod. I also have a tiny one that barely accommodates one camera and one accessory. In the middle, there is a well-padded bag that accommodates several cameras and a couple extra lenses for travel, but becomes a bit looser when I arrive and remove some of the lesser-used items. If you're using a point-and-shoot camera your bag needs will be more modest, but you should still have a place to stow your camera, film cards, extra batteries, and other stuff.

There are several types of camera bags, with much of the variation coming in how you carry them and where they open. Any of these can be festooned with extra zippered compartments and pockets, and lots of straps and fasteners, so you don't have to choose a bag based on complexity and doo-dads alone. How you discover the one that suits you best depends a great deal on your *modus peregrinati.* Only the first three, however, are considered by serious travel-oriented photographers, and will probably be needed only by those who have advanced cameras that are accompanied by lots of accessories and lenses:

✦ **Traditional shoulder bags.** These bags open at the top or top/front and house your equipment in pockets or slots inside. They provide lots of room for their size, but you must usually access the gear through the top opening, so stacking items in layers increases the time needed to retrieve something on the bottom. All the weight of the bag rests on your shoulder, which can be tiring at the end of a long day if you have a lot of stuff. However, shoulder bags are available in both large and small sizes,

so you can easily select a small, less painful model if your packing needs are small.

✦ **Backpacks.** These range in size from small enough for just the camera, a couple of lenses, and some accessories, to massive carry-alls that can include your clothing and every other item you're carrying with you (great for photographers who are camping or sleeping in youth hostels). One drawback is that you have to take the pack off and put it down every time you need to retrieve something. However, backpacks designed for photographers open from the front as well as the back, so you can access anything in your kit without burrowing.

✦ **Sling Bags.** This type of bag operates both as a backpack and a shoulder bag, sliding from a position where most of the weight is on your back to one with the broad strap resting on your shoulder, without the need to set the bag down. They may open from the top, front, or a combination of the two. As with traditional shoulder bags and backpacks, sling bags are available in a variety of sizes and configurations.

✦ **Modular belt systems.** These are more suited for traveling photojournalists than normal people who don't want to be decorated with photo gear or pouches for water bottles or cell phones as they travel. They're best used by people who don't plan on sitting down very often. Belt systems put the weight on your hips and leave multiple accessories within easy reach even when you're also wearing a backpack. The modularity of the

system means it can be configured for almost any sort of situation.

✦ **Chest bags.** A chest bag enables you to carry your camera harnessed to your chest where you can get to it quickly and easily. Most of these bags can also be switched to a belt and positioned to ride on the hip as well.

In choosing among these types of camera bags, like those shown in figure 5.2, take the following factors into account:

✦ **Size.** Your camera bag should have enough room to hold your equipment, plus additional space for small items you pick up along the way, such as souvenir knickknacks. You don't want your bag to be too crowded, so having a little extra space for a guidebook (like this one) and other small items lets you avoid carrying a retail store sack around with you all day. Now, if you decide to buy three bottles of wine during your day out in Florence, those probably aren't going to fit!

✦ **Flexibility.** Your bag should include multiple compartments, preferably with Velcro loops, that you can reconfigure as needed to accept different types of equipment. Remember that your needs can change during the trip. In one place you might need to be able to grab that external flash quickly, while in another, you may need fast access to your digital film because you're shooting action pictures quickly.

✦ **Sturdy strap.** A good travel photo bag has a sturdy strap that's securely stitched to the sides and bottom of the bag, and not attached with grommets or other types of fasteners that can be complicated or not as sturdy.

✦ **Toughness.** A bag that will last you many trips should be made of tough nylon, canvas, or leather.

✦ **Camouflage.** Some folks favor a bag that doesn't look like an expensive camera bag to avoid attracting the attention of bad guys when the gear is tucked away out of sight. When I was preparing for

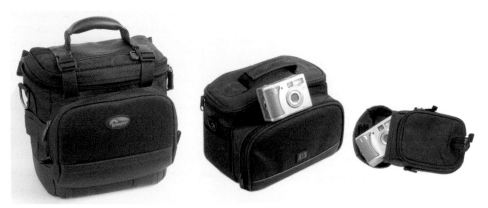

5.2. Camera bags come in various sizes to hold all your equipment for quick, convenient access.

my last solo trip to Europe, I eschewed a more professional-looking bag the camera store clerk recommended in favor of a sturdy, but less expensive-looking bag of similar size. "I don't care if I look professional or not," I told him. "I just don't want to look tempting."

✦ **Security and convenience.** Good bags offer multiple methods of closing, including a fast method with Velcro tape or clasps and a more secure method of closure using zippers or clips. This obviously takes more effort to open and close, but it makes accidental opening less likely. Use the easy closures when you're actively taking pictures, and zip everything up when you're on the move and don't need fast access to your equipment to keep unwanted hands out.

✦ **Weather protection.** The bag needs a top flap that closes over the main compartment to keep water from seeping into the bag during a sudden, unexpected downpour.

Toting a tripod or monopod

A tripod holds your camera steady while you frame and take a photograph. Larger units may be a little too cumbersome to take on a trip, but if you're serious about photography you should consider a smaller, more portable model. A monopod is a one-legged version of a tripod. While it can't stand on its own as a camera stand, it is much more totable and can provide some of the same steadying influence.

On my last few trips, I carried both a tripod and monopod and found they opened the doors to some wonderful creative effects, such as longer exposures in dim light for dusk and dawn photos. They can brace your camera to reduce vibration and camera shake when you use telephoto zoom settings to pull in distant subjects.

You can also use a tripod to hold the camera in place so you can get in the picture, too, using your camera's self-timer. They also allow taking multiple horizontal shots that can be easily stitched together into panoramas in an image editor. After you use a tripod for awhile, you'll find that it allows you to frame your compositions more precisely and get repeated shots from the exact same vantage point when you experiment with filters or lighting techniques.

Digital cameras are small enough that massive professional tripods aren't necessary. You can usually get by with a model that weighs just a pound or two and may fold down to 18 to 20 inches for easy transport (like the compact model shown in figure 5.3). Most common models are made of aluminum, but you can find even lighter versions of both tripods and monopods constructed of carbon fiber, basalt, or some other space-age material.

When choosing a tripod for travel photography, it's important not to let your quest for light weight and small size seduce you into taking a tripod that's too flimsy to do the job. There are some tripods that stretch from tabletop size to full size — which sounds great in theory — but actually sway like a reed in the wind when fully unfolded. The steadiest tripods usually have three sections, each about one-third the height of the tripod when unfolded. The legs collapse inside each other when the tripod is put away.

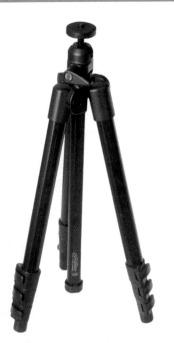

5.3. A compact tripod like this 20-inch, 2 pound model can even fit in your carry-on luggage.

Four- or five-section legs collapse to an even smaller size, but, because each leg section must be smaller and smaller to fit inside the section above it, the sections at the ends of the legs can be very thin. Choose a tripod with the fewest number of leg sections that can be accommodated in your luggage or strapped under your camera bag.

Tripods gain extra height through a center column that can be raised even farther when the legs are fully extended. If possible, use the center column as little as you can (especially fully extended), as it places your camera at the end of a long pole that can flex and sway with the slightest vibration.

In terms of utility for traveling, other features commonly found in tripods and monopods have less importance.

They include:

✦ **Locking legs.** As the legs of a tripod or monopod are extended, you need to lock the legs in position at the desired height. If you don't have a lot of time to photograph a particular site, the speed with which you can lock and unlock your unit's legs can become important. With a tripod having legs in three sections, you'll have six individual locks to manipulate. Your tripod or monopod may have rings that are twisted to lock the legs in place or levers, which can usually be operated more quickly.

✦ **Range of movement.** Some legs can be set to a right angle from the camera mount, so the tripod can be lowered quite close to the ground or set at different angles on uneven surfaces.

✦ **Mounting heads.** The mounting head is the device that the digital camera is fastened to when attached to your tripod or monopod. You're probably familiar with the traditional pan-and-tilt head, which can be rotated horizontally, tilted up or down, and usually flipped sideways to allow changing the camera to a vertical orientation. However, pan-and-tilt heads are most useful for video cameras. A ball head, which uses a ball-and-socket arrangement, allows rotating the camera over a full range and is more practical for digital travel photography because of its light weight, small size, and versatility in movement.

If you would rather not carry a tripod or monopod with you at all, there are alternatives such as clamp devices that fasten to any handy fence post or other support, and ordinary beanbags, which can be placed on any steady surface and then used to cradle the camera so it doesn't move or vibrate.

5.4. A ball head is the most flexible arrangement for travel photography.

Selecting an electronic flash

Use of an electronic flash is covered in Chapter 4, but perhaps you haven't made up your mind whether you want to take one along. Maybe your digital camera has no external flash contact to plug in an auxiliary flash (although you probably can still use a *slave* flash that's triggered by the light from your main unit). Or, you just don't want the extra weight. Most of the time you can get by without an external flash unit. But if you want to take one, be sure and select a unit that's small, compact, and uses readily available batteries. If both your camera and your flash use AA rechargeable batteries, you only need a single charger.

Make sure the flash you want to use works with your camera's automatic exposure system. That usually means buying a dedicated flash designed especially for your camera. It plugs into your camera's hot shoe or connects through a special cable that carries all the electronic signals that allow your camera and flash to communicate with each other.

Tip

If you're traveling with a lot of relatively new camera equipment and are visiting countries known for bargain prices on such gear, you might want to consider registering your stuff with the U.S. Customs Office. That ensures that you won't be asked to pay duty for "importing" your equipment on your return. Most travelers don't bother, and the likelihood of U.S. citizens being hassled is remote. (On my last trip overseas I was waved through customs by a fellow who did nothing more than collect customs declaration cards as we passed by.) However, if you want to cover all the bases, you can download a Certificate of Registration (form CF/4457) at www.customs.ustreas.gov/ linkhandler/cgov/ toolbox/forms/4457.ctt/ cbp_4457.pdf. *Fill it out, and bring your gear to the customs office. Officials will confirm the contents of the form and stamp it.*

Expanding Your Point-and-Shoot Camera's Optical Capabilities

Although your point-and-shoot camera doesn't have interchangeable lenses, many

models can accept add-on lens adapters that provide the equivalent of a longer telephoto or wider angle view. These are best suited for cameras with a modest zoom range (say, 3X), and not really needed for those who have 6X, 8X, or even 12X lenses already on their cameras.

These adapters might be offered by your camera manufacturer, but several third-party sellers have models that can be fitted to a variety of digital cameras. The key consideration is whether your digital camera has a threaded or bayonet mount on the front of the lens that can be used to fasten the adapter. If your lens is flush with the camera or extends only an inch or so and doesn't have a provision for filters or other accessories, you're out of luck.

Lens adapters are described by the amount of magnification they provide. A 0.75X adapter turns your camera's 35mm wide angle (equivalent) focal length into a useful 26mm (equivalent) optic. Similarly, if you attach a 1.5X converter to a lens with the equivalent of a 100mm lens, you end up with a 150mm telephoto. These adapters cost you a little sharpness, but can be handy when you need them, and may help you get a few more years' use out of your current digital camera before you upgrade.

If your digital camera does have threads on the front, you can also buy attachments that let you focus much more closely, too. Most current digital cameras already focus down to within a few inches of your subject, but close-up attachments can be useful with older digital cameras that don't offer up-close-and-personal shooting capabilities.

Expanding Your dSLR's Options with Extra Lenses

Digital SLR owners have equipment options that aren't available to users of other types of digital cameras. One of the most exciting creative avenues involves interchangeable lenses. The ability to remove your current lens and replace it with another one that offers additional capabilities is invaluable. Anyone who has used a dSLR for a while will certainly discover that there are at least a few pictures that can't be taken with the basic lens furnished with the camera (usually an 18-55mm or 18-70mm zoom). Consider taking along an additional lens or two on your trip. Here are some of the key reasons for expanding your lens complement:

✦ **Wider view.** When your back is against a wall — literally — you need a lens with a wider perspective. A lens with a shorter focal length lets you take interior photos without going outside to shoot through a window, or asking the owner of a 21st-century vegetable cart to move so you can photograph that 16th-century cathedral. You can emphasize the foreground in a landscape picture while embracing a much wider field of view. Move in close with a wide-angle lens to use the perspective distortion that results as a creative element. For most digital SLRs, wide-angle lenses generally fall into the 10mm to 24mm range, and include both fish-eye (distorted, curved view) and rectilinear (non-distorted — mostly) perspectives.

5.5. Get a broader view with a wide-angle lens.

✦ **Longer view.** A longer telephoto lens can do several things for you that a shorter lens cannot. A telephoto lens reaches out and brings distant objects closer to the camera, and it is especially valuable when "sneaker zoom" (moving closer or farther away) won't work. A long lens has less depth of field, so you can more easily throw a distracting background or foreground out of focus for a creative effect. Telephoto lenses have the opposite perspective distortion found in wide-angle lenses: subjects, such as faces, appear to be broader and flattened. So the appearance of a narrow face might be improved simply by using a longer zoom setting. That same distortion is great when you want to reduce the apparent distance between distant objects—the same effect used in Hollywood to make it appear that the hero is darting in and out between oncoming cars that are actually separated by 30 feet or more. The turrets in figure 5.6 are spread apart in the wide-angle view (left), but appear to be on top of each other (right) when shot with a telephoto lens. With most digital SLRs, a 50mm lens or zoom setting has something of a telephoto effect, and longer lenses extend out to 600mm or much more.

✦ **Macro focusing.** Macro lenses let you focus as close as an inch or two from the front of the lens, offering a different perspective on familiar objects. These lenses are available both as prime lenses and as macro-zoom lenses. The available range of focal lengths is important because sometimes

you want to get as close as possible to capture a particular viewpoint (for example, to emphasize the stamens in a delicate flower petal) or back off a few feet to avoid intimidating your subject (perhaps a hyperactive hummingbird). Photographing nature as you travel can be one of the pleasures of visiting new places—if you take the time to stop and smell the roses (or daisies, as you can see in figure 5.7).

✦ **Sharper image.** Some lenses, such as fixed focal-length prime lenses, are sharper, overall, than others. Inexpensive zoom lenses are often noticeably less sharp than the discriminating photographer might prefer. In addition, lenses rarely have the same sharpness at all apertures and zoom settings. A wide-angle lens, for example, might have lots of barrel distortion and fuzzy corners at its widest setting, and if you shoot many photos at that focal length you might be better served with a different optic. Lenses also fall down in sharpness when they're asked to do things they aren't designed for, such as taking macro photos with a zoom that's best suited for sports photography or shooting at maximum aperture under low-light conditions.

✦ **Faster aperture.** Your 300mm f/4.5 lens may be sharp enough and have the perfect focal length for the sports photography you're planning to do. But, you find that it's not fast enough to let you use a high enough shutter speed. What you may really need is a 300mm f/2.8 lens, optimized for shooting wide open. The difference between a shot grabbed at 1/500 second at f/2.8 and the same image captured at 1/180 second at f/4.5 can be significant in terms of stopping the action. In addition, your f/2.8 lens might be sharpest when stopped down to f/5.6. You might have to use f/8 to get similar sharpness with the f/4.5 optic.

✦ **Special features.** Another reason to choose an add-on lens is to gain special features. While the close-up capabilities of a macro lens are certainly a special feature, there

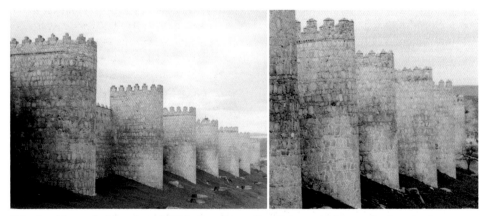

5.6. A wide-angle lens view (left) better shows the distance between the turrets. A telephoto lens compresses them together (right).

5.7. Macro lenses provide extra magnification to capture natural beauty as you travel.

are more exotic capabilities at your disposal. These include lenses with shifting elements that provide a certain amount of perspective control for photographic architecture and monuments on your trip (although such lenses are very expensive and not available for all digital SLRs). Other special lenses include fish-eye lenses and vibration-reduction lenses that compensate for camera shake and give you sharper results at slower shutter speeds. When you need or want an unusual feature, you'll be glad your camera has interchangeable lenses.

Choosing between zoom or fixed focal-length lenses

It wasn't that long ago that serious photographers worked almost exclusively with fixed focal-length/prime lenses rather than zooms. Many zoom lenses were big, heavy, and not very sharp. The most expensive zooms were sharp, but they were still big and heavy. Today, you can buy an 18-200mm lens that is about 3 or 4 inches long and weighs less than a pound.

Some of these early zoom lenses had a nasty habit of shifting focus as you zoomed in or out. They were used primarily for applications where it wasn't always practical to change lenses rapidly (such as sports or spot news), or when the zoom capability itself was needed for a special look, such as the ever-popular "zoom during exposure" effect.

Today, optical science has made great strides, and there are lots of zoom lenses available that even the most snobbish photographer can endorse. They're smaller, lighter, faster, and sharper, making them the perfect traveling companion.

Prime lens considerations

Use a prime lens when you must have the ultimate in sharpness or speed at a particular focal length. For example, several vendors offer f/1.4 lenses in fixed 28mm, 50mm, and 85mm focal lengths that are unmatched for speed and resolution. You can buy 300mm and 400mm lenses with f/2.8 maximum apertures, and 500mm or 600mm f/4 super-telephotos. (All of these bigger lenses are probably too large for everyday travel!) Prime lenses are a good choice when you don't mind carrying a selection of lenses, have freedom of movement, and can get closer to your subject or have room to back up a little to fill the frame appropriately.

Zoom lens considerations

Size, speed, and sharpness tend to be the chief drawbacks of zoom lenses. Because of the additional elements required to zoom, these lenses tend to be quite a bit larger than their fixed focal-length counterparts. The disparity can be huge if you take most of your photos at the short end of the zoom range; a 50mm f/1.8 prime lens, at 5 ounces, might be only 20 percent of the size and weight of a slower zoom lens that covers the same focal length.

The most affordable zoom lenses tend to change their maximum aperture as the focal length increases. An f/3.5 lens might become an f/5.6 lens when cranked all the way out. A smaller maximum f-stop brings with it a penalty in exposure flexibility, viewfinder brightness, and autofocus capabilities. (Some cameras' automatic focus systems won't function if the f-stop is smaller than f/5.6.) Lenses that don't change their maximum aperture as they zoom are more costly.

Choosing lenses for your trip

If you have a selection of interchangeable lenses, choosing which ones to take for your trip can be agonizing. You want to travel as light as possible, but you also don't want to end up thousands of miles from home and wishing you had a particular lens that would be perfect for a given photograph. The next section gives you some things to think about when compiling your final roster.

Expanding your view with wide angles

Travel photography involves a tempting array of photo opportunities that can benefit from a wide-angle lens or zoom lens that extends deeply into the wide-angle perspective. These shooting situations include:

✦ **Building and monument exteriors.** Some areas are known for distinctive architecture that reflects the culture of a city or country, such as the modern architecture in Holland, the bustle and history embodied in Japanese structures, the cathedrals of France, the castles in Spain, the skyscrapers of New York, or the "painted lady" Victorian homes of San Francisco. They all offer great settings for photography. Don't forget great structures, too, such as the CN Tower in Toronto, the Eiffel Tower in Paris, or the St. Louis Gateway Arch in Missouri. Many of these structures call for a wide-angle lens that lets you capture a photograph in tight surroundings.

✦ **Crowded interiors.** Indoors, you find your back up against a wall — literally — more often than not when trying to capture images of

memorable interior architecture, and the interiors of historical sites (assuming photography is permitted). You'll be glad you brought along a wide-angle lens when faced with situations like the one shown in figure 5.8.

✦ **Expansive vistas.** Nothing allows you to take in a sweeping panorama as well as a wide-angle lens.

✦ **Creative distortion.** Shoot a subject from very close using a wide-angle lens and you can end up with some creative exaggeration of the size of objects that are close to the camera. Wide angles provide a special viewpoint that you can use to create interesting looks in your travel photos.

For the most flexibility, you'll want a wide-angle lens that produces the equivalent of the view of an 18mm lens on a full-frame 35mm film camera (or full-frame digital camera) after the crop factor (also called, erroneously, a lens "multiplier") has been applied. Depending on the crop factor produced by your camera (which can range from 1.3X to 1.6X and 2.0X), you might need a lens or zoom with a focal length of about 10mm to 12mm at its wide end. You'll find such prime lenses and zooms available from a variety of vendors.

The lens that comes with your camera probably provides no more than the equivalent of about a 27mm wide angle, so a wide-angle zoom or prime should definitely be on your must-take list.

Getting closer with a telephoto lens

There are lots of situations commonly encountered while traveling that can benefit from having a telephoto lens that is longer than the focal lengths of your camera's basic lens.

✦ **Focusing on details.** A figure or carving embedded in the side of a building, an interesting weather vane atop a roof, or an erupting volcano you'd rather not approach are subjects that you may want to get close to but can't. A telephoto

5.8. Wide-angle lenses can be useful in crowded interiors.

lens or telephoto zoom might be the answer.

✦ **Reducing relative distances.** Use the capabilities of a telephoto lens to squeeze distant objects closer together for creative effect.

✦ **Being discreet.** A telephoto lens enables you to fill your frame with a skittish creature without the need to get so close that you scare it away. You can photograph people in the act of being themselves from a non-intrusive distance, too, as long as you're open about it and aren't spying on anyone's private life. Kids at play, for example, often are more relaxed and natural if photographed from a slight distance without the photographer crowding in on their activities. (Make sure you have tacit permission from parents or guardians to take pictures of children!)

While the telephoto setting of the basic lens furnished with your camera probably will serve you well in all these situations, if you can find room in your kit for a lens with a longer reach, there are lots of situations where it comes in handy. Something in the 70mm to 200mm (actual) focal length range — roughly the equivalent of a 105mm to 300mm zoom on a full-frame camera — is the ideal combination of reach and relatively small size. Anything longer might be too much bulk to carry on a trip, unless you feel you'll put it to a lot of use or aren't hampered by size and weight considerations for your gear.

The latest 18-200mm zooms (Nikon's version even has vibration reduction) might actually serve as two lenses in one, replacing your camera's basic lens while providing an effective longer telephoto, too. If you plan to take a wide-angle zoom in the 12-24mm or 10-20mm range, you may find a 28-200mm or 28-300mm lens provides a better match with less overlap.

Techniques
for Great
Travel Photos

One of the most enjoyable things about travel photography is the opportunity to try out new photo techniques with new and exciting subjects, in places you've never visited before. Or, if you're visiting a favorite travel destination, each visit gives you the chance to capture the sights and activities in interesting new ways.

Perhaps you'd like to try your hand at photographing the exotic flowers that bloom wild, but are cultivated only in greenhouses back home. Or, the interesting architecture and monuments you encounter encourage you to explore photography of structures and buildings. Maybe you'll want to delve deeply into people pictures as you capture candid images of interesting people — whether they are local denizens or members of your travel party. Because you're relaxed, surrounded by new sights, sounds, and smells, and equipped with a digital camera, you'll want to photograph as many different types of subjects as possible.

Of course, the first time you try a different kind of picture-taking, including new types of travel photography, you may find the new subject matter intimidating. An "old hand" at your side can point out the pitfalls and help spark your creativity. That's where this chapter comes into play. Each section provides a consistent formula for exploring one of the most common shooting situations you'll encounter on your trip. You find tips for choosing a lens, selecting the right ISO setting, and composing the picture. You can open this book to any photo subject and follow the guidelines to get good pictures right off the bat.

Basics of Composition

The very best photos are carefully planned and executed, and even though you may feel rushed on your trip as you hustle from place to place, take the time to do a good job in planning and taking your pictures.

Good execution means more than proper exposure and sharp images, especially because some very good pictures are deliberately under- or overexposed and include an element of blur in their design. Beyond the technical aspects, good travel images have a pleasing composition; that is, the selection and arrangement of the photo's subject matter within the frame in a way that catches the eye and enhances the understanding of the subject matter.

Here are some questions to ask yourself as you compose your picture:

✦ **What do I want to say?** Will this photo make a statement? For example, am I trying to emphasize how differently those who live in other lands go about their lives? Should it tell something about the subject? Is the intent to create a mood: exotic, tranquil, bustling with life? Know what kind of message you want to convey and who your audience is. Your messages will vary, depending on your

6.1. There's no mistake about what's the center of interest of this photograph.

destination, and whether you are shooting a serene landscape, quiet village, or active city.

✦ **What's my main subject?** A picture of a group of glacial rock formations may not be as effective as one that focuses on a single unusual ice-carved rock shape. Even if the picture is packed with interesting elements, select one as the subject of the photo. If you're faced with many choices, focus on several different subjects and choose which ones you like best after you get home from your trip.

✦ **Where's the center of interest?** Find one place in the picture that naturally draws the eye and becomes a starting place for the exploration of the rest of the image. Da Vinci's *The Last Supper* includes several groupings of diners, but viewers always end up looking first at the gentleman seated in the center. Even if you don't plan on visiting Milan, Italy, to photograph the actual fresco, keep this compositional technique in mind.

✦ **Would this picture look better with a vertical or horizontal orientation?** Trees and structures such as the Washington Monument may look best in vertical compositions; landscapes often lend themselves to horizontal layouts. Choose the right orientation now, and avoid wasting pixels when you crop later on. Don't be afraid of orienting a composition to turn a horizontal subject into a more interesting vertical one. Living creatures, too, have natural

6.2. Cropping this animal photo into a vertical composition emphasizes the creature's arboreal nature.

orientations: horizontal for dachshunds not performing tricks, and vertical for giraffes or ostriches.

✦ **What's the right shooting distance and angle?** Where you stand and your perspective may form an important element of your composition. For example, getting down on the floor with a crawling baby provides a much more interesting viewpoint than a shot taken 10 feet away from eye-level. Apply this concept to your travel photos, too. Don't photograph a festival entirely from eye-level: Get above the festivities or down low to show what the celebration looks like to a child.

✦ **Where will my subject be when I *take* the picture?** Action photography, especially, forces you to think quickly. Your composition can be affected not just by where your main subject is now, but where it is at the time the picture is taken. Plan your photo of a moving train so that you are ready to snap when the train is in an interesting position relative to its background.

✦ **How will the background affect the photo?** Objects in the background may become part of the composition — even if we don't

6.3. The out-of-focus background echoes the main subject. If it was in sharp focus, the background might be a distraction.

want them to. Pay close attention to what's visible behind your subjects. Move to eliminate distracting background, or use a larger lens opening to throw them out of focus.

✦ **How should the subjects in the photo be arranged?** This is the essence of good composition: arranging the elements of the photograph in a pleasing way. Sometimes you can move picture elements or ask them to relocate. Other times you need to change your position to arrive at the best composition.

✦ **How should the eye move within the composition?** Viewers don't stare at a photograph; their eyes wander around the frame to explore other objects in the picture. You can use lines and curves to draw the eye from one part of the picture to another and balance the number and size of elements to lead the viewer on an interesting visual journey. The brick walkway in figure 6.4 creates a natural visual path to the castle.

The Rule of Thirds

Photographers often consciously or unconsciously follow a guideline called the Rule of Thirds, which is a way of dividing a picture horizontally and vertically into thirds, as shown in figure 6.5. The best place to position important subject matter is often at one of the points located one-third of the way from the top, bottom, and sides of the frame.

6.4. The curving lines of the brick walkway lead the eye to the castle in the background.

6.5. You can locate the main subject at one of the intersections of imaginary lines placed one-third of the way from the top, bottom, and sides of your composition.

Other times, you'll want to break the Rule of Thirds, which, despite its name, is actually just a guideline. For example, you can ignore it when your main subject matter is too large to fit comfortably at one of the imaginary intersection points. Or you might decide that centering the subject helps illustrate a concept, such as being surrounded, or placing the subject at one side of the picture implies motion, either into or out of the frame. Perhaps you want to show symmetry in a photograph that uses the subject matter in a geometric pattern. Following the Rule of Thirds usually places emphasis on one intersection over another; breaking the rule can create a more neutral (although static!) composition.

Other compositional tips

Here are some more compositional rules of thumb you can use to improve your pictures:

✦ **If subjects aren't facing the camera, try to arrange them so they look into the center of the frame rather than out of it.** This rule doesn't apply only to people. An automobile, a tree swaying in the wind, or an interesting animal all look more natural if they are oriented toward the frame.

✦ **Use curves, lines, and shapes to guide the viewer.** For example, you can use fences, a gracefully curving seashore, meandering roads, railroad tracks, or a reced-ing line of trees to lead the eye through the composition. Curved lines are gentle; straight lines and rigid geometric shapes are more forceful.

✦ **Look for patterns that add interest.** A group portrait of three people is more interesting if the subjects pose in a triangular or diamond shape, rather than in a straight line.

6.6. Have your subject look into the frame, rather than out of it.

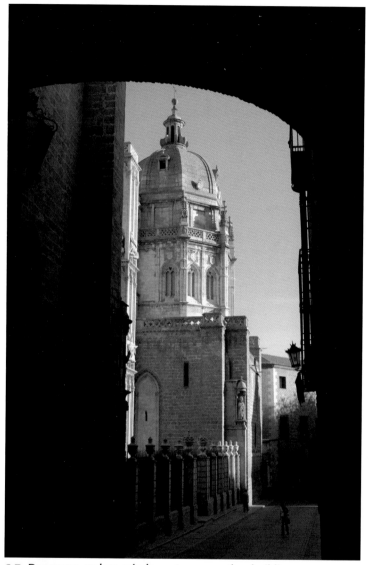

6.7. Doorways, arches, windows, trees, or other buildings can serve as a frame for your pictures.

✦ **Balance your compositions by placing something of interest on each half (left and right, top and bottom).** For example, if you have a group of people on one side of the frame, use a tree, building, or some other balancing subject

matter on the other side to keep the picture from looking lopsided.

✦ **Frame your images by using doorways, windows, arches, the space between buildings, or the enveloping branches of trees as a border.** Usually, these frames are

in the foreground, which creates a feeling of depth, but if you're creative you can find ways to use background objects to frame a composition.

✦ **Avoid mergers.** Mergers are those unintentional combinations of unrelated portions of an image, such as the classic "Eiffel Tower growing out of the top of the subject's head" shot.

Tourist (photography) traps

You've no doubt seen lots of travel photographs in your lifetime, even you, yourself haven't taken too many. So given your broad exposure to travel photos, it's easy to fall into the trap of just duplicating the kinds of shots you've seen before. Did you travel thousands of miles just to photograph your family waving at the camera while standing in front of the Grand Canyon? Is it tempting to see just how much of that expansive vista you can cram into a single photograph? Are you photographing everything from eye-level, reproducing the same view that millions of other tourists have captured with their cameras?

Perhaps you just need to be reminded of the most common travel photography traps that even the most avid photographer falls into at times. Here is my list of the five worst offenses.

✦ **Mugging for the camera.** Figure 6.8 is just a snapshot, but it fails in more ways than I can count (the sneaker-clad foot at lower left is particularly amusing). The two kids are captured posing in front of the magnificent Niagara Falls, but the photo portrays neither the children

6.8. Neither Niagara Falls nor the kids are portrayed in an interesting way in this snapshot.

nor the falls very well. If you want to prove that your family has visited one of nature's wonders, at least take the time to pose them in an attractive way. And don't forget to take a few shots of the falls with no humans intruding on the view.

✦ **Standing too far away.** Most amateur travel photographers stand too far from their subjects when they take their photos or use a zoom setting that is too wide. That isn't so bad if the frame is at least filled with interesting subject matter, but all that extra view often goes to waste, as you can see at top in figure 6.9. If you need to crop your photo heavily to remove the extraneous area, you waste valuable pixels, and spend more

6.9. Standing too far away can fill your photo with extraneous subject matter, including, in this case, utility wires and a roadway. Move closer or zoom in to trim the fat from your image.

time processing your pictures in an image editor than you need to. Move in close or use your zoom lens to frame an interesting photo.

✦ **Not varying your angles.** So many photos are taken from eye-level, when a much better and more interesting vantage point can be gained from above or below your subject. Changing your shooting angle — from side to side or up and down — gives you an interesting perspective and a new take on subjects that have been photographed millions of times by thousands of tourists.

6.10. Unusual angles, like this shot taken from the base of a memorial tower, provide an interesting viewpoint that takes the photo beyond the mundane.

✦ **Overuse of flash.** Even dimly lit indoor scenes can be photographed successfully if you place your digital camera on a steady surface and use the self-timer to trip the shutter. Figure 6.11 shows a hotel room carved out of the tower of a 16th-century castle, illuminated almost entirely by the light that streams in through the window. Electronic flash would have spoiled this photo's mood.

✦ **Shooting only horizontally oriented photos.** It's amazing how many people shoot only landscape-format travel pictures — even when they're not photographing landscapes! Some subjects (the Washington Monument comes to mind) almost force you to rotate the camera 90 degrees and snap a vertically oriented picture, but creative photographers go beyond the obvious and find vertical compositions everywhere.

6.11. Natural lighting is often best for travel photos.

6.12. This image works as both a horizontal and vertical picture. Learn to see both orientations in every subject you shoot.

Abstract Photography

Not every travel photo you take has to be an accurate rendition of a subject you encounter on your journey. Abstract photography is your chance to make — rather than take — a picture. When shooting abstract images, your goal is not to present a realistic representation of a person or object but, rather, to find interest in shapes, colors, and texture. One definition of abstract art says that the artistic content of such images depends on the internal form rather than the pictorial representation. That's another way of saying that the subject of the photo is no longer the subject!

You can let your imagination run wild when you experiment with abstract photography. An image doesn't have to look like anything familiar. Some people will tell you that if it's possible to tell what an abstract subject really is, then the image isn't abstract enough. Use abstract shapes to add a dimension to your travel photography.

6.13. You can find abstract patterns everywhere you look, even in buildings and monuments or other structures.

Inspiration

French photographer Arnaud Claass once said, "In painting, the curve is a hill; in photography, the hill is a curve." In other words, while painters attempt to use abstraction to create an imaginative image of a subject, photographers use abstract techniques to deconstruct an existing image down to its component parts. Both approaches create art that doesn't look precisely like the original subject, but which evokes feelings related to the subject matter in some way.

You can find abstract images in nature by isolating or enhancing parts of natural objects such as plants, clouds, rocks, and bodies of water. Many wonderful abstracts have been created by photographing the interiors of minerals that have been sliced open, or capturing the surfaces of rocks polished over eons by ocean waves.

It's also possible to create abstract compositions by arranging objects in interesting ways, and then photographing them in nonrepresentational ways. A collection of seashells that you've stacked, lit from behind, and then photographed from a few inches away can be the basis for interesting abstract images that resemble the original shells only superficially and on close examination of the picture. Familiar objects, such as the sails of a boat, photographed in unfamiliar ways, can become high art.

6.14. The line of a sail can represent an abstract curve.

Abstract photography practice

6.15. An unusual angle turns this sunrise photo into an abstract image.

Table 6.1
Taking Abstract Pictures

Setup	**Practice Picture:** For figure 6.15, I wanted to capture the clouds at sunrise in an unusual, abstract way. Viewing familiar objects from unusual angles often turns them into abstract compositions, so all I need to do is invert my finished photo and crop it tightly so the horizon (now at the top of the frame) isn't visible. **On Your Own:** Some of the best abstract images can be obtained from unusual angles or close-up views of everyday subjects, such as flowers or details of picturesque old buildings you encounter. If you bring a tripod with you, it's easy to experiment with different angles, then "lock down" the camera when you find a view you like.
Lighting	**Practice Picture:** The light from the rising sun was fine, but I wanted to avoid the typical ruddy look of sunrise photos in order to increase the abstract quality. So, I set my camera's white balance feature to Tungsten, which rebalanced the image so it had more of a blue cast. **On Your Own:** Experiment with colored reflectors or colored pieces of plastic held in front of the light source to add interesting colorcasts.

Continued

Table 6.1 *(continued)*

Lens	**Practice Picture:** Wide-angle zoom setting. In this case, I wanted to include as much of the sky as possible so I could crop down to the most interesting portion.
	On Your Own: Try wide-angle zoom settings to give unusual perspectives to your photos. With most non-SLR digital cameras, the wide-angle setting is used for close-focusing macro photos, too. If you're using a digital SLR, try a special macro lens, or use a zoom setting, which tends to flatten the image, reducing the three-dimensional quality.
Camera Settings	**Practice Picture:** JPEG capture. Shutter-priority AE with white balance set to Tungsten. Saturation set to Enhanced, and both Sharpness and Contrast set to High.
	On Your Own: Shutter-priority AE mode lets you choose a brief shutter speed to freeze your subject and create a sharp image. Extra saturation, sharpness, and contrast increase the abstract appearance at the expense of realism. If your camera offers RAW capture, you can also boost these values when converting the RAW image and processing it in your image editor.
Exposure	**Practice Picture:** ISO 200, f/8, 1/125 second.
	On Your Own: While f/8 works fine for my photo, close-up abstracts call for a small lens aperture, which increases the depth of field so that the entire image is sharp.
Accessories	A tripod lets you lock down the camera once you find an angle you like. It steadies the camera to produce a sharp image, and if you shoot close-up images, it makes it possible to stop down to a small f-stop without worrying that the resulting long shutter speeds will cause image blur.

Abstract photography tips

✦ **Go abstract in post-processing.** Many mundane conventional photographs can be transformed into abstract prizewinners by skillful manipulation in an image editor. Filter plug-ins can enhance edges, add textures, change color values, and perform other magic after the fact.

✦ **Freezing and blending time.** A high shutter speed can freeze a moment that isn't ordinarily easy to view, such as when a rock strikes the surface of a pond to produce concentric waves. Slow shutter speeds can merge a series of moments into one abstract image.

✦ **Use color and form to create abstract looks.** Exaggerated colors and shapes produce a nonrealistic look that has an abstract quality. Colored gels over your light sources can create an otherworldly look. An unusual angle can change a familiar shape into an abstract one.

✦ **Crop and rotate.** Try flipping an image vertically to create an unfamiliar look. When the light source

seems to come from below, rather than above as we expect, our eyes see a subject in a new way. Or rotate the image to produce a new perspective, then crop tightly to zoom in on a particular part of the image that has abstract qualities of its own.

Action and Adventure Photography

If you're one of those who must keep moving even when on vacation, then perhaps adventure travel is your cup of tea. Nothing excites you more than the thought of traveling to Vail or Aspen or the mountains of Europe for some exhilarating skiing. Maybe you want to head to Kitty Hawk, North Carolina, for some hang-gliding instructions, or the Caribbean for scuba diving or sailing. If you're involved in adventures of this sort, you'll no doubt want to capture your adventures with your digital camera.

Perhaps you like to enjoy your action as a spectator. There are dedicated baseball fans who travel to spring training each year to watch their favorite team polish its skills. Others take in a game during their vacations when their home sports team is on the road. Or maybe you enjoy watching an exotic sport like jai alai, or think a visit to Wimbledon for the Championships is a wonderful way to spend your free time.

Action photography isn't limited to sports, of course. You encounter fast-moving action at amusement parks, while swimming at the beach, or while struggling to climb a mountain. Everything from sky diving to golf to motoring all lend themselves to action photography. Fortunately, the digital camera's (especially digital SLRs) fast response and rapid-fire continuous shooting mode capabilities make it a popular tool for capturing adventure travel experiences as well as sports shots at football or baseball games, soccer and tennis matches, and those more aggressive pastimes they call hockey and rugby.

The dual challenges facing action photographers are knowing the right subject and knowing the right time. The other aspects are just technical details that are easy to master. However, you always need to understand enough about what is going on to anticipate where the most exciting action takes place and be ready to photograph that subject. Then you need to have the instincts to pull the trigger at exactly the right instant to capture that decisive moment.

Inspiration

Action photography is exciting because it freezes a moment in time. The goal is to find exactly the right moment to capture. Your digital camera simplifies the process in several ways. Once the camera is up to your eye and you see a picture you want to take, the autofocus and autoexposure systems work so quickly that you can press the release button and take a picture in an instant, allowing for the slight shutter lag that plagues many point-and-shoot digital cameras. Finally, the digital camera's continuous shooting mode can fire off bursts of shots as quickly as two to three frames per second or more, so even if your timing is slightly off you can still improve your chances of grabbing the precise instant. See the tips which follow for advice on catching action with any digital camera.

6.16. A long lens, a good choice of location, perfect timing, and a little help from the digital camera's continuous shooting mode combined to produce this shot of a duck's frantic take off.

6.17. The peak moment is always the most exciting instant, and there may even be a pause where a fast shutter speed isn't needed to freeze the action.

Action and adventure photography practice

6.18. If you like to fly powered paragliders – or know someone who does – you can savor the excitement with photos like this one.

Table 6.2
Taking Action and Adventure Pictures

Setup	**Practice Picture:** Spotting a clutch of powered paragliders (see figure 6.18) while visiting a West Coast city, I followed their flight path to a small airport where a group of pilots was enjoying the summer breezes.
	On Your Own: Know where to stand or sit for the best action-shooting opportunities. For powered paragliders or similar aircraft, a vantage point at the edge of the runway gives you many opportunities to shoot the powered craft taking off and landing. For marathon races, the finish line is a traditional spot, but you can get better shots at checkpoints along the way.

Continued

Table 6.2 *(continued)*

Lighting	**Practice Picture:** Daylight was just fine at this midafternoon session under beautiful skies.
	On Your Own: You may find the illumination is less than perfect, particularly on gloomy days or at dusk. There's not a lot you can do, except, when the outdoor illumination is really scarce, use a flash to fill in murky areas. Indoors, the light may be OK as is if you boost the ISO setting to 400 or higher if your camera has additional sensitivity settings (most digital SLRs go up to ISO 1600 or ISO 3200).
Lens	**Practice Picture:** Long telephoto lens, a 170-500mm zoom on a digital SLR. When you're far from the action, the longer the focal length you can muster, the better.
	On Your Own: Your lens choice depends on the type of action you're shooting. Indoor activities may call for wide-angle or normal focal lengths. Outdoors, if you can get close to the action, a zoom lens might cover all the bases. If you're not close to the action, a prime lens or zoom in the longer range (up to the equivalent of 300mm on a 35mm film camera) might be required. You'll need a lens that's fairly fast if you want the digital camera's autofocus features to focus for you. A wide aperture also makes it easier to focus manually. However, most of your shots will be taken with the lens stopped down to produce sufficient depth of field.
Camera Settings	**Practice Picture:** JPEG Fine. Shutter-priority AE and continuous shooting mode.
	On Your Own: Most digital cameras can usually store JPEG images more quickly than RAW format (if available), so when you shoot quickly and continuously, you gain some speed with very little quality loss by choosing JPEG. Select Shutter-priority mode so you can choose the highest appropriate shutter speed when you want to stop action. Under reduced light levels, drop down to a slower shutter speed or boost the ISO setting.
Exposure	**Practice Picture:** ISO 400, f/11, 1/1000 second.
	On Your Own: At ISO 400, the f/11 aperture provided enough depth of field, and 1/1000 second was plenty fast enough to freeze the action as the powered paraglider soared through the air. Image noise wasn't a problem with this digital camera at ISO 400, but good results are possible at ISO 800 if you need a smaller aperture or faster shutter speed.
Accessories	Even with high shutter speeds, a tripod or monopod can help steady a long lens and produce sharper results. Compact tripods and monopods made of carbon fiber or magnesium are light in weight and easily totable. Indoors, a flash might be useful.

Action and adventure photography tips

✦ **Anticipate action.** Become sensitive to the rhythm of the activity and learn exactly when to be ready to press the shutter release to capture the peak moment.

✦ **Be ready to use manual focus or focus lock.** Autofocus works great; however, don't be afraid to turn off the autofocus feature, manually focus (if available with your digital camera), or lock focus on a position where you think action will take place, by pressing the shutter release part way. Snap the picture when your subjects are in position.

✦ **Take advantage of peak action.** Many activities involve action peaks that coincide with the most decisive moment. These moments all make great pictures.

✦ **Shoot oncoming action.** Movement that's headed directly toward the camera can be frozen at a slower shutter speed than movement that's across the field of view. If you don't have enough light to use the highest shutter speed, try photographing oncoming action to freeze the motion.

Animal and Wildlife Photography

For some destinations, the animals (wild or otherwise) are one of the main reasons for visiting. Traveling to Africa on a photographic safari is the dream of every serious wildlife picture-taker. Florida serves up a double bonus, with a stunning array of wild animals of every type within its beaches and wetlands, plus an assortment of nature preserves and theme parks such as Busch Gardens, Sea World, Marineland, Disney's Animal Kingdom, Parrot Jungle Island, Gatorland, and more.

San Diego is noted for its zoo, but if you hanker for animals in their natural habitat, you'll find them in any national park. If you travel to any of these places, or others known for their wildlife, you'll want to experiment with photographs of nature's creatures.

If a zoo or animal-friendly theme park is your destination, keep in mind this apparent contradiction: Everybody likes interesting pictures of animals, but nobody likes photographs of caged animals. The solution is to photograph these animals as if you are on a safari and they are in their natural surroundings. No one will be fooled into thinking you took a trip to the African grasslands, but if you do a good job, even the most

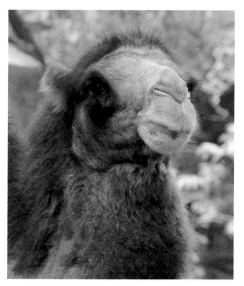

6.19. Catching animals doing human-like things — such as this camel staring at the camera with curiosity in his eyes — adds a touch of personality to your photos.

jaded viewer will enjoy your animal photographs as much as if they were snapped in the wild.

Zoo animals are better cared for and less mangy than the in-the-wild variety, so you're likely to get more attractive-looking creatures to photograph. Modern zoos go to great lengths to duplicate the animals' natural habitats, and you find a minimum of bars and other barriers that inhibit your photography. It's likely you can get up-close and personal with quite a few interesting fauna, with no danger to you or them.

Inspiration

Animals are fun to shoot because their antics and behaviors so often reflect human

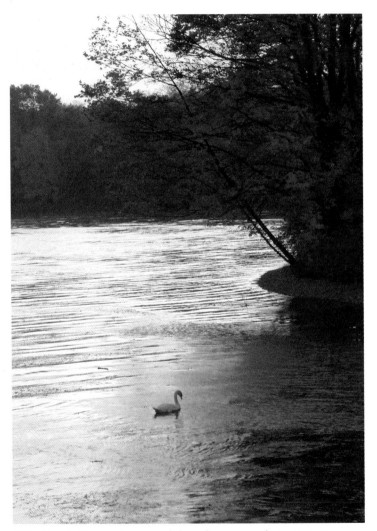

6.20. Locate the creatures, and then don't scare them away to capture natural-looking images like this one.

society. You can look for the relationships of the big cats in their prides, the squabbling of bands of monkeys, and the serene looks of giraffes that seem to be "above it all" in more ways than one. Often, the parallels between animals and the humans who observe them provide fodder for interesting photographic observations.

Animal and wildlife photography practice

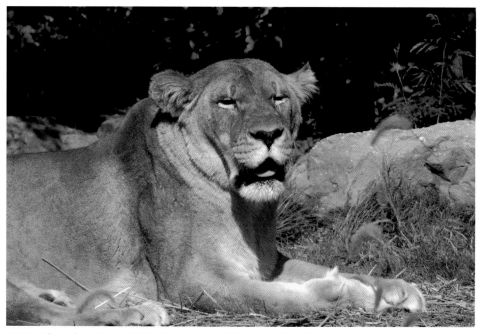

6.21. A long lens brought this lioness to within pouncing distance.

Table 6.3
Taking Pictures at Zoos and Wildlife Preserves

Setup	**Practice Picture:** A rock wall and steep moat separated me from this lioness in figure 6.21. I set my camera up on a tripod and waited for her to look my way.
	On Your Own: Patience is its own reward at zoos. Plan on spending the morning there shooting animals, then wander around photographing flowers and plant life during the hottest hours of the day. Return to shooting the animals in the late afternoon and evening when they become active again. Find a creature you like, and spend enough time to learn its habits. The payoff will be a picture that far surpasses the snapshots the other zoo visitors get.

Continued

Table 6.3 *(continued)*

Lighting	**Practice Picture:** The lioness's compound had lots of trees, so I took most of my pictures when she decided to bask in a sunny spot. **On Your Own:** You'll be working with the available light most of the time. Unless you can get closer than about 15 feet to the animal, fill flash won't do you much good.
Lens	**Practice Picture:** A long telephoto lens, equivalent to 180mm. **On Your Own:** Your digital camera's longest zoom setting lets you shoot close-up photographs of animals that are 40 to 50 feet away. You probably won't need a wide-angle lens much at zoos, so if you're using a digital SLR, pack your longest lens. A long prime lens with a large maximum aperture (f/4 to f/2.8) is preferable to a slower zoom lens.
Camera Settings	**Practice Picture:** JPEG capture. Shutter-priority AE. Saturation set to Enhanced. **On Your Own:** Even with a tripod, you'll want to use a relatively high shutter speed. I've found that the very longest lenses and zoom settings are almost impossible to handhold on a digital camera, even with 1/1000 or 1/2000 second shutter speeds. If your digital camera has image stabilization/vibration reduction/anti-shake features, this is the time to use them.
Exposure	**Practice Picture:** ISO 200, f/8, 1/1000 second. **On Your Own:** Use selective focus to eliminate elements of the cage or enclosure, so an aperture like f/8 is a good choice. Use a high shutter speed to freeze any movement of the animal and to eliminate residual camera shake.
Accessories	Bring along a tripod or monopod.

Animal and wildlife photography tips

✦ **Get close.** You'll probably have to use a telephoto lens or zoom setting to get close to most animals, but a head shot of a yawning tiger is a lot more interesting than a long shot of the beast pacing around in his enclosure.

✦ **Don't annoy the animals.** Chimps won't say "Cheese!" and smile, nor will tigers turn your way just because you jump up and down and yell. If there are monkeys about, you probably don't want to attract their attention (don't ask why). Instead, just watch patiently until your animal poses in an interesting way on its own.

✦ **Favor outdoor locations.** Many exhibits of larger animals have both an indoor and outdoor component. The animals may come inside to feed or at night, and choose to spend other time outdoors in good weather. You want photographs of them outdoors, not inside.

✦ **Go early.** The animals are more active early in the morning. By the time the sun is high in the sky and the real crowds arrive, many of the animals are ready for a nap.

✦ **Use a tripod.** That long lens calls for either a high shutter speed or the steadiness a tripod can provide. A monopod can serve as a substitute, but a lightweight tripod isn't that difficult to carry around even the largest zoos for the few hours you're there.

✦ **Open wide.** If you must shoot through bars or a fence, use a longer lens or zoom setting and open your aperture all the way to throw the obstruction out of focus. Selective focus also lets you disguise the walls or fake rocks in the background that advertise that your animal is not in the wild. If you work with a digital SLR, use the camera's depth-of-field preview button to confirm that your DOF trick is working.

✦ **Get down to their level, or below.** Think like prey — or predator. Animals don't spend a lot of time looking at what's above them, and overhead is not a great angle for photographing wildlife, either. If you have a choice of angles, get low.

✦ **Shoot at an angle.** Try this if you have to shoot through glass. Also, either bracket flash exposures or calculate exposure manually because your camera may not calculate the settings accurately under those conditions.

Architecture and Monument Photography

Professional architectural photography is specialized and involves complex guidelines and sophisticated equipment. There are no such strictures on the kind of informal amateur architecture you can do just for fun as you travel with your digital camera. Whether you take some snapshots of interesting buildings or look to document historic monuments, taking photos of interior and exterior architecture is fun and easy.

Architectural photos can be used for documentation, too, to show how a structure you've visited more than once has changed through the years. Some of the most dramatic architectural photos are taken at night, using long time exposures or techniques like painting with light, both of which are covered later in this chapter.

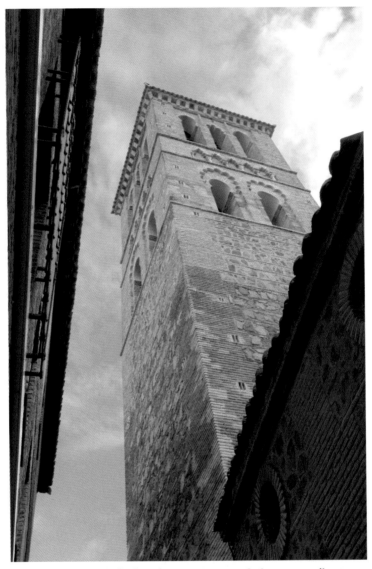

6.22. Choose an angle that shows a structure in its surroundings.

Inspiration

The best architectural photographs involve a bit of planning, even if that's nothing more than walking around the site to choose the best location for the shot. Or you might want to take some test shots and come back at a specific time, say, to photograph an urban building on Sunday morning when automobile and foot traffic is light. A particular structure might look best at sunset.

However, the biggest challenge you need to plan for is illumination. Existing lighting can be dim, uneven, or harsh. You may encounter mixed illumination when daylight streams

in windows to blend with incandescent room illumination, or lighting that is tinted. Some of these problems can be countered by mounting your digital camera on a tripod and using a long exposure. Perhaps you can add lighting by supplementing existing light with reflectors or using lights mounted on stands. "Painting with light, by manually tripping an electronic flash aimed at different areas of an outdoor structure several times during a long exposure can work, too.

6.23. Large interiors make challenging subjects because the available illumination may be less than perfect. The skylight provided uneven lighting, but it was enough for this photo.

Architecture and monument photography practice

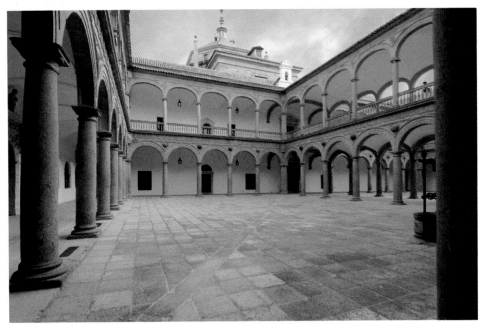

6.24. The profusion of lines and angles in this photo called for careful positioning to choose the best perspective.

Table 6.4
Taking Architectural Photos

Setup	**Practice Picture:** This interior patio, open to the sky, has many arches and columns, as you can see in figure 6.24. I carefully walked around the perimeter until I found a view that allowed taking in as much of the patio as possible.
	On Your Own: If you're not shooting an open-air interior of this sort, find a shooting spot that shows a building at its best, with a clean background and uncluttered foreground. Look for surrounding trees or other structures that can serve as a frame. You can look at articles in travel magazines for ideas for the most flattering way to shoot a particular type of building, and then try to improve on those techniques as you apply them to different structures.
Lighting	**Practice Picture:** Unadorned daylight during midafternoon provides the perfect lighting for this portrait of a significant old building.
	On Your Own: To avoid harsh shadows that can obscure important details, wait for slight cloud cover to soften the illumination. If you find a particular spot that's ideal and you have the luxury of time, choose the time of day that provides the best lighting.

Lens	**Practice Picture:** Wide-angle lens, the equivalent of 20mm, with the camera kept as level as possible to avoid distorting the upper reaches of the columns and arches.
	On Your Own: Your lens or zoom setting choice depends on whether you can get far enough away to avoid tilting the camera to take in the top of the structure. You may be able to straighten out the lines in an image editor if the image displays some distortion.
Camera Settings	**Practice Picture:** RAW capture. Shutter-priority AE with a custom curve, saturation Enhanced, and sharpening Medium High.
	On Your Own: Outdoors in bright sun, you can usually use Shutter-priority to specify a speed that will nullify camera shake, and let the camera choose the appropriate aperture.
Exposure	**Practice Picture:** ISO 200, f/13, 1/500 second.
	On Your Own: Use center-weighted or spot metering to ensure that the exposure is made for the building itself and not any bright surroundings such as sky or snow. If your camera offers automatic bracketing, use it to take several consecutive pictures at slightly different exposures so you can choose the one that most accurately portrays the building.
Accessories	A tripod can help to allow a repeatable perspective, in case you return from time to time to take additional shots from the sample angle. Record where you place the tripod legs by removing the camera after the shot and taking a picture of the tripod and its position. Flash can sometimes be used to fill in shadows, but be careful of reflections off windows.

Architecture photography tips

✦ **Shoot wide.** Exterior architecture often requires a wide-angle lens, while interiors almost always call for a wide setting to capture most rooms or spaces. Unless you're shooting inside a domed stadium, cathedral, or other large open space, you'll find yourself with a back to the wall sooner or later. Wide angles also help you include foreground details, such as land-scaping, that are frequently an important part of an architectural shot.

✦ **Watch out for lens distortion.** Some lenses produce lines that are slightly curved when they are supposed to be straight. While you might not notice this distortion most of the time, architectural design often depends on straight lines, and any warps introduced by your lens become readily apparent.

✦ **Avoid perspective distortion.** To avoid that "tipping over" look that results when the camera is tilted back, locate a viewpoint that's about half the height of the structure you want to photograph. It might be a neighboring building, a bluff overlooking the site, or some other elevation. Shoot the picture from that position, using the widest zoom lens setting you

have available and keeping the back of the camera parallel with the structure.

✦ **Ask permission.** You generally won't need permission to shoot and use photographs of buildings that are clearly visible from public areas. However, photography, or, at the very least flash photography and the use of tripods, may be forbidden in many museums, historic places, or public buildings.

Candid Photography

Using your digital camera as a candid camera is a great opportunity to "catch people in the act of being themselves" as the tagline of the television show of the same name says. Unlike formally posed photos, which must be set up very carefully to avoid a stiff, posed look, candid pictures require nothing of the photographer other than to frame an interesting, technically good image when the subject is relaxed and natural.

The craze for candids first hit the professional portrait and wedding realms more than 40 years ago. The true arbiters of commercial photography success — the paying customers — decided that candids should augment (or entirely replace) studio portraits and wedding pictures. Today, even

©Felix Hug www.hfphotography.net
6.26. The character in this gentleman's face becomes an important part of the photograph, which was captured in a fish market.

carefully crafted portraiture is likely to involve natural, candid-style backgrounds and less formal poses.

6.25. Sitting in a public square and watching people is fun, and a good time to capture candid portraits of traveling companions and folks you meet.

Inspiration

The goal of candid photography is not to grab pictures surreptitiously, with your subjects completely unaware that their picture is being taken. The best candid pictures

result when the subjects know exactly what is going on—and don't care. With relaxed and comfortable subjects, the photographer can take his or her time, waiting for the right moment or the right look to capture. The result is a more natural photograph that tells something about the people being photographed: who they are, what they care about, or even what they think of the photographer!

The key to good candid travel photography is to keep your subject at ease. You always want to let them know that you'll be taking their picture. Don't interrupt what's going on. Saying "Smile," "Say 'Cheese'," or "Look at the camera" is definitely self-defeating. Blend in, and become part of the group. If appropriate, join in the conversation. Then, any photograph you take will truly be candid and honest.

Candid photography practice

6.27. Some flamenco guitar music can provide interesting candid photo opportunities.

Table 6.5
Taking Candid Photography Pictures

Setup	**Practice Picture:** At a flamenco club in Seville, Spain, I spotted these performers entertaining the patrons. They were so absorbed in their music they never even noticed when I snapped the photo shown in figure 6.27.
	On Your Own: Some of the best candids result from experiences that you are participating in, rather than simply observing from a short distance. That's why it's a good idea to have your camera with you at all times, to better capture candid moments as they arise.

Continued

Table 6.5 *(continued)*

Lighting	**Practice Picture:** This was one situation in which flash was allowed, and also provided the best lighting.
	On Your Own: While candid photos taken by available light usually retain their informal quality better than those using a flash, sometimes the lighting will be so dim that flash is the only answer.
Lens	**Practice Picture:** A 50mm (equivalent) zoom setting.
	On Your Own: Many candid photos zero in on one or two people, and the photographer is free to choose a suitable shooting distance. A prime or zoom lens setting of about 25 to 50mm provides the same flattering look that a short telephoto/portrait lens or moderate wide-angle will produce. A wide-angle lens should be used for candids only if you must have the wider perspective and are willing to risk perspective distortion (or want to use it as a creative element).
Camera Settings	**Practice Picture:** JPEG Fine. Aperture-priority AE with white balance set for Flash.
	On Your Own: If your candid photos are indoors, but are illuminated entirely by daylight coming through nearby windows it, may call for setting white balance manually.
Exposure	**Practice Picture:** ISO 200, f/11, 1/125 second.
	On Your Own: If you want to isolate the subject from a cluttered background, use a relatively wide aperture such as f/5.6. If you need more front-to-back sharpness, choose a smaller f-stop. ISO can be set at 200 to 400, depending on the amount of light available.
Accessories	Avoid bulky accessories that turn your candid opportunity into a formal photo shoot. Instead of reflectors, look for any reflective object — even a shirt that you or a bystander is wearing — to bounce light into shadows. Similarly, avoid breaking out the tripod, if you can. Instead, if you must use a slower shutter speed, rest the camera on a handy object and press down with your left hand to steady it as you trip the shutter with your right index finger.

Candid photography tips

✦ **Blend in as much as you can.** Remember, candid photos taken on your trip should be un-posed and natural. That can't happen if your subjects are preoccupied with having a photographer around. Instead of standing around stiffly waiting for something interesting to happen, do what everyone else is doing and become part of the activity.

✦ **Be selective.** Snapping away wildly at every moment unnerves most people and destroys those unguarded moments you hope to capture. If you're touring with a group, wait until someone is doing something interesting — rather than just standing or sitting

around idly—then take your photo. Then, resume what you were doing and wait for the next moment.

✦ **Don't obsess over technical issues.** If your candid photo captures an interesting moment, viewers won't care if the exposure or focus isn't absolutely perfect, and a few imperfections might even make the photo appear to be more natural.

✦ **Don't subject your subject to embarrassment or ridicule.** From time to time all of us do something stupid or succumb to an accident and will even laugh about it if the moment is captured in a photograph. But as a photographer, don't be seen as deliberately seeking out embarrassing moments to photograph solely for their own sake—unless you're a paparazzi and fleet of foot!

Child Photography

Kids seem to enjoy travel even more than the grown-ups, and you shouldn't hesitate to take your children or grandchildren along on your photo safaris. My two youngest each made their first trips to Europe before they were 2 years old, and although the logistics of tending to the needs of toddlers while sightseeing in medieval villages can be tricky, the photos brought back are precious memories. Pictures of kids taken on vacation look better and are more treasured as time passes and the children grow older.

©Felix Hug www.hfphotography.net

6.28. Kids are kids everywhere, but sometimes the cultural differences can make an eye-catching photo.

6.29. Get the whole family in the photo for a memorable picture.

The first — and best — advice for child photography is to take lots of pictures, many more than you think you'll need, and as often as possible. Years later, you may find that a casual shot you didn't think much of at the time is one of your favorites.

Photography of your own children and grandchildren is always a joy, but taking pictures of these same kids that everyone, not just their closest relatives, will enjoy is more of a challenge. If the children are strangers you encounter in your travels, you have an additional hurdle: gaining their trust and the permission of their parent or guardian to take a photo. You need a combination of careful planning, a cooperative child, and some luck to get the best kid photos yet.

Inspiration

Children are easier to photograph if you get them involved in the photographic process. Making the session a game or even letting them take a few pictures of you can be a good way of breaking the ice. After a few shots, let them look at the pictures that have been taken on your camera's LCD. You'll find them much more cooperative and enthusiastic.

Child photography practice

6.30. Catching children offguard can sometimes yield a sweet picture.

Table 6.6
Taking Pictures of Children

Setup	**Practice Picture:** These kids fell asleep in the back of the van, making a memorable quiet moment shown in figure 6.30.
	On Your Own: You can shoot inside your car, in your hotel room or other indoor locations, or outdoors (which offers the most flexibility). Outdoor setups are great for kids because there's lots of room to choose different settings, and natural backgrounds are always interesting. Have them relax around the pool, or find a comfortable place for a fidgety child to sit while you take a few photos, whether it's a park bench, rock, or tree stump. Very small children who are old enough to sit up unaided can be plopped down on a blanket or even the grass. Make sure Mom or Dad is right next to the youngster, although out of the picture area, to avoid panicky feelings of abandonment — or the tendency to just crawl away!
Lighting	**Practice Picture:** Diffuse sunlight coming in the car windows was all the illumination needed.
	On Your Own: You'll usually be able to find a shaded area for your picture, but if you're shooting on the beach or in snow, it's a good idea to pose the child so he or she isn't staring into the sun. Use reflectors to fill in the shadows, or pop up the digital camera's built-in flash unit for fill. The Flash EV setting lets you dial back the power of the flash to provide a pleasing amount of fill light.
Lens	**Practice Picture:** Wide angle lens.
	On Your Own: A lens in the 60-70mm range serves the dual purpose of providing a flattering perspective for your subject, plus reducing the amount of depth of field so the background is out of focus. If you prefer a sharp background, use a wider lens (avoid anything wider than about 40mm when shooting this close) and a smaller f-stop. Use lenses wider than 40mm when you shoot a full-length or group photo.
Camera Settings	**Practice Picture:** Programmed exposure.
	On Your Own: Control the depth of field. Choose Aperture-priority AE mode and set the white balance to the type light in the scene.
Exposure	**Practice Picture:** ISO 200, f/8, 1/200 second.
	On Your Own: To ensure front-to-back sharpness, set a narrow aperture such as f/8 or f/16. If the background is distracting, use a wider aperture such as f/5.6 or f/4.5. Set the ISO to 200 or 400, depending on the amount of light available.
Accessories	White or silver reflectors are useful outdoors to fill in shadows and to cut down on harsh light.

Child photography tips

You don't need to be a parent to work with children — although it helps. Here are some techniques that can make children more comfortable:

✦ Many kids are natural hams, but especially rambunctious when experiencing new places on vacation. Others are painfully shy and become even more withdrawn in unfamiliar surroundings. If you want to get photos of younger children that involve something more interesting than mugging for the camera, make your shooting sessions something special. Let them participate in planning the shot.

✦ While it's tempting to have the kids wear new clothes on vacation, they'll be more relaxed and unconfined for your photos if they wear favorite outfits that are clean and attractive, but not stiff and new. Schedule a haircut a week before the trip. Then when you set up your shoot, a good combing or brushing and well-scrubbed face helps the child look his or her best for the pictures you show to the folks back home. Mom, Dad, or grandparents (if they accompany the parents on the trip) should be spiffed up, too, because the whole family will want to get in a few shots.

✦ Take your travel portraits in fun spots. Most of the towns you visit will have a park or playground that can serve as a good backdrop for pictures of the kids. Or use a historic building as your setting, letting the children explore the steps or interesting nooks and crannies before you shoot.

✦ Have some props available for the child to hold for a few pictures. The kids probably brought a few favorite toys on the trip or acquired some souvenirs along the way. Letting them hold the toy as you shoot will help them relax.

Now that you've got the know-how to get the little ones involved and calm, here are some tips for taking the picture:

✦ **Get down.** Get down low when you shoot a young child and capture a few pictures from the kid's viewpoint. The new perspective may surprise you.

✦ **Use soft light.** Choose a slightly overcast day or open shade for flattering lighting. Kids generally have great skin, but they also manage to collect nicks and scratches from just being a kid. Soft light minimizes these "defects."

✦ **Fill in those shadows.** The difference between an amateur snapshot of a child and a good-looking candid portrait is often whether or not the shadows are inky-dark, or bright and full of detail. You need soft shadows to model the contours of the face, but you don't want dark pits under the eyes, nose, or chin. Reflectors or fill flash are your friends.

✦ **Let the kid shoot you.** If the child is 5 or older, you can help him or her relax and participate in the shoot more readily if you let the

youngster become a co-conspirator. Have a point-and-shoot digital camera ready, or even allow the child to use your digital camera to snap off a few pictures of you. Show off the results. Then, it's *your* turn to take a few.

✦ **Get close.** Use a 40-70mm zoom lens setting and fill most of the frame with the child's head and shoulders, while allowing enough of the surroundings to indicate that, indeed, you're not in Kansas anymore (unless you are visiting Kansas on your trip!). For most kids, a medium close-up shows their personality best. Plus, your

shots will be different and more interesting than the typical full-length shot in front of a castle or monument that most parents take of their kids on vacation.

✦ **Include the parents.** Especially if you're one of them. Too many kids look through their family albums years later and ask, "Where were you, Dad (or Mom) when we visited Disney World?" You might enjoy looking at photos of your child more than pictures of yourself, but the time comes when everyone involved wants to see the kids and parents pictured together. And don't forget the grandparents!

Cultural Photography

You owe it to yourself to come home from your trip with photographs that reveal something of the culture of the country or region you visit. Just within the United States you find interesting contrasts of old and new culture when enjoying the South, the maritime coasts of Maine, or the laid-back glamour of Southern California. You'll find ethnic culture in areas in which immigrants from one country or another concentrated, such as the German influences in Milwaukee, Asian culture on the East and West Coasts, and Hispanic life in the Southwest and other areas. And, don't forget that immigrants have settled in all parts of the United States, and native people have been here all along. So you can find interesting cultures anywhere you go. Overseas,

6.31. The lion, considered a guardian creature in Chinese culture, is popular as sculpture found guarding the entrance to buildings.

you'll find customs and culture that have elements of the exotic as well as the familiar, such as children practicing soccer in front of a temple. Your digital photographs can help you remember and share cultural experiences.

Inspiration

Some of your most interesting images result from subjects that represent the culture of a region: Buddhist temples in Asia, castles in Spain, or festive traditional costumes worn for celebrations in almost any land. Go beyond the ordinary and search for paths less traveled by other photographers in search of cultural icons. For example, Spain has hundreds of castles erected to defend the countryside, and many of them are perched on hilltops almost within sight of the next castle. While many of these have been restored, others stand almost in ruins. Locate one of these almost-forgotten gems. You can climb around and explore among the fallen stones while capturing insightful photographs that recall medieval times more intimately than is possible with restored castles.

If you leave the beaten track in any region you can usually find great examples of culture that lend themselves to vivid photography.

©Felix Hug www.hfphotography.net
6.32. Two young boys kick a ball in front of a temple.

Cultural photography practice

6.33. This stone carving captures the spirit of an ancient culture.

Table 6.7
Taking Cultural Photography Pictures

Setup	**Practice Picture:** I couldn't interpret the carvings on this Central American wall, but the texture made an interesting photo, as shown in figure 6.33.
	On Your Own: Look for unusual angles that make your shot unique. Shoot from down low or from an elevated angle for a special look.
Lighting	**Practice Picture:** Ordinarily, midday sun is too harsh, but in this case it helped accentuate the rough texture of the stone walls.
	On Your Own: Early morning or late-afternoon light can be just as dramatic, casting longer shadows that help define shapes, plus adding a warm glow to your photos.
Lens	**Practice Picture:** A 28mm (equivalent) zoom setting.
	On Your Own: The important thing is to fill the frame with the subject matter that defines the cultural aspect of your photo, whether it's a temple, castle, or local resident decked out in costume.
Camera Settings	**Practice Picture:** JPEG Fine. Aperture-priority AE with white balance set for Daylight.
	On Your Own: Using Aperture-priority AE mode lets you choose the f-stop as appropriate.
Exposure	**Practice Picture:** ISO 200, f/11, 1/400 second.
	On Your Own: A standard daylight photograph from an exposure standpoint gives you an ideal combination of a brief shutter speed to freeze subject and camera motion, plus an f-stop that provides the best combination of resolution and depth of field.
Accessories	When shooting photos that reflect a culture, avoid intruding on the photo yourself or disrupting the activities you're picturing. That means candid-style photography, using a tripod only if necessary.

Event, Festival, and Holiday Celebration Photography

Events are activities of limited duration where there are a lot of people and lots of things going on. They include county fairs, parades, festivals like Mardi Gras or Carnivale, musical concerts, as well as weddings (who hasn't traveled cross-country to attend a nuptial?), Civil War reenactments, and many other celebrations. They may last a few hours, a full day, or as much as a week. Anywhere you travel, you're likely to encounter some sort of festival or event. In the United States alone you can travel across the country all summer doing nothing but visiting county fairs. Overseas, you discover that each small town or village probably has its own special day to celebrate

6.34. High school students parade through the streets of a European town celebrating a local holiday.

a local hero or religious figure, and entire countries or regions have holidays with an amazing variety of photo opportunities.

Whether it's the Fourth of July or Oktoberfest, you'll find lots of things to shoot at these events, usually with a lot of color, and all involving groups and individuals having fun. If you want your creativity sparked by a variety of situations, attending an event as a spectator or participant is a good place to start.

It sometimes helps to think of an event as an unfolding story that you can capture in photographs. Take photos that embody the theme of the event, including overall photographs that show the venue and its setting. Grab shots of the broad scope, the number of people in attendance, and the environment where the event takes place. Then zero in on little details, such as individuals enjoying moments, booths at an amusement part, a dignitary giving a speech, or an awards ceremony. Tell a story that transports the viewer to the event.

6.35. Civil War reenactments provide great opportunities to photograph the mock battles.

Planning can help you get the best shots. You can scout parade routes in advance, or recall what sort of lighting was used at the last rock concert you attended at a particular site. Events like Renaissance fairs or festivals usually have a schedule of events you can work from, which can usually be obtained by writing for one in advance or by visiting the organizer's Web site. A program lets you spot scheduling conflicts and separate the must-see events from those you'll catch if you have time.

Inspiration

Public events not only serve as photo opportunities, but also give us a chance to document our life and times in a way that will be interesting in years to come. For example, popular music concerts today are quite different from those staged during the late 1960s. Customs and fashions at weddings change over the years. Clothing worn even just 25 years ago can seem exotic or retro today. Give some consideration to photos that are interesting today, as well as those you'll take for posterity.

Don't overlook some great chances for behind-the-scenes photographs. As thrilling as Civil War reenactments at the actual battle sites are, the reenactors often set up authentic camping sites for themselves and their families, with 19th-century sleeping and cooking equipment. Hot air balloon ascensions have become part of many different holiday celebrations, and while the actual liftoffs are exciting, there's plenty to photograph of the aeronauts preparing their balloons for flight.

Event photography practice

6.36. Hot air balloons rise at the conclusion of a Balloon-A-Fair in Ohio.

Table 6.8
Taking Event, Festival, and Holiday Celebration Pictures

Setup	**Practice Picture:** I arrived early on the last day of the three-day Balloon-A-Fair so I could choose a shooting position only 50 yards from where the balloons take off, as shown in figure 6.36. The light prevailing wind told me the lighter-than-air craft would go straight up and then drift to the southeast, where I'd have a perfect unobstructed view. The camera was mounted on a monopod.
	On Your Own: Arrive on the scene for any special event as early as possible so you can vie for an advantageous shooting spot. After spending the day wandering around a festival taking photos, you'll enjoy settling in for the parade, concert, awards ceremony, or other events.
Lighting	**Practice Picture:** This picture was taken using only the mid-September daylight at about 5 p.m. when the sun was starting to descend toward dusk. The angle I chose provided good sidelighting on the right side of the balloons, which offered more detail than front lighting or backlighting, and allowed exposing the sky properly while capturing detail in the balloons.
	On Your Own: Lighting at events can vary dramatically during the course of the performance. For stage affairs there may be big, bright lights used for energetic portions, and more subdued illumination, often with a blue or other hue colorcast. If flash is allowed and dozens of delirious fans are snapping away, you can use your digital camera's built-in speedlight at a lower power setting to fill in some shadows. Using the flash at the full setting overpowers the existing light and gives your photo a harsh, snapshot-like look.
Lens	**Practice Picture:** Telephoto lens, equivalent to 300mm.
	On Your Own: Zoom lenses are great for events with bright lighting so you can change the focal length quickly, but if you're using a digital SLR for events at night, use the lens with the largest maximum aperture that you have because of its added low-light capabilities. Vibration-reduction lenses are also a good choice.
Camera Settings	**Practice Picture:** Shutter-priority AE mode, to allow using a fast shutter speed. The white balance was set to Daylight.
	On Your Own: If you want to control the depth of field, switch to Aperture-priority AE mode and set the white balance to the type light in the scene. If the light is low, switch to Shutter-priority AE mode.

Continued

Table 6.8 *(continued)*

Exposure	**Practice Picture:** ISO 400, f/11, 1/500 second. Although the balloons were moving rather slowly, a fast shutter speed countered any residual camera motion present even though the camera was mounted on a monopod.

On Your Own: Many events usually call for higher ISO ratings, and many digital cameras provide decent results at ISO 400. If you have a digital SLR, you might need ISO 1600 in very low light or when you're using a longer lens and want a higher shutter speed. At concerts, don't fear using lower shutter speeds to allow musicians' hands to blur slightly. Experiment with different shutter speeds to get different looks. For other kinds of events, particularly those taking place outdoors in bright sunlight, choose ISO 200 for the best results, or ISO 400 if you need a faster shutter speed. |
| **Accessories** | A monopod is almost a must to steady your camera for exposures that are longer than 1/200 second—or even for faster shutter speeds when using longer lenses. |

Event photography tips

✦ **Pack light to increase your mobility.** However, don't forget to take along a wide-angle lens to capture overall scenes and medium shots in close quarters, and at least a short telephoto for more intimate photos. At concerts, for example, you'll want a longer telephoto to shoot the action on stage and probably a monopod to steady your hand for longer exposures in low light. If flash is permitted, you might want a higher-powered external unit to extend your shooting range.

✦ **Get there early.** Although security is tight at some events, particularly major rock concerts (even if you have a backstage pass), shows and events at smaller venues with less-well-known participants can be more photographer-friendly, particularly if you arrive early and are able to chat as equipment is unloaded and being set up. (Don't get in the way!) At other kinds of events, getting there early lets you scout the area and capture some interesting photos of floats or exhibits as they are prepped.

✦ **Concerts and other events look best photographed from a variety of angles.** Don't spend the whole performance planted in front of the stage, right at street-level for a parade, or around the barbeque grill at a festival cookout. Roam around. Shoot from higher vantage points and from down low. Use both wide-angle and telephoto lenses.

✦ **Ask for permission before photographing adults or children who aren't performing.** Sometimes a gesture or a nod will be all you need to do to gain the

confidence of an adult. It's always best to explicitly ask for permission from a parent or guardian before photographing a child.

✦ **For outdoor events, plan for changing light conditions.** Bright sunlight at high noon calls for positioning yourself to avoid glare and squinting visitors. Late afternoon through sunset is a great time for more dramatic photos. Night pictures can be interesting, too, if you bring a tripod or mono-pod, or can use flash.

Flower, Plant, and Food Photography

Some countries and regions are known for their flowers (Holland and its tulips come to mind), while others are known for their cuisine (think Italy or New Orleans). For many, flowers and food can be almost as much fun to photograph as people, especially if you're in an unfamiliar region or country where the plant life and edibles seem a little exotic.

Like people, each blossom or dish has its own personality. Flowers come in endless varieties, and their infinite mixture of textures and shapes can be photographed from any number of angles. Foods can be arranged in different ways by creative cooks who strive for effective "presentation." If you like colors, flowers and fruits provide hues that are so unique that many of our colors — from rose to lilac to peach to orange — are named for them.

6.37. A nice tablecloth is all you need to get a great shot of your dinner or a snack.

Best of all, flowers and plants are the most patient subjects imaginable, and your dinner will wait on the table patiently if you choose to take a picture of it before consuming the meal. Your friends and relatives back home may marvel at the interesting food you dined on while on your trip.

Plants are even better as subjects: They sit for hours without flinching or moving, other than to follow the track of the sun across the sky or flutter in the breeze. You can adjust them, change their backgrounds, and even trim off a few stray fronds without hearing a single complaint. You can photograph them in any season, including indoors in the dead of winter. Floral photographs are universal, too, as flowers are loved in every country of the world.

While edible photo subjects are as close as your table or a nearby market, your travels may also lead you to public gardens and herbariums you can visit for your photo shoots. Photography is so likely to be part of the experience at such venues that you'll find maps leading you to the most popular exhibits, along with tips on the best vantage points for taking pictures. Take a few overall photos to show the garden's environment, then get closer for floral portraits of your favorites.

Inspiration

Flower and food photography is an excellent opportunity to apply your creative and compositional skills. Use color, shape, lines, and texture to create both abstract and concrete images. Experiment with selective focus and lighting (just move to another angle, and the lighting changes!). It's always fun to find plants and flowers that look like people or other objects when you want to add a little mystery or humor to your photographs.

When shooting flowers, you can capture individual blossoms or photograph groups of them together. As every professional or amateur flower arranger knows, floral groups of different types of plant life can be put together creatively in bouquets to form one-of-a-kind compositions.

6.38. A celebratory dinner is a great time to caputre a special memory from your trip.

If your digital camera has close-up capabilities or you have a dSLR with a macro lens, you can isolate an individual part of a flower to explore the mysteries of how these small-scale miracles are constructed. It's possible to spend an entire career doing nothing but photographing flowers, and many photographers do. Surely, you'll find many hours of enjoyment tackling this most interesting subject on your own.

Flower, plant, and food photography practice

6.39. Break a few rules; shoot from the side and allow the blooms in the foreground to go out of focus to create an unusual image.

Table 6.9
Taking Flower, Plant, and Food Pictures

Setup	**Practice Picture:** I wanted to show a bug's-eye view of some flowers, rather than the usual human viewpoint from above. I moved the camera down to shoot through the stems and blooms to get the photo shown in figure 6.39.
	On Your Own: Food and flowers respond well to similar photographic techniques. It's tempting to shoot down on both. That's why you might enjoy the unusual results you get from looking at edibles from a lower angle or by viewing a plant's world from its own level.
Lighting	**Practice Picture:** This shot was made in full midday bright sunlight, producing vivid colors and high contrast.
	On Your Own: While diffuse illumination can be suitable for such photos, this soft lighting tends to mask color and texture. Direct light brings out the brightest colors and most detail, but leads to dark shadows. Use reflectors or fill flash to more brightly illuminate individual parts of the subject and make the color pop out.
Lens	**Practice Picture:** A 105mm macro lens on a digital SLR.
	On Your Own: You don't need a digital SLR to reproduce this picture, but macro lenses are ideal for flower and food photography. A longer macro lens lets you step back and helps throw the background or (in this case) the foreground out of focus. To photograph a full table, large groups of plants, or an entire field of blossoms, use a 24 to 25mm lens or zoom setting.
Camera Settings	**Practice Picture:** Aperture-priority AE. The white balance was set to Auto. Color saturation set to Enhanced. Manual focus used to prevent camera from locking in on foreground flowers.
	On Your Own: Usually you want to control the aperture yourself, either to limit depth of field for selective focus effects or to increase the DOF to allow several flowers to remain in sharp focus.
Exposure	**Practice Picture:** ISO 200, f/4, 1/3200 second.
	On Your Own: An ISO 200 is ideal for most outdoor lighting conditions. To blur the background, start with an f/5.6 aperture. For more generous depth of field, use an f/8 or f/11 aperture.
Accessories	Contemplative shots such as macro photos of flowers are often best made with a tripod, which lets you position the camera precisely and fine-tune focus manually if you need to.

Flower, plant, and food photography tips

✦ **Try natural backlighting.** Get behind the subject with the sun shining through to capture details of the back-illuminated blossom. The translucent petals and leaves seem to glow with a life of their own.

✦ **Rearrange food and flowers for an attractive presentation.** You may look a little odd doing so, but it's usually worth the trouble to move foods into an interesting pattern or adjust the position of flowers slightly to get the most attractive arrangement.

✦ **Spritz some moisture on your subject.** Some foods, especially fruits, and most flowers look more attractive if misted with a few drops of water before you shoot.

The reflections off the droplets add to the three-dimensional look, too.

✦ **Use manual focus.** When shooting flowers, play with manual focus and large apertures to throw various parts of the blossom in and out of focus, creating a dramatic and romantic look.

✦ **Boost saturation.** Pump up the richness of the colors in food or flower photography by setting Saturation to Enhanced. A polarizing filter can be used to create even greater saturation.

✦ **Experiment with time-lapse photography.** If your digital camera has time-lapse capabilities, use that feature to snap off photographs of a plant automatically at intervals. You can grab shots of the flower turning to face the sun, or shoot a sequence that shows a bud opening to its full floral glory.

Group Photography

Sooner or later, you'll be asked to shoot a photo of the group you're traveling with. Resist the urge to line everybody up in front of the Great Pyramid or pose them as if they were propping up the Leaning Tower of Pisa. Instead, try to capture the members of your group doing something interesting. Make them part of the composition, as in figure 6.40. Or use the setting for your travels as a background for a group portrait, which can involve two people or a mob of them. Each presents very different challenges.

While the specific challenges in travel group photography vary, depending on the size of the group, consider the following elements when photographing collections of any number of people.

Location and lighting

Photographs in which two or more members of your group are lined up in a row are deadly dull. Select your location carefully so individuals can be posed with their heads at slightly different heights. Choose a site that lends itself to having some members standing and some seated. For small

groups, a few stools may do the job. For larger groups, stairs, risers, a hillside with some interesting rocks, or a combination of picnic tables and benches may serve as your stage. Outdoors, daylight may serve as your illumination, particularly if you can find a shady spot that's facing a reflective structure (such as a building) that can cast light into the shadows. On-camera flash rarely works with groups larger than five or six people, because there often is not enough light to cover the full area of the group, and those in the back receive significantly less exposure than those in the front.

Find a people wrangler

For any group larger than four or five people, it's a good idea to have one member of your group serve as an assistant to help you arrange your group. It's easier to tell your helper, "Have Uncle Joe move closer to Aunt Mary, and ask the twins to switch places with their parents" than to shout these instructions to your group. Your assistant can assemble the group around the main subject, and then help you group the remaining folks into classic diamond arrangements (described in a tip that follows) that provide the most interesting compositions. Make sure that you and your helper are communicating with the group at all times, however. If those in your crowd feel they are on their own while you fiddle with the posing and camera, their attention will wander.

Catch the blinkers, nodders, and turners

The more people you have in a group photo, the more likely it is that someone will blink during the exposure or turn his or

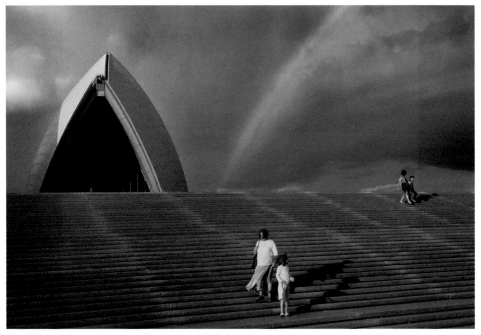

©Felix Hug www.hfphotography.net

6.40. The Sydney Opera House in Australia serves as a backdrop for this interesting photograph that combines people, architecture, and a rainbow.

her head at the worst possible moment. It's almost impossible to detect these problems on a tiny LCD review image. When you're ready to shoot, ask your group if everyone can see the camera clearly. That request alerts them not to look away. It's always a good idea to take at least as many pictures as there are people in the group, up to about eight or ten shots. Multiple photos increase your chances of getting one in which everyone is looking at the camera and smiling acceptably.

If you're using flash, ask the group to watch for the color of the flash when it goes off. After you take the picture, ask if anyone saw a red flash instead of white. If they saw red, they saw the flash through their closed eyelids and you need to shoot at least one more. Finally, although you should warn your group when you're about to take a picture, don't use a countdown or some precise tip-off. Many folks flinch or blink at the exact moment they think a photo is about to be taken.

Posing Tips

The goal of portraiture is to make subjects look the best that they can look. Here are a few techniques you can use to achieve this goal:

✦ Avoid having all the heads in the same horizontal plane by arranging members of your group so their faces are at different heights. Then ask them to pose with their bodies at a slight angle from vertical so their faces aren't ramrod straight.

✦ Pose your group in geometric shapes. The diamond formation is a classic arrangement, with one person at the top, one at the bottom, and two at either side (at slightly different heights). You can arrange even large groups into diamonds and sub-diamonds to create an interesting composition.

✦ The edges of hands are more attractive than the back or palms of the hands. Have your subjects hold their hands in their laps, or perhaps resting on the shoulder of another member of the group. Keep the hands away from faces.

✦ Use an upright hand to show how you want your individual subjects to move their heads, rather than just telling them to turn this way or that. Your hand can rotate around your wrist to indicate you'd like them to turn at the neck, tilt, to indicate movement toward or away from a particular shoulder, or pivot forward and back tomahawk style to show when you need them to lean toward or away from the camera.

✦ Make sure your subjects' eyes are looking in the same direction their noses are pointed.

✦ Use the fewest number of rows to make the most of your depth of field.

✦ If you shoot groups frequently, develop some patter to keep your group engaged and attentive while you set up and shoot. Humor can help, too. For example, to diffuse impatience during multiple shots, a comment like, "You're doing fine, but I have to keep doing this until I get it right!" can help.

Inspiration

The photos of the people in your travel group that you take today may be of interest for much longer than you think, possibly 30 to 40 years in the future, even though your digital files will probably have to be copied from CD or DVD to whatever media replaces them in a dozen years (or less!). If you travel in an organized tour with people you don't know, write down the names of everyone in the photo for posterity. You can also do that even if each person is a close friend or family member. Can you name every single person in your kindergarten class photo today — even though you might have attended school with those kids for several years? Can you guarantee that your group photo won't fall into the hands of some family or company archivist in the future who doesn't personally know each individual, but wants to have their names anyway? Jot down the names now, and help out your descendants.

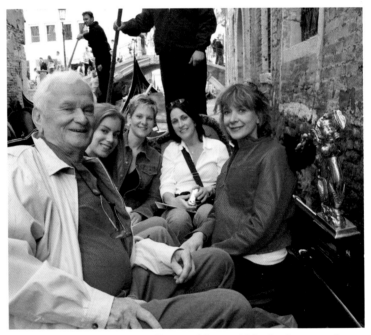

6.41. Careful placement of all five subjects within the frame makes for a tight composition, while still revealing that the photo was taken in a gondola in Venice, Italy.

Group portrait photography practice

6.42. Take time out from a busy schedule to take some informal portraits of your traveling companions.

Table 6.10
Taking Group Portraits

Setup	**Practice Picture:** Two or more people are all you need for a casual portrait, as shown in figure 6.42.
	On Your Own: For candid shots, small groups can be posed anywhere you'd shoot an individual portrait. For larger groups and more formal pictures, find an area that's large enough to accommodate everyone, and includes some surfaces you can use to provide seats or resting places. You can use a stool or rock can to elevate yourself slightly so you're not shooting up at the group.
Lighting	**Practice Picture:** Sunlight, outdoors.
	On Your Own: Outdoors, you can work with existing light, preferable in open shade. But if your group moves indoors, you need more meticulous planning. One or two off-camera flashes, perhaps bounced from a wall or ceiling, can help illuminate a large group. Watch for flash bouncing off glasses, too. Ask your subjects who wear glasses to tilt their heads back slightly to avoid bouncing the flash back into the camera lens.
Lens	**Practice Picture:** A zoom lens set to the equivalent of 80mm.
	On Your Own: For groups of two to three people, choose a 60mm zoom setting; for five to ten, a normal lens of 35-40mm works well; larger groups require a wide-angle lens to take everyone in, but if you find yourself shooting with a lens at less than 20mm, try stepping back first to avoid the distortion you sometimes get with more extreme wide-angle lenses.
Camera Settings	**Practice Picture:** Programmed exposure.
	On Your Own: You want to control depth of field in group photos, so use Aperture-priority AE mode to choose the aperture, and let the camera select a shutter speed.
Exposure	**Practice Picture:** ISO 200, f/11, 1/400 second.
	On Your Own: For small groups, a wider f-stop lets you throw the background out of focus. For larger groups arranged in more than one row, use f/8 to f/11 to increase the depth of field.
Accessories	If you have one with you, a tripod is a good idea for group photos. You can compose your image, then step away and rearrange people as you compose the picture without the need to reframe when you're ready to shoot.

Group portrait photography tips

✦ **Check for subjects in disarray.** Photos of large groups consist of pictures of individuals, and each person in your shot will want to look his or her best. Take the time to review your posing, looking for unfortunate expressions, wrinkled clothing, mussed hair, and so forth, for each person in the group.

✦ **Check for any lighting errors.** Look carefully for shadows cast on people's faces (particularly if you're using an off-camera flash), glare off glasses or jewelry, and other lighting problems.

✦ **Take many more photos than you think you'll need.** You never know: This might be the last trip this particular group takes together. As long as you have everyone in front of your camera, take the time to shoot lots of photos. After all, as a digital photographer, you don't have to pay extra for film, processing, and proofs.

Infrared Travel Photography

Vacations are a great time to experiment with new photographic techniques. The combination of new sights and new ways to capture them can spark your creativity to a new level. Infrared photography is one type of digital imaging that not enough travel photographers play with. It's even one arena in which those of you who own point-and-shoot cameras with an optical viewfinder have a significant edge over

6.43. Although infrared photography is most often used for scenic vistas, it can give a picture such as the one of this news kiosk in Europe an old-time look.

those who choose to work with digital SLR cameras, because they allow viewing the image through the viewfinder, while dSLR owners must shoot blind. For many, it may be an introduction to the pleasures of black-and-white photography.

Infrared photography ignores visible light and captures your subjects almost exclusively by the infrared light they reflect. This lets you render foliage in eerie shades of white, and the sky in an unearthly black color. Human skin takes on a soft, fuzzy glow. You'll either love or hate the way infrared photography modifies an image. Even so, if you're the adventurous sort, plan on taking a few of these special pictures on your next adventure.

Inspiration

You need a special filter to shoot infrared pictures, so you must use a digital camera that accepts filters. Higher-end amateur cameras and digital SLRs all accommodate filter attachments, but basic point-and-shoot cameras may require an adapter. Because the best photos are taken using a tripod, you can also set your camera on a tripod and hold a filter in front of the lens during the exposure.

Digital camera sensors are highly sensitive to infrared illumination, so most camera vendors try to filter this light out by placing a "hot mirror" in front of the sensor. Even so, enough infrared leaks through so that most digital cameras can still take infrared photos, although using longer shutter speeds that would be used for a regular exposure. Test your camera by taking a picture of a TV remote control pointed at the camera with a button depressed. If a spot of light shows up in your image, your camera is sensitive to infrared light.

Once you establish that your camera is sensitive enough to infrared light, you should purchase a filter that blocks visible wavelengths while passing infrared illumination.

6.44. Infrared photography darkens skies and lightens foliage to create dramatic black-and-white images.

You can use Hoya R72, Wratten #89B, #88A, #87, #87C , and #88A filters. Expect to pay about $75 for a larger size to fit dSLR camera lenses, or less than $50 for a filter for smaller lens sizes and point-and-shoot cameras. You can also find this filter as 3-x-3-inch gelatin sheets. Your camera store might have to special-order a filter for you, so allow enough time before you leave on your trip.

If your camera does not have an SLR or EVF (electronic viewfinder) viewing system, you can simply compose the picture through your optical viewfinder. If your camera has only an LCD, the image is often be very dim, but if your viewfinder "gains up" (amplifies the signal) for dark images, you should still be able to see something. Those with SLR or EVF viewfinders may need to shoot blind; but because the camera should be mounted on a tripod you can aim and frame prior to mounting the filter.

Use long exposures, preferably with the camera on a tripod. Use a small f-stop to account for the difference in focus point for infrared light. Manual focusing is a good idea if your camera allows it. Infrared images are highly tinged with red, which you may like. You can also adjust them in your image editor to produce a black-and-white image. Although infrared photography is a more advanced photo technique, even intermediate travel photographers can enjoy it.

Infrared travel photography practice

6.45. This scenic river was the perfect location for an infrared photo.

Table 6.11
Taking Infrared Travel Pictures

Setup	**Practice Picture:** This quiet river bend was perfect for an infrared photo, shown in figure 6.45. Except for a lone angler, I encountered no other visitors during the time it took me to set up my camera and tripod on the shore. The quiet water and abundant foliage framing a cloud-dotted sky attracted me to this viewpoint.
	On Your Own: Because infrared photography lightens greenery and darkens the sky, look for scenes that include both.
Lighting	**Practice Picture:** Midday sunlight provided the perfect illumination for this shot. All I needed to do was wait until the sun moved out from behind some clouds that were outside the image area.
	On Your Own: Sunny days work best for infrared photography because the bright light contains lots of infrared illumination.
Lens	**Practice Picture:** Equivalent of a 28mm wide-angle zoom setting.
	On Your Own: Use a wide-angle lens to take in a broad view. Remember that the foreground is emphasized, so it should contain interesting elements, too.
Camera Settings	**Practice Picture:** RAW capture. Manual exposure. White balance was set manually, using the trees in the background as a neutral color source.
	On Your Own: RAW capture, if your camera offers it, gives you access to many of the camera's adjustments after the picture was taken. Manual exposure lets you zero in on the correct exposure because your autoexposure system might not be able to read infrared illumination. Daylight white balance doesn't accurately portray an image (in case you decide to keep your image in color rather than convert it to black and white), so setting WB manually can produce a better representation. Generally, only more advanced photographers who want to play with their pictures in an image editor need to worry about this.
Exposure	**Practice Picture:** ISO 400, f/11, 1/4 second, determined by snapping a few test pictures, reviewing them on the LCD, and then adjusting the exposure.
	On Your Own: Infrared pictures often look grainy anyway, so using a high ISO won't add too much noise and lets you shoot at slightly faster shutter speeds. With very long exposures (more than a few seconds) blurring of gently swaying tree branches can become a problem.
Accessories	A tripod helps you steady the camera and makes it easy to fine-tune your composition before you mount the infrared filter.

Landmark Photography

Landmark subjects, such as the Golden Gate Bridge, Eiffel Tower, the London tower that houses Big Ben (which is actually a bell inside the tower, rather than the famed tower itself), the Taj Mahal, Great Wall of China, and the Great Pyramid are all iconic subjects that you simply must capture when you visit their home locations. Other landmarks are the shooting spot itself, such as the top of the Empire State Building, or the view of Paris from next to the gargoyles at Notre Dame Cathedral in Paris. Your challenge, should you choose to accept it, is to picture these landmarks and their surroundings in new and interesting ways.

New angles, tight cropping, unusual times of day, oddball lens selection (say, using an extreme wide angle for a landmark most often pictured using a normal or telephoto lens — or vice versa), and other creative techniques can be used to capture that special picture of a familiar subject.

Inspiration

Think of landmark photography as your chance to add your vision to a well-known location in such a way that your friends, relatives, and colleagues will smile and say, "I've never seen that place pictured like that before!"

Landmark photographs often involve a bit of planning, even if you do little more than walk around the site to determine the best angle or light for the shot. You may even decide that you could better a better shot at a different time of day and plan a return visit; for example, a landmark might look best at sunset. Allow the light and the setting to inspire you to find a new way of looking at an old scene.

6.46. The giant rocks at Stonehenge were aligned for reasons known only to its builders, but you can use their layout to frame your own interesting compositions.

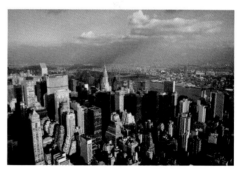

6.47. The view from the top of the Empire State Building is almost as famous as the structure itself. Shooting in late afternoon to take advantage of the waning golden sunlight gives this image a special look.

Landmark photography practice

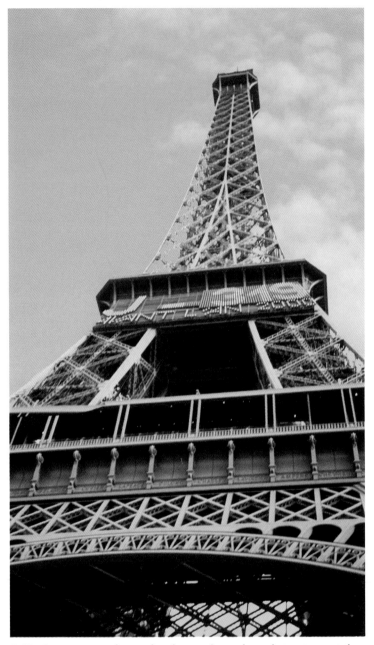

6.48. One way to subtract the clutter of people and structures at the base of the Eiffel Tower is to exclude them from the shot.

Table 6.12
Taking Landmark Pictures

Setup	**Practice Picture:** The Eiffel Tower seems much larger than anticipated when you visit it for the first time. Rather than attempt to photograph it from a distance, I elected to stand at the base and shoot up to show exactly how impressive this structure is (see figure 6.48).
	On Your Own: While pointing your camera upward produces perspective distortion, sometimes this look doesn't detract from the photo. Experiment with different angles to see which works best for your landmark.
Lighting	**Practice Picture:** Bright daylight had enough contrast to show off the texture of this beloved tower.
	On Your Own: You rarely have any control over the lighting when you shoot famous landmarks — but you can select a favored time. The Eiffel Tower, for example, looks great in the daytime, but magnificent at night when it is illuminated in spectacular ways.
Lens	**Practice Picture:** Wide-angle zoom at the equivalent of 35mm.
	On Your Own: You may need to use a wide-angle lens to take in all of a particular landmark, but if there is room to back up, experiment with longer lenses, too. The Eiffel Tower, for example, can be photographed from afar from the vantage points of other locations in Paris, such as Notre Dame Cathedral if you use a telephoto lens (the distance is quite a stretch).
Camera Settings	**Practice Picture:** RAW capture. Shutter-priority AE, with Saturation set to Enhanced. Although I could have boosted saturation during conversion from RAW, it's easier to make your basic settings at the time you shoot.
	On Your Own: RAW, if your camera allows it, simplifies changing white balance and other settings before image editing. Shutter-priority mode lets you set a high enough shutter speed to freeze your landmark image and counteract any camera or photographer shake if you don't use a tripod.
Exposure	**Practice Picture:** ISO 200, f/11, 1/500 second. Slight underexposure produced a slightly silhouetted effect and helped make the colors richer.
	On Your Own: If the sky is included in your photo, make sure your metering system doesn't underexpose the image too much.
Accessories	Landmarks near water can benefit from a circular polarizer to tame reflections.

Landmark photography tips

Here are some ideas for creating unusual views of familiar subjects:

✦ **Add People.** Some landmarks are customarily shown without people in the photograph. If you want to spice up your photo of Mt. Fuji or Bryce Canyon or the St. Louis Gateway Arch, first take a few pictures of the landmark uncluttered by human forms. But then try a few that include people. Avoid lining up members of your group or having an individual gawk or point at the landmark. Use your creativity to find a way to include a person in the photograph in a natural way. For example, showing someone overwhelmed by the sheer size of the Gateway Arch, shot from underneath the Arch and looking upward, could make a dramatic image.

✦ **Subtract People.** You might find that a landmark, such as the Great Pyramid of Giza, is literally crawling with visitors during your photo session. The base of the Eiffel Tower is cluttered with queues of sightseers and kiosks. If you can't visit the landmark at an unusual hour when there are fewer people around, use an imaginative angle to exclude tourists from your photo.

✦ **Use Reflections.** The Lincoln Memorial or Washington Monument seen mirrored by the Reflecting Pool on the Mall in Washington, D.C., are almost clichés of their own. But you can try for a different angle—perhaps higher or lower than customary—to put your own stamp on an image, even of well-known reflected landmarks such as the Taj Mahal. You might find pools of water near other monuments, too, which can be used to create an unusual look.

✦ **Get Extra Close or Farther Away.** You'll often find well-worn paths and bare spots at the locations favored for photographing popular landmarks. Some even have helpful "Picture Spot" signs to make sure you don't miss the traditional vantage point. That should be your cue to get closer or farther away, and to zoom in or out with a longer telephoto or shorter wide-angle lens.

✦ **Create a Panorama.** Try taking three or four shots of a single landmark, starting a little to the left of the landmark and overlapping your photo a little each time. Some digital cameras even have a panorama setting that helps you do this by placing a ghost image of your last shot at one side of the LCD as you compose the next image. Then assemble all your photos into a panorama to provide a broader view of a familiar subject.

Landscape and Nature Photography

Like floral photography, landscape and nature photography provides you with a universe of photo subjects there for the taking, courtesy of Mother Nature. This kind of photography provides a dual joy: the thrill of

©*Felix Hug www.hfphotography.net*
6.49. Take advantage of views from the plane to gain a unique perspective.

the hunt as you track down suitable scenic locations to shoot and the challenge of using your creativity to capture the scene in a new and interesting way.

Landscapes are an ever-changing subject, too. The same scene can be photographed in summer, winter, fall, or spring, and look different each time. Indeed, a series of these photos of a favorite vista in different seasons makes an interesting and rewarding project.

Inspiration

Nature photography can take many forms. You can photograph a landscape as it really is, capturing a view exactly as you see it in a moment in time. Or you can look for an unusual view or perspective that adds a fantasy-world quality. The three basic styles of landscape photography actually have names: representational (realistic scenery with no manipulation), impressionistic (using photographic techniques such as filters or special exposures that provide a less-realistic impression of the landscape), and abstract (with the landscape reduced to its essential components so that the photo may not resemble the original scene at all).

Look for wildlife to populate your landscape, or shoot a scene with only the trees and plants, rocks, sky, and bodies of water to fill the view. Choose the time of day or season of the year. You may be working with the raw materials nature provides you, but your options are almost endless.

6.50. This picturesque waterfall was discovered in a quaint Western Reserve village.

Scouting Locations

As you enjoy landscape and nature photography, here are some tricks you can use to find good scenes to shoot:

✦ If you're in an unfamiliar area, check with the staff of a camping or sporting goods store, or fishing tackle shop. Stop in and buy a map or make another small purchase, then quiz these local experts to discover where the best hiking trails or fishing spots are.

✦ Buy a local newspaper, and find out what time the sun or moon rises or sets. Dusk or dawn is a particularly good time for landscape photography because the light is warm and the lower angle of the sun brings out the texture of the scenery. Find times for high and low tides, too, if you're at the seashore.

✦ Don't get lost! Carry a compass so you always know where you are when scouting locations. Plus, you can use the compass with local subposition tables you can use to determine exactly where the sun or moon will be at sunset or sunrise. If the sun sets behind a particular mountain, you can use that information to choose your position.

✦ Include weather in your plans. Rainy or cloudy weather may put a damper on your photography, or it can form the basis for some interesting, moody shots. The National Weather Service or local weather forecasters can let you know in advance whether to expect clear skies, clouds, wind, or other conditions.

Landscape and nature photography practice

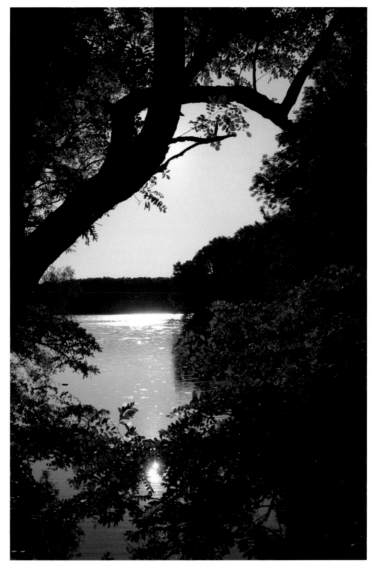

6.51. Dusk at the lake during late fall is a time of solitude and vivid colors that make for beautiful scenic landscapes.

Table 6.13
Taking Landscape and Nature Pictures

Setup	**Practice Picture:** This Canadian lake is full of water-skiers, swimmers, and boaters during the summer, but in fall it becomes a perfect backdrop for striking scenics. I captured this view in figure 6.51 just a few yards from what is during three months of the year a busy beach. A tripod steadied the camera.
	On Your Own: You don't need to find a remote location to find unspoiled wilderness. Even sites close to home can make attractive scenic photos if you're careful to crop out the signs of civilization.
Lighting	**Practice Picture:** I began my trek in search of photo locations in late afternoon, and it was almost dusk by the time I found this site. The sun, low in the sky, provided all the illumination needed.
	On Your Own: You don't have much control over the available illumination when shooting scenics; tools like reflectors or fill flash are little help when photographing vistas that may extend miles from your camera. Your best bet is to choose your time and place, and take your shots when the light is best for the kind of photography you want to take.
Lens	**Practice Picture:** A wide-angle zoom lens at the equivalent of 40mm.
	On Your Own: Use a wide-angle lens to take in a broad view, but keep in mind that the foreground will be emphasized. If you're far enough from your chosen scene, a telephoto lens captures more of the distant landscape and less of the foreground. Use a long telephoto to reach out and grab scenes containing easily spooked wildlife.
Camera Settings	**Practice Picture:** RAW capture. Shutter-priority AE with Saturation set to Enhanced. Although I could have boosted saturation during conversion from RAW, it's easier to make your basic settings at the time you shoot.
	On Your Own: Shutter-priority mode lets you set a high enough shutter speed to freeze your landscape and counteract any camera or photographer shake if you don't use a tripod.
Exposure	**Practice Picture:** ISO 400, f/11, 1/500 second. Slight underexposure produced a slightly silhouetted effect and helped make the colors richer.
	On Your Own: This late in the day, an ISO setting of 400 allows a higher shutter speed. Any extra noise caused by the ISO boost shows up only in the distant trees and in shadow areas.
Accessories	A tripod may help you steady the camera and make it easy to fine-tune your composition. Use a quick-release plate so you can experiment with various angles and views, and then lock down the camera on the tripod only when you decide on a basic composition. A circular polarizer and a (rain) umbrella and raincoat might be handy, too.

Landscape and nature photography tips

✦ **Use a circular polarizer with caution.** A polarizer can remove reflections from water, cut through haze when photographing distant scenes, and boost color saturation. However, a polarizer may also cause vignetting with extra-wide-angle lenses, will reduce the amount of light reaching your sensor (increasing exposure times), and may be unpredictable when applied to images with a great deal of sky area.

✦ **Bracket your exposures.** The same scene can look dramatically different when photographed at a half to a full stop (or more) extra exposure, or with a similar amount of underexposure. An ordinary dusk scene can turn into a dramatic silhouette.

✦ **Take along protective gear for inclement weather.** A sudden shower can drench you and your digital camera. An unexpected gust of wind can spoil an exposure or even tip over a tripod-mounted camera. An umbrella (the rain variety) can protect you from precipitation or shield your camera from a stiff wind.

Light Trail Photography

There's no reason to run out of things to photograph on your travels. All you need is a little light—literally. Every type of photography requires light to make an exposure, but did you know that it's easy to make light itself your subject? You probably know that if your camera moves during a long exposure (which can range from 1/30 second to several seconds or minutes) everything in the photo becomes streaky—especially light sources within the frame.

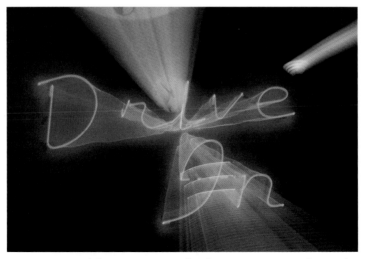

6.52. I mounted the camera on a tripod, set an exposure of several seconds, and then zoomed during the exposure to produce this photo of a classic Route 66-style drive-in restaurant sign.

If the points of light are the only things bright enough to register, what you end up with is a photo that captures light trails. These trails show the path the light takes as the camera shakes or, in the case of non-stationary illumination, the movement of the light itself. Figure 6.52 shows an example of a fixed light source and a moving camera.

Alternatively, you can lock down the camera on a tripod and leave the shutter open long enough to capture moving lights at night, such as the headlights or taillights of moving automobiles, a rotating Ferris wheel, or fireworks displays.

Inspiration

Use your imagination to come up with different ways of recording light trails. Here are a few ideas to get you started:

✦ Outdoors on a very dark night, set the camera up on a tripod and open the shutter for a 30-second time exposure. A helper positioned within the camera's field of view can use a penlight pointed at the camera to write or draw an image

with light. As long as no light spills over onto the person wielding the penlight, only the light trail will appear in the picture. Place a transparent piece of colored plastic in front of the penlight to change the color of the light trail, even during the exposure. If your confederate wants to inscribe actual words in midair, remember to use script letters and write backward!

✦ Tie the penlight on a piece of long cord, suspend it from an overhead tree branch, and place the digital camera on the ground, pointing upward. Swing the penlight back and forth, pendulum-fashion, or in a figure-8 or other pattern. Then open the shutter for a few seconds. You'll record a regular pattern. Carefully pass pieces of colored plastic in front of the lens to create multicolored streaks.

✦ Mount the camera on a tripod, point it at a busy street, and shoot long exposures to capture the streaking headlights and taillights of the automobiles. Experiment with various exposures, starting

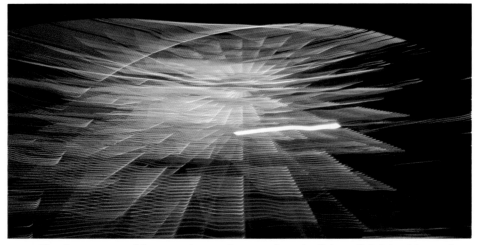

6.53. The shutter opened for several seconds to produce the light trails left by this rotating Ferris wheel.

with about 1 second to 20 seconds to create different effects. Trains are another great source of light streaks, especially at stations or crossings.

Light trail photography practice

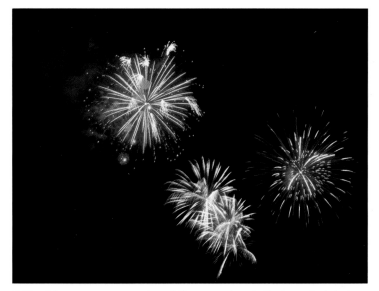

6.54. A long exposure captured the many bursts that erupted during the finale of a Fourth of July fireworks extravaganza.

Table 6.14
Taking Pictures of Fireworks

Setup	**Practice Picture:** For figure 6.54 I arrived early at the fireworks show so I could pick out a prime location on a small hill slightly elevated above the crowd and at the edge of a stand of trees so I could set up a tripod without obstructing the view of those seated in the vicinity.
	On Your Own: A position close to where the fireworks are set off lets you point the camera up at the sky's canopy and capture all the streaks and flares with ease. On the other hand, a more distant location lets you photograph fireworks against a city's skyline. Both positions are excellent, but you won't have time to use both for one fireworks show. Choose one for a particular display, and then try out the other strategy at the next show.
Lighting	**Practice Picture:** The fireworks provide all the light you need.
	On Your Own: This is one type of photography that doesn't require making many lighting decisions.

Continued

Table 6.14 *(continued)*

Lens	**Practice Picture:** A wide-angle lens, equivalent to 35mm.
	On Your Own: A wide-angle lens is usually required to catch the area of the sky that's exploding with light and color. Even a fish-eye lens can be used for an interesting effect. If you're farther away from the display, you may need a telephoto lens to capture only the fireworks.
Camera Settings	**Practice Picture:** JPEG capture. Manual exposure with both shutter speed and aperture set by hand. Saturation set to Enhanced.
	On Your Own: If your camera doesn't allow manual exposure, try using a long automatic exposure in the 20- to 30-second range. Depth of field and stopping the action are not considerations. Don't be tempted to use Noise Reduction to decrease noise in the long exposures; the extra time the reduction step takes will cause you to miss some shots.
Exposure	**Practice Picture:** ISO 200, f/11, 30 seconds.
	On Your Own: Don't rely on any autoexposure mode if you can avoid it. Your best bet is to try a few manual exposure settings and adjust as necessary.
Accessories	A steady tripod is a must. You also should have a penlight so you can locate the control buttons in the dark! Carry an umbrella so your camera isn't drenched if it rains unexpectedly. The infrared remote control can be used to trip the shutter or to produce a Bulb-type exposure that continues until you press the remote control button a second time.

Light trail photography tips

✦ **You must use a tripod.** Fireworks and other types of light trail images usually require a second or two to expose, and nobody can handhold a camera for that long.

✦ **Review the first one or two shots you take.** Use your LCD to see if the light trails are being imaged as you like. Decrease the f-stop if the streaks appear to be too washed out, or increase the exposure if the streaks appear too dark. Experiment with different exposure times to capture more or fewer streaks in one picture.

✦ **Track the skyrockets in flight.** When shooting fireworks, you can time the start of your exposure for the moment just before they reach the top of their arc and explode, then trip the shutter. An exposure of 1 to 4 seconds will capture single displays. Longer exposures can be used if you want to image a series of bursts in one shot.

✦ **Don't worry about visual noise.** It's almost unavoidable at longer exposures, and it won't be evident once you start playing with the brightness and contrast of your shots in your image editor.

Macro Photography

Close-up, or macro, photography is another chance for you to cut loose and let your imagination run free. Although you can have lots of fun shooting close-ups as you travel about, macro photography is one of those rainy-day activities that can be carried out when you're stuck in your hotel room for a few hours. That weird crystal saltshaker you unearthed at a village market might be the perfect fodder for an imaginative close-up that captures its brilliance and texture. Grains of sand you find on the beach, spider webs, the interior workings of a finely crafted Swiss watch, and many other objects can make fascinating macro subjects. Or you can photograph something as mundane as the coins you pick up during your travels.

6.55. Those coins that have been weighing down your pockets can make interesting photo subjects.

Inspiration

Explore the world around you as you travel by discovering interesting subjects in common objects. Once you find subject matter that gives your imagination a workout, the next step is to make it big.

6.56. A close-up photo reveals the character in a 200-year-old wooden door.

You don't have to purchase an expensive macro lens to enjoy close-up photography. The lens you already have on your digital camera may focus close enough for some kinds of macro work. Or you can buy a close-up adapter lens for about $30. Several close-up attachments can be used at once to produce additional magnification at the cost of a little sharpness.

Macro and close-up photography practice

6.57. Lladró porcelain figurines can sometimes be purchased less expensively overseas. Photograph your purchase for insurance purposes or just to share with your friends or fellow collectors by e-mail.

Table 6.15
Taking Close-Up Photos

Setup	**Practice Picture:** I draped a black velour cloth over a hotel room couch and let the light from the windows provide most of the illumination for the image in figure 6.57, with a metallic reflector off to the right to provide bright highlights in the porcelain.
	On Your Own: If you plan on taking many close-up photos, carry along a selection of fabrics to use as backgrounds. They're lightweight and won't fill up your luggage.
Lighting	**Practice Picture:** Window light did the trick, providing a relatively soft illumination with just enough contrast to show details of the figurine, while speckling its surface with highlights that showed off its gloss. A single reflector located just below the camera lens filled in the shadows.
	On Your Own: Direct flash won't give good results for this kind of photography. It is too harsh and you may even find that the camera's lens or lens hood casts a shadow on the item being photographed.
Lens	**Practice Picture:** Short telephoto zoom lens set at the equivalent of 50mm.
	On Your Own: Point-and-shoot camera users can focus close with the lens built into the camera. Digital SLR owners can use a macro lens or close-focusing prime or zoom lens to provide the magnification you need. You can also use a 50mm f/1.8 or other prime lens with extension tubes to photograph objects from a few inches to a few feet from the camera.
Camera Settings	**Practice Picture:** JPEG capture. Aperture-priority AE with Saturation set to Enhanced.
	On Your Own: As with other close-up photos, you want to control the depth of field, so choose Aperture-priority AE mode, if available, or your camera's Close-Up Scene Mode, and set the white balance to the type of light in the scene.
Exposure	**Practice Picture:** ISO 200, f/11, 1/30 second.
	On Your Own: Usually, you want to use an f-stop between f/11 and f/22 to maximize front-to-back sharpness. If the camera is mounted on a tripod, you can use longer shutter speeds as required and stick with an ISO setting of 200 for maximum quality.
Accessories	Any white card — even a local newspaper — to use as a reflector to fill in the shadows. Use the self-timer on your camera to trip the shutter without shake.

Macro photography tips

✦ Press down the shutter-release button halfway to freeze focus, or set your camera/lens to manual focus and zero in on the exact plane you want to appear sharpest.

✦ If you don't have a remote control, use the self-timer to trip the shutter. Even if you press the shutter release carefully, you'll probably still jostle the camera a little.

✦ Remember that long exposures take some time. Just because you hear a click doesn't mean the picture is finished. Wait until the shutter closes again before touching the camera, or review the image on the LCD.

✦ Use the camera's LCD to review your close-up photos right away so you can double-check for bad reflections or other defects. It takes a long time to set up a close-up photo, so get it right this time rather than having to set up everything again later.

Mountain and Valley Photography

I admit that there are lots of fascinating things to photograph when your travels take you to flat terrain. Amber waves of grain in Iowa and broad expanses of sagebrush vistas in Texas are wonderful photo opportunities. But nothing captures the imagination quite as well as the rugged mountainsides that mark the most energetic geological activities of Mother Nature. You'll find rounded volcano peaks in Hawaii and other locations, rough-hewn mountains in Europe, Asia, and the American West, Canada, and Latin America. There are more weathered hills in the Eastern U.S. and other locations that have remained geologically stable after a few million years of erosion.

Don't forget the attraction of valleys, too. Whether carved out by glaciers or etched by rivers, the spaces between mountain peaks have a charm all their own. One of my favorite places to visit is Juneau, Alaska. Although it is the state capital, it is a charming small town perched on the edges of

Mount Juneau, right on the Gastineau Channel, with breathtaking views of both.

Oddly enough, mountains are often locales for spectacular photographs featuring water. The reflections of towering rock walls in placid pools make for some powerful imagery, as you can see in figure 6.60.

Inspiration

Good mountain locales for photography are not difficult to find, but getting off the beaten track to the best vantage points can require a great deal of exertion. Most of the time, it is impossible to drive right up to the best view of a mountain vista, except if you're satisfied with taking pictures from overlook points at the side of the highways that wend through the peaks.

Instead, be prepared to hike to a good location. In Juneau, for example, some of the best shots can be taken by following hiking trails that take you to various glacier locations. Find a shooting spot that's not too close to civilization but still provides a distant view of the mountains or valley features you want to capture.

©Felix Hug www.hfphotography.net

6.58. Mountains attract us, but human habitations cluster in valleys.

New mountain photographers are often surprised to learn that once you get right up close and personal with these geological features, you are often too close for an overall view of the mountain. You need to be several miles away to photograph most mountains in their entirety. Within the foothills and up the mountainside itself you may find yourself concentrating on smaller details, such as cliffs, precipices, the valleys below, or distant views of the peak.

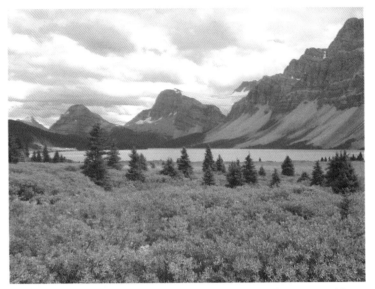

6.59. Lakes lodged between mountain peaks provide opportunities to spice up your foregrounds even as you feature the mountains themselves in your photographs.

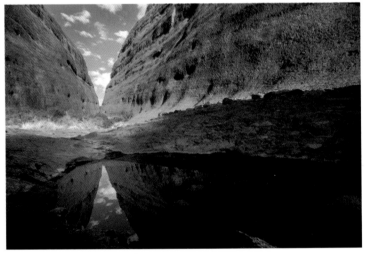

©Felix Hug www.hfphotography.net
6.60. The dramatic canyon walls are effectively reflected in the stream that runs between them.

Mountain and valley photography practice

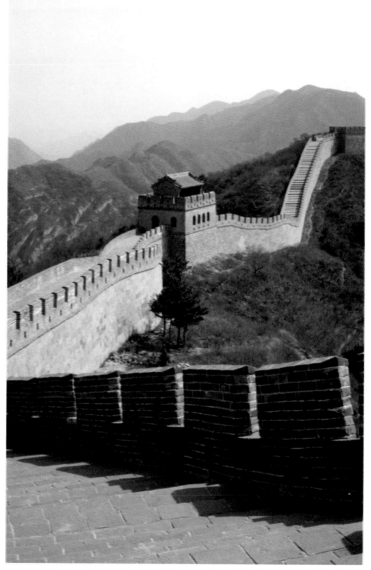

6.61. This mountain view combines peaks with the Great Wall of China.

Table 6.16
Taking Mountain and Valley Pictures

Setup	**Practice Picture:** It's a long trek to the Great Wall of China (see figure 6.61), but the view of the mountains and human-built Wonder of the World is worth it.
	On Your Own: Don't be surprised if you're dozens of miles from the actual mountain peaks when you discover the best location for your shot. If you have time, drive around the foothills looking for lakes, villages, and other scenic locations that can serve as an interesting foreground.
Lighting	**Practice Picture:** Bright daylight.
	On Your Own: Mountains look grand at any time of daylight, from dawn to dusk. A special time is at sunrise or sunset when the sun peeks over the crests of the mountains to provide glancing illumination to the valleys in between.
Lens	**Practice Picture:** A wide-angle zoom.
	On Your Own: If you use a wide-angle lens to take in a broad view the foreground will be especially emphasized. If there is nothing of particular interest in the foreground, switch to a telephoto lens or zoom setting and fill the frame with the mountain itself.
Camera Settings	**Practice Picture:** Programmed exposure.
	On Your Own: Shutter-priority mode lets you set a high enough shutter speed to freeze your vista and prevent camera or photographer shake that can plague your photos if you're not using a tripod.
Exposure	**Practice Picture:** ISO 200, f/11, 1/500 second.
	On Your Own: Your camera's matrix metering system will usually do a good job of calculating exposure, but if you have a Landscape Scene mode, this might be a good time to try it out.
Accessories	A circular polarizing filter might be a good idea if there are reflections on any water, such as a lake, stream, or river that appears in your mountain portraits.

Museum and Art Photography

Many travelers use their visits to important cities as a good reason to take in the cultural treasures at museums, galleries, and other sites. The good folks who run these institutions have taken the time to collect outstanding artwork, mementoes, collectible items, and other exhibits so that you can view — and photograph — things that you probably would not have the opportunity to experience otherwise.

Museums come in all types and sizes. Many house great collections of art, with some of them specializing in certain types of works (modern art or sculpture, for example), while others provide a broad range of

6.63. Outdoor sculpture gardens are excellent sites for appreciating and photographing carved and cast artwork.

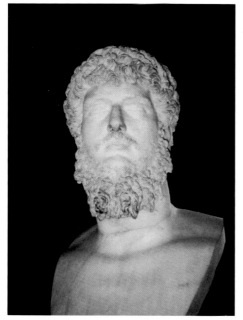

6.62. Artwork like this Greek bust is sometimes displayed in dim alcoves with accent lighting, which can make photography especially challenging.

exhibits. Most large cities have a natural history museum as a repository for things like dinosaurs or geological displays. There are museums dedicated to technology, too: Chicago's famed Museum of Science and Industry has long been a prime destination for visitors to the Windy City who want to experience the interactive exhibits.

Not all museums are concerned with cultural matters. There is a museum at the Baseball Hall of Fame in Cooperstown, New York, and one devoted to professional football memorabilia at the Pro Football Hall of Fame in Canton, Ohio. Graceland in Nashville is a museum of sorts devoted to Elvis Presley, and Liberace has his own museum in Las Vegas.

The various Ripley's Believe It Or Not museums host oddities, and, perhaps oddest of all, in Altadena, California, there's a banana museum with 17,000 items. If you have a real taste for unusual museums, Madrid, Spain, has a Museo del Jamón, which is actually a chain of bars with an incredible number of hams (jamónes) on display.

However, the trickiest museums in which to collect photographs are art museums, particularly in Europe where many of the finest collections are housed in religious institutions. Such venues are more challenging because they frequently serve double-duty as churches, cathedrals, and synagogues, and are likely to have strict rules about what can and cannot be photographed and whether or not flash is permitted.

Inspiration

Artwork displayed in most museums is priceless, of course, but even so may be insured for hundreds of thousands of dollars per piece. As you might expect, there are rules about what you can and cannot take pictures of. Make sure you know the rules governing photography at any venue you visit before getting your camera out.

Museum and art photography practice

6.64. Some of the finest art collections in Europe are displayed in churches and cathedrals, with Old Masters' paintings and carvings proudly shown in many houses of worship.

Table 6.17
Taking Museum Pictures

Setup	**Practice Picture:** I asked at the ticket kiosk at the entrance to this Jesuit church-museum and was told that photography was OK as long as I didn't use electronic flash. Inside, I found a breathtaking array of artworks, including polychrome wood carvings painted and overlaid with gold leaf, and a wonderful selection of Renaissance paintings. I steadied my camera with a monopod and took the snapshot shown in figure 6.64.

On Your Own: Don't be scared off if you think you don't know the local language well enough to ask permission to shoot. The staff at most museums are a lot more accustomed to dealing with those who speak other languages than you are with talking to museum staff, so even if they don't speak English, you may find it easy enough to make your intentions known. |
| **Lighting** | **Practice Picture:** Sunlight streaming in the high windows provided sufficient diffuse illumination.

On Your Own: Church museums are often better lit than those in cathedrals, which have stained-glass windows (themselves excellent photographic subjects). You might have to contend with dimmer lighting, or spot or flood lighting that illuminates the artwork. |
| **Lens** | **Practice Picture:** Wide-angle zoom set at the equivalent of 35mm.

On Your Own: Use the wide-angle setting of your point-and-shoot camera. If you use a digital SLR, use a lens with the widest maximum aperture possible. It's even worthwhile to take along a fast f/1.4 or f/1.8 prime lens on your trip. |
| **Camera Settings** | **Practice Picture:** RAW capture. Shutter-priority AE.

On Your Own: Your point-and-shoot digital camera may have a Museum or Manner mode, which automatically disables the flash and may silence the shutter click sound, while setting up the camera for photos at slower shutter speeds. If you have a more advanced camera, use Shutter-priority mode, and set your camera to the slowest shutter speed you find acceptable for handheld use. |
| **Exposure** | **Practice Picture:** ISO 800, f/4, 1/25 second.

On Your Own: Although your digital camera's matrix metering system does a good job with most scenes, you might want to bracket exposures to get different looks. Hold your camera steady at slow shutter speeds! |
| **Accessories** | A monopod can serve as a support for your camera during longer exposures in areas with lower light levels. |

Museum and art photography tips

If you know what the ground rules are at a particular museum, you may find that you can take many more photos than you expected. The regulations are designed to protect the artwork and prevent nuisance photographers from interfering with enjoyment of the museum for other patrons — not to protect postcard sales at the museum shop.

✦ **Ask at the front desk if you may take photos without flash.** I've found that some museums that have No Photography signs out front (in Europe often there is just a picture of a camera with the universal symbol for NO drawn through it) are in fact opposed only to flash photography, or to flash and the use of intrusive tripods. If you ask about non-flash photography you just may get permission.

✦ **Tuck your camera in its bag if photography is prohibited.** A few of the very largest museums will ask you to check your camera bag in a cloakroom, but most will let you go on inside with your equipment. I've found that walking around the museum with a camera around your neck earns extra attention from the guards, so if I do not intend to take pictures, I put my camera in its bag to make the custodians' jobs easier.

✦ **Don't try to sneak a few pictures, even if you see others doing so.** I'm always amazed to see other tourists abusing a museum's trust by snapping away — with flash — despite signs displayed at every entrance that flash photography is prohibited. They may get one or two shots before the guards clamp down, or even ask them to check their cameras, but it's still rude and paints a poor picture of photographers. A few bad eggs can lead to banning of all cameras and photography at a particular venue.

✦ **Leave your tripod in the hotel room unless you've made special arrangements.** I haven't encountered any decent-sized museums that will let any photographer just stroll in with a tripod. A compact walking-stick sized monopod might pass muster, but tripods are almost always a no-no.

✦ **Make special arrangements.** Many museums afford extra privileges to art students, teachers, and others who have a serious interest in the arts. If you write or call ahead, you just might get permission to take non-flash photos in museums that normally don't allow picture-taking or even an okay to bring a tripod.

✦ **Respect the art.** Most museums operate on the assumption that visitors won't get too close to important artworks, especially when taking photos. That's great, because it means that you're often not separated from works by velvet ropes or barricades. If you are allowed to shoot pictures, keep your distance.

✦ **Respect the institution.** If the museum also happens to be a house of worship, show additional respect. Keep your voices extra low, particularly when services are underway, and don't enter areas not actually open for public access.

Night and Evening Photography

Photography during the evening and after dusk is a challenge because, once the sun goes down, there is much less light available to take the photo. Add-on light sources, such as electronic flash, can be used only as a last resort, because as soon as you add an auxiliary light, the scene immediately loses its nighttime charm. Unless you're looking for a retro-Speed Graphic look reminiscent of the 1930s-1950s photojournalist Weegee (Arthur Fellig, who was not noted as a travel photographer), flash at night is a less-than-perfect solution.

Instead, the goal of most night and evening photography is to reproduce a scene much as it appears to the unaided eye, or, alternatively, with blur, streaking lights, or other effects added that enhance the mood or create an effect.

One interesting thing about night and evening photography is that it can encompass so many other types of travel pictures that are also covered in this chapter. If you're interested in photographs of street life, you find lots of opportunities to capture people being themselves after dark. Should you want to shoot light trails, night and late evening are excellent times for that. And in the moments after sunset, you can grab some of the most interesting evening pictures of all in the half-light moments of twilight.

Because night photography is so challenging technically, it is an excellent test of your skills and an opportunity to create some arresting images.

6.65. Nightlife outdoors can be exciting, filled with people strolling, musicians entertaining for tips, and other activities. High ISO settings you need to capture this activity may result in a grainy photo, but the natural look makes it worth the sacrifice.

Inspiration

Correct exposure at night means boosting the amount of light that reaches your sensor. That can be accomplished in several ways, often in combinations. Here are some guidelines:

✦ **Use the widest possible aperture.** Digital SLRs do the best job because of the flexibility they have in using different optics. A fast prime lens, with a maximum aperture of f/1.8 to f/1.4, lets you get some handheld shots of some brightly lit night scenes using reasonably short shutter speeds.

✦ **Use the longest exposure time you can handhold.** For most people, 1/30 second is about the longest exposure that can be used without a tripod with a wide-angle or normal lens. Short telephotos require 1/60 to 1/125 second, making them less suitable for night photography without a tripod. However, you can take handheld exposures of 1/15 second or longer using lenses and cameras with vibration reduction (or image stabilization or anti-shake) features.

✦ **Use a tripod, monopod, or other handy support.** Brace your camera or fix it tight, and you can take shake-free photos of several seconds to 30 seconds or longer.

✦ **Boost the ISO.** Increase the sensor's sensitivity to magnify the available light. Unfortunately, raising the ISO setting above 400 also magnifies the grainy effect known as noise. If you're not in a hurry,

6.66. High on a hill overlooking a city, a tripod-mounted camera catches the bright neon lights and streaking automobile headlights and taillights.

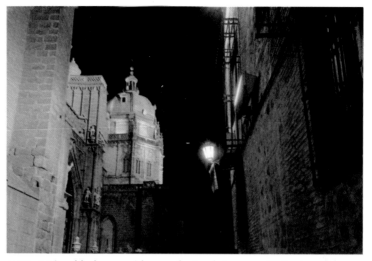

6.67. A tripod helps provide a rock-steady image of this church tower at night, using available street illumination and the lights mounted in the tower itself.

your digital camera's Noise Reduction option takes a second, blank frame for the same interval as your original exposure, then subtracts the noise found in this dark frame from the equivalent pixels in your original shot. This step effectively doubles the time needed to take a picture, meaning you have a 30-second wait following a 30-second exposure before you can take the next picture.

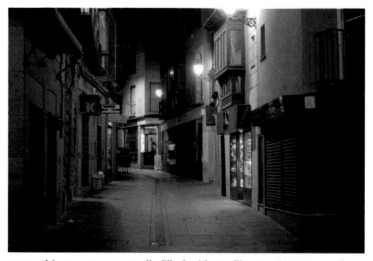

6.68. This street was actually filled with strolling tourists. None of them remained in one place long enough to register during the 30-second exposure.

Night and evening photography practice

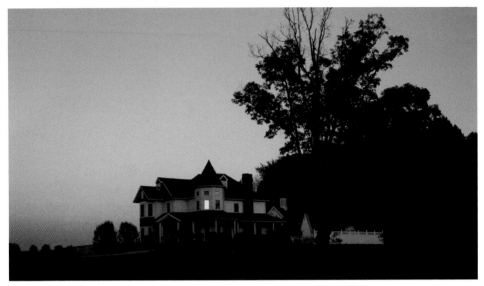

6.69. Early evening officially begins when the sun goes down, and that can be the best time to capture some moody night scenes such as this murky, but detailed rural vista.

Table 6.18
Taking Night and Evening Pictures

Setup	**Practice Picture:** I spotted the scene in figure 6.69 just after dusk after a long day of driving to my next destination. I didn't even get out of the car. I pulled over, rolled down the window halfway and rested the lens on the edge to snap off a series of shots.
	On Your Own: If you keep your camera ready to go at all times, you can constantly be on the lookout for grab shots. You don't necessarily need a tripod for night scenes. Rest your camera on an available object to steady it. If your scene is relatively unmoving, use the self-timer to trigger the shot and avoid shaking the camera with your trigger finger.
Lighting	**Practice Picture:** The waning sunlight is enough for this exposure, as reflected skylight illuminates the field in the foreground.
	On Your Own: Try to work with the light that is available. If you must use supplementary light, bounce it off reflectors or other objects, and don't let it become strong enough to overpower the existing light. At most, you just want to fill in some of the darker shadows, especially when the available light is overhead and high in contrast.

Lens	**Practice Picture:** Wide-angle lens set to the equivalent of 35mm.
	On Your Own: The wide-angle setting of most point-and-shoot cameras works fine for landscape evening photos like this one. Unless you need to reach out to photograph something at a distance, fast wide-angle prime lenses, or zoom lenses at a wide-angle setting are your best choice for night photography. Longer lenses usually have a smaller maximum aperture and require more careful bracing to avoid blur from camera/ photographer shake.
Camera Settings	**Practice Picture:** RAW capture. Shutter-priority AE with saturation set to Vivid.
	On Your Own: If your camera has a Night Scene mode, use that. Using Shutter-priority mode, set your camera to the slowest shutter speed you find acceptable (based on whether you are handholding or using the camera on a tripod), and the metering system will select an f-stop. For wide-angle scenes extending to infinity, the depth of field is usually not important. Unless the foreground is very close to the camera, everything will be acceptably sharp even wide open.
Exposure	**Practice Picture:** ISO 800, f/3.5, 1/160 second.
	On Your Own: Again, your digital camera's matrix metering system will do a good job with most night scenes, but bracketing is still a good idea. You might actually prefer an image that is darker or lighter than the one the camera takes by default.
Accessories	A tripod, monopod, a clamp with camera tripod mount attached, or even an ordinary beanbag like those kindergarteners toss at playtime can serve as a support or cradle for your camera during long nighttime exposures.

Night and evening photography tips

✦ **If you absolutely must use flash, use Slow Sync mode.** This allows use of longer shutter speeds with flash so that existing light in a scene can supplement the flash illumination. With any luck, you get a good balance and reduce the direct-flash look in your final image.

✦ **Shoot in twilight.** This gives a nighttime look that takes advantage of the remaining illumination from the setting sun.

✦ **When blur is unavoidable due to long exposure times, use it as a picture element.** Streaking light trails can enhance an otherwise staid night-scene photo.

✦ **If you have a choice, shoot on nights with a full moon.** The extra light from the moon can provide

more detail without spoiling the night-scene look of your photo.

✦ **Bracket exposures.** Precise exposure at night is iffy under the best circumstances, so it's difficult to determine the ideal exposure. Instead of fretting over the perfect settings, try bracketing. A photo that's half a stop or more under- or overexposed can have a completely different look, and can be of higher quality than if you produced the same result in an image editor.

Panoramic Photography

No scenic photo is quite as breathtaking as a sweeping panorama. Horizons look more impressive, mountain ranges more majestic, and vistas more alluring when presented in extra-wide views. If you shoot scenic photography — from landscapes to seascapes — experiment with panoramas. You can create them in your camera, crop a single photo into a narrow panoramic strip, or assemble them from multiple shots in your image editor.

Some of the charm of panoramas comes from the refreshing departure from the typical 3:2 aspect ratio that originated with 35mm still-photo film frames, and which lives on in the 3008-×-2000-pixel resolution of the typical 6-megapixel digital camera. Even common print sizes, such as 5 × 7, 8 × 10, or 11 × 14 inches provide a staid squat rectangular format.

You can go far beyond that with your digital camera, producing panoramas that stretch across your screen or print in just about any ultrawide view you choose.

6.70. If a vista looks like it would make a good panorama, take the picture, and then crop off the top and bottom later to eliminate excess sky and foreground areas, as was done in this case.

Creating a Panorama

There are several different ways to create panoramas. The easiest method is to take a wide-angle photo of your vista, and then crop off the top and bottom portions of the image to create a view that's much wider than it is tall. If you go this route, start with the sharpest possible original image. Mount your camera on a tripod, set sensitivity to ISO 200, and work with the sharpest suitable lens in your collection set to its sharpest f-stop.

Another method for creating a panorama is to take several photos and merge them in your image editor. (Photoshop and Photoshop Elements both have special tools for stitching photos together.) For the best results, mount your camera on a tripod and pan from one side to the other as you take several overlapping photos. (The term *pan* comes from panorama, by the way.) Ideally, the pivot point should be the center of the lens (there are special mounts with adjustments for this purpose), but for casual panoramas, mounting the camera using the digital camera's tripod socket works fine. Some digital cameras help you shoot panoramas in a special Panorama Scene mode by providing a ghost image of the previous shot at one edge of the viewfinder so you can more easily overlap images.

Inspiration

Panoramas have held our fascination since the first panoramic-style still photos were taken in the 1840s, based on a series of daguerreotypes that were framed or hung side-by-side. By the early 20th century, cameras with motorized lenses that moved to embrace a panoramic view were invented specifically for panoramic photography.

Early panoramas weren't limited to landscapes, and your digital versions can use wide-ranging subjects, too. For example, early panorama cameras were used to photograph groups, such as school classes or fraternal organizations. You can use digital techniques to create extra-wide group photos that gain some interest simply through their unusual, panoramic format.

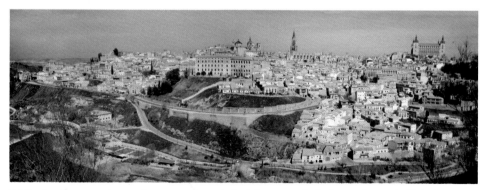

6.71. Another way to create a panorama is to take several photographs and stitch them together in an image editor. This view of Toledo, Spain, was assembled from two different images taken seconds apart.

Panoramic photography practice

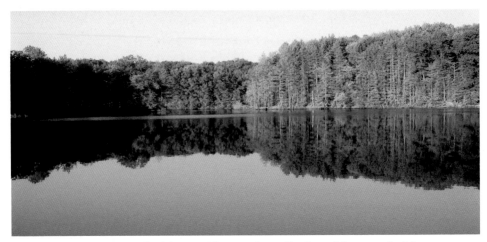

6.72. The calm waters of the lake provide a perfect reflection of the trees in this panorama photo.

Table 6.19
Taking Panorama Pictures

Setup	**Practice Picture:** Much of the sky and foreground were extraneous from this view of a secluded lake, so when I took the photo I was already planning to take the photo and crop it to a narrow panorama aspect ratio in my image editor, as you can see in figure 6.72.
	On Your Own: Look for scenes that can be cropped to produce images that are much wider than they are tall. Mountains and other kinds of landscapes and skylines are especially appropriate.
Lighting	**Practice Picture:** The existing daytime light was just fine for this panorama.
	On Your Own: As with conventional landscape photography, your control over lighting is generally limited to choosing the best time of day or night to take the photo. Unless you take a picture on the spur of the moment, think about planning ahead and showing up at your site when the lighting is dramatic.
Lens	**Practice Picture:** Wide-angle zoom at the equivalent of 28mm.
	On Your Own: Choose a good moderate wide-angle lens to capture your vista for panoramas created by cropping a single photo. If you stitch pictures together, you might want to try a slightly wider zoom setting to reduce the number of images you need to collect. Avoid very wide-angle lenses and the distortion they produce.

Camera Settings	**Practice Picture:** RAW capture. Shutter-priority AE.
	On Your Own: Use Shutter-priority AE, and select a high shutter speed to produce the sharpest possible image.
Exposure	**Practice Picture:** ISO 200, f/8, 1/800 second.
	On Your Own: Unless you include foreground objects for framing, you can select a high shutter speed and let the camera go ahead and open the lens fairly wide, with no worries about the shallower depth of field. Use ISO 100 or ISO 200 in bright daylight, and consider increasing sensitivity to ISO 400 during early morning or late-afternoon hours.
Accessories	For dawn or dusk shots, a tripod can help steady the camera during longer exposures.

Panoramic photography tips

✦ **Use a tripod.** If you shoot several photos to be stitched together later, use a tripod to help you keep all the shots in the same horizontal plane.

✦ **Overlap.** Each photo in a series should overlap its neighbor by at least 10 percent to make it easier to stitch the images together smoothly.

✦ **Watch the exposure.** You make your life simpler if you use the same exposure for each photograph in a panorama series. Use the digital camera's exposure lock feature, or else your camera will calculate a new exposure for each shot.

✦ **Save time with software.** If you don't have Photoshop or Photoshop Elements, do a Google search to find the latest photo-stitching software for your particular computer platform (Windows or Mac). Your camera may have come with stitching software, too. While you can stitch images together manually, the right software can save a lot of time.

Pattern Photography

Photography of patterns has a lot in common with abstract photography to the extent that the subject of the photograph may be the form and shape of the content, rather than the subject itself. However, photos of patterns are often more representational of the real objects in the picture. You can still tell that the photo shows a line of fence posts or an overhead lighting grid or some other recognizable object. However, the patterns that the content of the photo makes are easily discernable and either add to the charm of the underlying photo if the pattern is subtle, or become the most striking element of the picture if the pattern is strong and dynamic.

6.73. The rounded shape of the blown-glass flowers form an interesting and colorful pattern.

You can find patterns everywhere you look. Human-made objects tend to be designed around regular forms that repeat themselves at intervals. Buildings may have arrays of windows or a series of arches. Nature also creates wondrous patterns, from the hexagons of a bee-hive's honeycomb to the streamlined formations migrating birds assemble as they fly south for the winter. You find patterns indoors or out, in any weather, and any time of day. If abstract photos are too abstract for you, patterns may satisfy your creative urges.

Many parts of the U.S. are known for the brilliant fall colors of their foliage, and these regions go all out to attract tourists. One of my family's favorite autumn excursions is to spend a few days visiting about a half-dozen farms that cater to tourists during the harvest season by offering cornfield mazes, hayrides, pumpkin carving competitions, and sales of dried and fresh gourds, handicrafts, and Indian corn.

Inspiration

To really flex your mind muscles, give yourself an assignment to go out and seek out patterns. Photographer Simon Nathan used to photograph individual letters of the alphabet on signs, buildings, or wherever he found them, eventually collecting them all onto a CD-ROM that showed the endless variety of patterns that can be found in something as simple as the alphabet.

You can specialize in one kind of pattern, too, seeing how many variations on, say, railroad tracks or spider webs you can find. Or choose the type of pattern itself as your specialty, and shoot disparate subjects that all share the same kind of geometric arrangement. You might group the concentric circles of a Ferris wheel with hubcaps or dart boards.

6.74 You can find patterns anywhere you look while traveling. These smooth-edged stones where discovered while crossing a stream.

Pattern photography practice

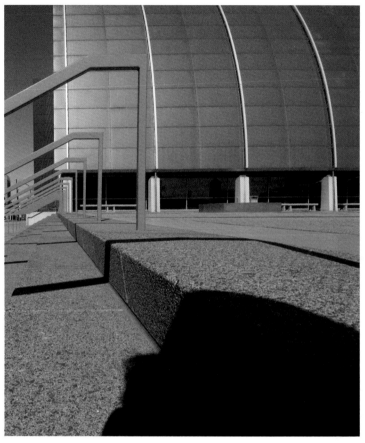

6.75. The Inventor's Hall of Fame museum is a tourist destination all by itself, but I found some interesting patterns in its structure as well as the railing and walkway leading to the entrance.

Table 6.20
Taking Pictures of Patterns

Setup	**Practice Picture:** Outside this museum, I discovered three different patterns in one shot (see figure 6.75), formed by the curved structure of the Hall, the receding lines of the railing, and the long stretch of stairs leading to a plaza in front of the building.

Continued

Table 6.20 *(continued)*

On Your Own: While some patterns are built into the makeup of your subject, others appear when you choose a particular angle or perspective. When you spot a promising subject, examine it from all sides to find the one shot that best shows off the pattern you discovered.

Lighting **Practice Picture:** The sunlight provided all the illumination required.

On Your Own: Favorable lighting can make or break a pattern. Strong light from an angle emphasizes texture and edges. Dark shadows build contrast that can make a pattern seem even more dramatic. If you shoot indoors with complete control over the lighting, use these characteristics to make your patterns more vivid. Outdoors, look for angles that make the most of the light that is available to emphasize your pattern.

Lens **Practice Picture:** 12-24mm zoom lens at the 12mm setting.

On Your Own: Your lens choice really depends on the subject. Some patterns can be found in close-ups shot with macro lenses. Others appear when you use a telephoto lens to compress the distance between objects, merging them together into a new pattern. Wide-angle lenses can emphasize patterns in the foreground of the photo.

Camera Settings **Practice Picture:** Aperture-priority AE with Saturation set to Enhanced to deepen the blue in the sky.

On Your Own: If your digital camera has exposure controls, you will want to have control over the depth of field, so choose Aperture-priority AE mode and set the white balance to the type of light in the scene.

Exposure **Practice Picture:** ISO 200, f/16, 1/200 second.

On Your Own: When shooting close-up patterns handheld without a net (that is, a tripod), choose a small f-stop and a fast shutter speed to counter camera shake. Boost the ISO to 400 under dimmer lighting to make sure you can use both a depth-of-field enhancing aperture and an action-freezing shutter speed.

Accessories A polarizing filter is sometimes handy for reducing reflections on the glass or metal panels that often are found in architectural patterns.

Pattern photography tips

✦ **Create your own patterns.** Arrange objects in a pattern that pleases you, or rearrange an existing pattern to provide a more artistic arrangement. Several stacks of coins, for example, can be arranged so they're perfectly straight or slightly skewed, each creating a different pattern effect.

✦ **Use scale to enhance or diminish the realism of your pattern.** If you don't include any objects of known size in the photo, the viewer may not be able to visualize the scale of the objects in your pattern. If you're looking for an

abstract quality, that can be a good thing. Yet, if you want a realistic photo in which the pattern is only a strong element in the composition, make sure the scale is obvious from the photo's context.

✦ **Patterns don't have to be physical objects.** Light shining through a grille or series of fence posts can create interesting patterns. Colors can create patterns, too.

Seascape Photography

Photographers of seascapes fall into two different categories: those who live near the ocean and those who wish they did. For such a simple subject — basically a seashore lapped by a relentless ocean of water — seascapes can be taken in an almost infinite variety. In that sense, seascapes are like sunsets: Despite the same basic elements, no two are exactly alike. If you're a photographer who doesn't live near the ocean, your trip to the shore can be an especially memorable opportunity for picture-taking.

Seascapes can be demanding because of environmental considerations. Beaches are often sunny, but just as often beset by murky fog, so you may struggle with excessively contrasty lighting one day and bland lighting the next. Rain, salty spray, and other weather hazards can make pursuit of the perfect seascape challenging.

Like other kinds of landscape photography, seascapes are often best when unpopulated by humans and devoid of structures, other than, perhaps, a grass hut or two when photographing that uncharted desert isle. You can often avoid this problem simply by taking a trek down the shore to a less popular area or scheduling your session for early mornings when only a few shell collectors or anglers are likely to be about. At sunset, most of the sunbathers have left and the few party-oriented folk who remain usually cluster around their campfires.

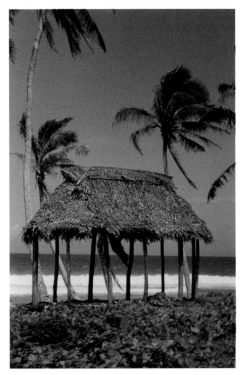

6.76. Even if your ideal escape isn't to live on the beach in a grass hut, an island retreat under swaying palms can make an interesting photograph.

With a little ingenuity, you can find the beach scene of your dreams and capture some memorable seascapes.

Inspiration

Seascapes are photographed so much, give yourself an assignment to shoot something really different the next time you take up photography at the shore. Here are some idea starters:

6.77. The setting sun and the texture of the sand say "ocean" quite clearly, even though the sea is actually just on the other side of the hilly stand of trees.

✦ **Shoot from offshore.** Instead of standing at one end of a beach and pointing your camera up or down the shore, find a way to position yourself offshore, and shoot the beach from the perspective of a breaker. A fishing pier that extends a healthy distance out from the shore is a good place to start. You can also shoot from this vantage point onboard a boat that's brought to a halt a safe distance from shore.

✦ **Use a high angle.** Shoot down on the shore from a nearby cliff, a lighthouse that's open to the public, or, if you're adventurous, a hang glider.

✦ **Use a low angle.** Get down so your camera is almost resting on the sand (but keep the sand out of your camera!), and try some seascapes that are heavy on foreground emphasis and quite unlike anything you've seen before.

✦ **Blur the waves.** Mount your camera on a tripod, add at least an 8X neutral density filter to your lens, and try a long exposure that lets the waves merge into a foamy blur. At ISO 200 with an ND filter, you should be able to shoot at 1/15 second at f/32 or 1/8 second at f/32 on an overcast day. Substitute an infrared filter like the Hoya R72, and you can easily manage several-second exposures — and get some weird infrared effects to boot.

✦ **Include some wildlife.** While people and most buildings detract from true seascapes, a few seagulls scattered along the shore can break the monotony and add some

interest. Spread a little seagull food along the sand, then back off 20 or 30 yards and compose your shot as your extra cast members arrive.

Seascape photography practice

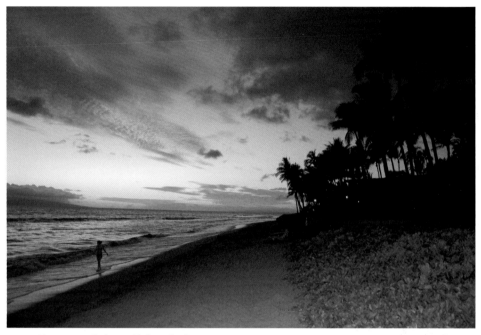

6.78. The ocean is beautiful at dusk.

Table 6.21	
Taking Seascapes	
Setup	**Practice Picture:** It was almost sunset before the interesting seaside locale in figure 6.78 turned up.
	On Your Own: Rough-looking roads and trails leading off the main highway often dead-end at scenic overlooks and interesting hiking routes that are perfect for photography. If you're new to an area, ask one of the locals for directions to the most stunning views.
Lighting	**Practice Picture:** Sunset illumination.
	On Your Own: As with other types of landscape photography, you usually can't choose your lighting, but you can choose to wait until the illumination looks good. Sometimes you have to come back a different day, but when the lighting is just right you know that being patient is worth it.

Continued

Table 6.21 *(continued)*

Lens	**Practice Picture:** Wide-angle zoom set to the equivalent of 27mm.
	On Your Own: Wide-angle lenses and zoom settings work well with seascapes, and a zoom is handy to have if your photographic perch makes it difficult to move closer or farther away from your favored vista. You need a telephoto zoom only to pull in distant views.
Camera Settings	**Practice Picture:** JPEG capture. Shutter-priority AE.
	On Your Own: Choose a shutter speed that neutralizes camera/photographer shake; let the exposure system set an aperture for you.
Exposure	**Practice Picture:** ISO 200, f/3.5, 1/100 second.
	On Your Own: It's easy to handhold a wide-angle lens at 1/400 second, and f/8 is usually a good, sharp aperture to use for subject matter that extends out to infinity. If it's very cloudy or near dusk, you might want to up the sensitivity to ISO 400.
Accessories	A waterproof camera bag can help store your extra lenses and provide a safe haven for your camera to protect it from rain and surf.

Seascape photography tips

✦ **Keep the horizon level.** A seascape photo will almost always have the sea on the horizon somewhere, and a sloping horizon is a sure tip-off that you didn't compose your photo carefully.

✦ **Monitor your exposures.** Use the digital camera's histogram feature to review your shots after the first few, and then use Exposure Compensation to add or subtract a little if required to get photos with detail in the shadows without washing out the highlights.

✦ **Don't let sand gum up your works.** Back when film cameras used lots of precision-made gears, rollers, springs, and other components, a few grains of sand could quickly disable a fine piece of machinery. Digital cameras are rugged and have electronic components that are less prone to damage from a little dust or sand, but you definitely don't want to get any silicon dioxide granules inside your lens or lens mount, within the mirror box chamber, or anywhere near the sensor. Use caution when operating your digital camera around sand and salt water, and change lenses only when you're certain a gust of wind or an over-muscled bully won't kick sand into the innards.

✦ **Remember the tides.** High tide provides a clean beach, but low tide leaves behind a treasury of shells, seaweed, and other objects (including old shoes and tires) that can enhance or detract from your photos. Learn which time of day a particular seashore is most photogenic before setting out on your seascape trek.

Street Life Photography

Urban areas have a charm of their own. The pace is more hurried, the ambiance a little grittier, and the variety of photo subjects almost infinite. You can spend a year photographing everything within a one-block area and still not exhaust all the possibilities. Smaller town centers offer many interesting photographic opportunities, too.

The focus of street life photography is often on the people, but there's a lot more to explore. Old buildings, monuments, storefront windows, or kiosks packed with things for sale all present interesting photographic fodder. Or you can concentrate on the streets themselves, the bustle of traffic and pedestrians, or whistle-blowing bicycle messengers. The animals that populate the streets, including stray dogs, voracious pigeons, and darting squirrels, are worthy of photographic study. Take refuge in the peace

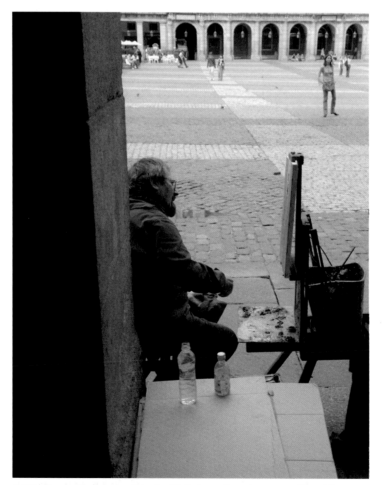

6.79. Every city is populated with interesting characters like this artist. You can capture their personality in an image if you are careful not to intrude.

of an urban park and capture the contradictions of an island of natural beauty hemmed in by tall buildings.

Photography of street life has been a cornucopia of photographic opportunities for as long as cameras have been used in cities.

Inspiration

Photographing people on the streets has become more complex in the 21st century. Security concerns have tightened restrictions on photography around certain buildings, including most government installations. Paparazzi have given impromptu people photography something of a sour reputation as an intrusive invasion of privacy. In parts of some cities, a few denizens may be engaging in activity that they don't want captured on film. If you want to be successful on the streets, follow a few rules:

✦ **Ask permission to shoot people on the street.** You don't need to walk up to every photo subject and say, "Hi, I'm a photographer. May I take your picture?" A simple quizzical nod and a gesture with your camera will alert your subject that you'd like to snap a photo. If you're met with a smile or ignored, go right ahead and shoot. Should your victim turn away from you, glare, or flash a finger salute, that's your signal to back off.

✦ **Never photograph children without asking the adult they are with.** If the child is unaccompanied, look for another subject. Granted, you'll miss some cute kid shots, but the chance of being mistaken for a bad person is too much to risk. The only possible exception to this rule might be if you are a female photographer, preferably accompanied by children of your own.

6.80. I spent an hour or two each day for a week sitting in the main square of this Spanish city watching and photographing the residents and tourists. I couldn't resist shooting this old couple, who could be found strolling there each day at noon without fail.

✦ **Leverage your personality.** Recognize that photographers, including yourself, fall into one of several different personality types. Some folks have an outgoing way that lets them photograph people aggressively without offending or alarming their subjects. Other people approach street photography more tentatively or tend to blend into the background. If you know which style is more suitable for you, work with your personality rather than against it.

✦ **Don't act in a suspicious way.** Photographing with a long lens from a parked car is a good way to attract unwanted attention to yourself. In fact, any kind of furtive photography is likely to ensure that your street-shooting session is a short one.

Street-life photography practice

6.81. In many European cities, public squares are the usual gathering spot for young people after school.

Table 6.22
Taking Pictures of Street Life

Setup	**Practice Picture:** I shoot most of my street-life photos in public squares, where a good selection of interesting folks can always be found enjoying their daily life, as these two young guitar players in figure 6.81 are. I used a monopod to steady the camera for this telephoto shot.
	On Your Own: In seeking your street subject matter, look for simple arrangements of people or objects that make an interesting composition. You'll rarely be able to rearrange your subjects to suit your needs, so explore all the angles to get the best perspective.
Lighting	**Practice Picture:** It was a bright day, but there was a slight overcast that softened the shadows of this street shot.
	On Your Own: Using reflectors, flash, or other extra lighting can quickly destroy the mood of your street scene, so try to work with the lighting that is already there. City streets can often be fairly shady because of the shadows cast by tall buildings, so you often find that exactly the sort of diffuse lighting you need is already available.

Continued

Table 6.22 (continued)

Lens	**Practice Picture:** Telephoto zoom at the equivalent of 200mm. **On Your Own:** Crowded streets often call for wide-angle views, but you also need to be able to zoom in for an impromptu portrait. The zoom lens of most digital cameras provides a suitable range. You might need a wider optic for photos that include buildings, and a faster lens can come in handy in lower light levels and at night.
Camera Settings	**Practice Picture:** RAW capture. Aperture-priority AE, with Saturation set to Enhanced. **On Your Own:** Aperture-priority AE mode gives you greater control over the depth of field, but if light levels are low you might want to switch to Shutter-priority to make sure that your shutter speed is high enough to counter camera shake.
Exposure	**Practice Picture:** ISO 200, f/11, 1/200 second. **On Your Own:** To ensure front-to-back sharpness, set a narrow aperture such as f/8 or f/16. If the background is distracting, use a wider aperture such as f/5.6 or f/4.0. Set the ISO to 200 or 400, depending on the amount of light available.
Accessories	A monopod for steadying the camera is more practical than a tripod in urban situations. It's easier to set up, requires less room, and won't bog you down with unnecessary weight.

Street-life photography tips

✦ **Tell a story.** Some of the best photos of street life are photojournalist-style images that tell a story about the people and their activities in the urban area you picture.

✦ **Travel light.** When working in cities, you'll be on foot much of the time, scooting between locations by bus or taxi. You won't want to be lugging every lens and accessory around with you. Decide in advance what sort of pictures you're looking for, and take only your digital camera and a few suitable lenses and accessories.

✦ **Cities are busy places: Incorporate that into your pictures.** Don't be afraid to use blur to emphasize the frenetic pace of urban life. Slower shutter speeds and a camera mounted on a monopod can yield interesting photos in which the buildings are sharp, but pedestrians and traffic all have an element of movement.

✦ **Learn to use wide-angle lenses.** The tight confines of crowded streets probably mean you'll be using wide-angle lenses a lot. Experiment with ways to avoid perspective distortion, such as shooting from eye-level, or exaggerate it by using low or high angles.

Sunset and Sunrise Photography

Sunsets and sunrises are classic photo subjects that are difficult to mess up. You can take them wherever you happen to be, if the rigors of your trip allow you to get up early enough or stay up late enough to photograph them. Their crisp compositions tolerate a wide range of exposures, tend to provide vivid colors in infinite variety, and a picture taken from one position on one day might look entirely different from one taken at the same place the next day. Sunrises and sunsets are so beautiful they can make even average photographers look brilliant.

You can shoot unadorned sunrises and sunsets with nothing but the sky and horizon showing, or incorporate foreground subjects into the picture. Place the emphasis on the sky itself with a wide-angle lens, or zero in on the majesty of the setting sun with a telephoto setting or lens.

Your choice of shooting a sunrise depends primarily on whether you're willing to get up early and where the sun will be at the time you take the picture. For example, on the East Coast of the United States, the sun peeping over the ocean's edge must be captured in the early morning hours. On the West Coast, sunsets over the Pacific are the norm. However, you can shoot the rising sun with a lake, mountain range, or city skyline, too, simply by choosing your position.

Inspiration

During my last trip to Europe during a crisp October, I made a point of getting up and out of my hotel at 6 a.m. or earlier in order to photograph the sunrises from a different

6.82. This winter sunset backlights an ice-encrusted tree and provides an interesting combination of tones, with the deep blue of the sky echoed by the blue-tinted snow in the foreground, and the yellow setting sun cutting a swath through the middle.

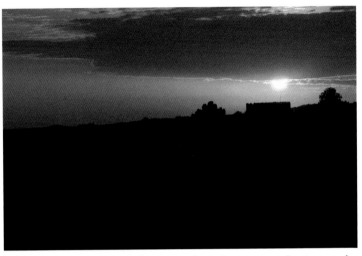

6.83. Here, the contrast is between the soft contours of nature and the multicolored sky hues in the sunset.

Shooting Silhouettes

Because sunrises and sunset, by definition, are backlit, they are the perfect opportunity to shoot silhouettes. You can outline things at the horizon or create silhouettes from closer subjects, such as people or buildings. Here are some things to consider.

✦ **Make underexposure work for you.** Silhouettes are black outlines against a bright background, so you usually have to underexpose from what the digital camera considers the ideal exposure. Use the Exposure Value compensation to reduce exposure by two stops.

✦ **Shoot sharp.** Silhouettes usually look best when the outlined subject is sharp. Watch your focus; use the Focus Lock button or manual focus if necessary to ensure sharp focus.

✦ **Use imaginative compositions.** It's too easy to just find an interesting shape and shoot it at sundown in silhouette mode. Use the dramatic lighting to enhance your composition. For example, one favorite wedding shot is the bride and groom in profile facing each other, jointly holding a half-filled wine glass. Shot at sunset as a silhouette, the shapes of the couple's faces contrast beautifully with the nonsilhouetted image of the transparent wine glass.

✦ **Use colored filters or enhanced saturation.** This can make the sunset more brilliant, while retaining the dramatically dark outline of the silhouette.

location each day. Then I found a different vantage point to shoot that day's sunset. My goal was to capture some interesting silhouettes illuminated primarily by the sunrises and sunsets.

Silhouettes are dramatic and mysterious, and while you don't have to wait for sunrise or sunset to shoot them, you'll find that these times of day provide both the right kind of light and proper mood.

Sunset and sunrise photography practice

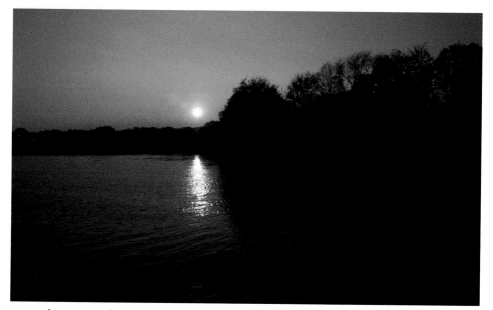

6.84. The sun was low in the sky on this crisp fall day. It was still a couple minutes from sunset. I underexposed the picture by three f-stops and warmed the tones in an image editor.

Table 6.23
Taking Sunset Pictures

Setup	**Practice Picture:** I spotted this scene in figure 6.84 while strolling around a lake one fall afternoon and liked the curve of the shore. I decided the composition would work better as a sunset silhouette, so that's how I shot it.
	On Your Own: As with other kinds of landscape photography, the key to finding a good composition is to scout the area beforehand and then come back, if necessary, when lighting is ideal.

Continued

Table 6.23 *(continued)*

Lighting	**Practice Picture:** I maneuvered to find a spot where the sun would silhouette the trees in an interesting way.
	On Your Own: Sometimes, taking a few steps to the left or right can dramatically change the relationship and lighting provided by the setting and rising sun and objects in the foreground.
Lens	**Practice Picture:** A zoom lens at the equivalent of 50mm.
	On Your Own: Wide-angle lenses are fine if you want to take in a large area of sky. A telephoto setting is a better choice to emphasize the sun and exclude more of the foreground.
Camera Settings	**Practice Picture:** RAW capture. Shutter-priority AE.
	On Your Own: Use a high shutter speed to minimize camera shake and a small f-stop (the larger numbers) to underexpose the foreground in a silhouette.
Exposure	**Practice Picture:** ISO 200, f/16, 1/800 second.
	On Your Own: Underexpose by one or two f-stops to create your silhouette effect.
Accessories	A star filter can add an interesting effect to the sun, but a small f-stop tends to produce a star-like effect anyway.

Sunset and sunrise photography tips

✦ **Sunrises and sunsets aren't created equal.** There are some subtle differences between sunrises and sunsets that can be accentuated depending on the time of year. For example, sunrises can take place after a cold night, so you might encounter a lot of fog that forms in the cool air above a warmer ground. In some parts of the country, sunsets can be plagued by smog or haze that clears up by morning.

✦ **Experiment with filters.** Try split-gradients, star filters, colors, diffraction gratings, and other add-ons for some interesting variations.

Water and Reflection Photography

Water and reflections go hand in hand and work together to produce some beautiful images. Whether you're photographing at the seaside, next to a lake, or just by the hotel swimming pool, water lends itself to a variety of creative techniques.

Inspiration

When shooting around water, the key is to be prepared so you're in no danger of you or your equipment getting wet, overly cold, or thrown about. Some larger camera shoulder bags have a built-in raincoat that lets them be used in inclement weather. The covering pulls out and makes it easy for photographers to continue working even in the worst

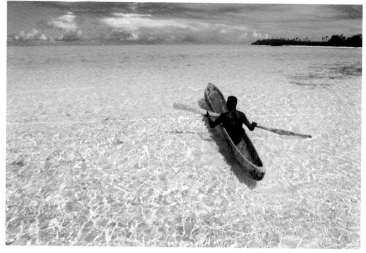

©Felix Hug www.hfphotography.net

6.85. Clean, clear water in a shallow area provides a wonderful view of the textured sea floor and its interesting reflective qualities.

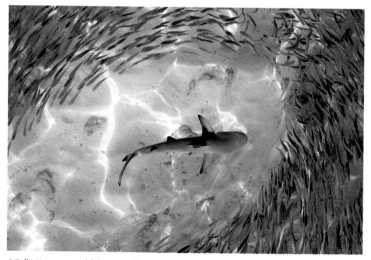

©Felix Hug www.hfphotography.net

6.86. Respect! Nobody messes with the shark, as this chilling picture clearly shows. Also, notice the reflection created by the texture of the sandy bottom.

conditions. If you're on a boat and can bring a small cooler, use it to keep your gear dry.

You can make a water-resistant case for your digital camera out of a reclosable plastic bag. Cut a hole for the lens to peep through, and place a clear-glass UV filter over the lens to protect it from moisture. You can activate most camera controls right through the plastic bag.

Experiment with long shutter speeds and a tripod-mounted camera to see what the slowly moving water looks like when you let it blur slightly, while the subject being reflected remains sharp. You may have to use a neutral density filter to get a sufficiently lengthy exposure in daylight, even at ISO 50 or ISO 100.

Water and reflection photography practice

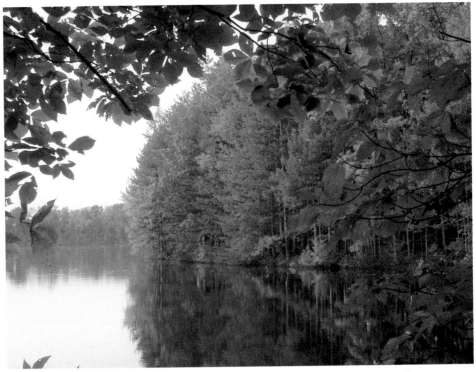

6.87. The lake provides a perfect mirror for the fall colors in this idyllic nature shot.

Table 6.24
Taking Water Reflections Pictures

Setup	**Practice Picture:** I was walking around the edges of this lake, enjoying the fall colors, when I spotted this vista with tree branches in the foreground providing a perfect frame, as you can see in figure 6.87.
	On Your Own: Head for the nearest body of water to find your own reflective subjects.
Lighting	**Practice Picture:** The sky was overcast, so the colors of the trees were, if anything, muted. Even so, the diffuse lighting provided a serene look.
	On Your Own: Although you can work with the light on hand, if it's not actually raining or snowing wait until the sun comes out from behind the clouds to give your photos a little more contrast and snap.
Lens	**Practice Picture:** A wide-angle lens at the equivalent of 35mm.
	On Your Own: Use the same lenses you work with for landscape photography; wide-angles for the big picture, and longer lenses and zooms to capture details.
Camera Settings	**Practice Picture:** RAW capture. Aperture-priority AE. Saturation set to Enhanced to counter the muted colors of the overcast day.
	On Your Own: Use Aperture-priority AE mode to control depth of field when you need to. Make sure the original subject and its reflection are both in sharp focus.
Exposure	**Practice Picture:** ISO 200, f/11, 1/200 second.
	On Your Own: Your digital camera's matrix metering system should do a good job with scenes of this type. ISO 100 or 200 should be enough for good exposures, but on very overcast days you may have to use ISO 400.
Accessories	A tripod can help you frame your photos more precisely and hold the camera steady if you want to use a longer exposure to blur the water. A polarizer can reduce reflections.

Water and reflection photography tips

✦ You might find a circular polarizer useful for cutting down on atmospheric haze and improving contrast of the water. Polarizers always work best when the camera is pointed at right angles to the sun.

✦ Graduated gray or colored filters can darken the sky to improve the rendition of the foreground while keeping the water from becoming overexposed.

✦ Windy days are always great for shooting water if you want choppy waves and ripples. However, if you want a crystal-clear reflection in placid water visit a smaller lake or pond (as opposed to a large lake or the ocean) and opt for a day with less wind.

✦ For a creative, surreal effect, try flipping your photo vertically so that the reflection is the "main" image, and the original scene is the "reflection." Viewers will be intrigued when you point out what you've done – or if they catch on themselves.

Weather Photography

Everybody talks about the weather, and your digital camera gives you the opportunity to do something about it. Instead of hunkering down indoors when skies are dark and cloudy, the air is cold, and precipitation is enthusiastically precipitating, you can go out and grab some interesting shots that reflect Mother Nature at work. Of course, bright sunny days are weather, too, but windy, overcast, snowy, or rainy conditions have the makings of some interesting photos.

Weather pictures can be used to create photographic art, as documentation for changing climates, or as a tool for reporting damage to your insurance company following a major storm.

Inspiration

As you travel, you'll find lots of opportunities to incorporate the weather into your photographs. Once, while visiting Segovia, Spain, (which is separated from Madrid by the lofty Guadarrama Mountains) a balmy April day turned quickly back into winter by the next morning – the entire city was covered in a

6.88. Winter vacations provide ample opportunity for interesting weather photos, such as this shot of ice clinging to tree branches.

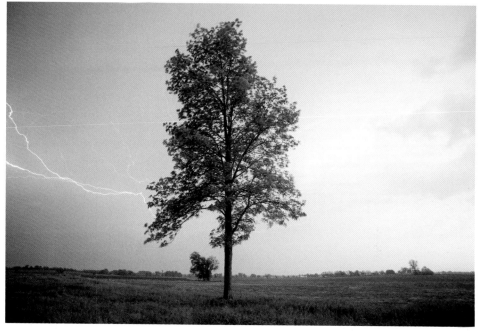

©Pete Ruesch

6.89. If you are brave, amazing photographs can be taken during lightning storms.

blanket of snow. And, with all the monuments and interesting architecture covered in snow, it created new and different photo opportunities. So, don't let rain, snow, or even fog stop you from getting great and unique shots of your travels.

Mother Nature has lots of surprises for you. Lightning is among the most interesting weather phenomenon to photograph. There are even storm chasers who drive around looking for storms so they can photograph bolts from the sky. All you need is to mount your digital camera on a tripod, switch to Manual, and choose a small f-stop and long exposure. Point the camera in a direction where you've seen lightning in the last few minutes, and wait for another flash to pop. Just be certain you're not out in the open where you can lure a strike yourself!

The less adventurous might want to specialize in cloudy skies instead. There are lots of different types of clouds, ranging from wispy to menacing, and all make good photo subjects.

Tip *You can shoot clouds and then use an image editor to drop them into cloudless skies in other photographs you've taken.*

Weather photography practice

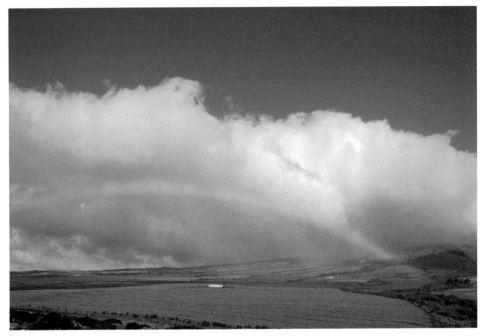

6.90. The rainbow is the beautiful aftermath of a valley rain shower.

Table 6.25
Taking Weather Pictures

Setup	**Practice Picture:** The rainbow shown in figure 6.90 appeared moments after a rain shower in the valley below had ended.
	On Your Own: Interesting weather conditions are definitely worth a little field trip looking for good shooting situations. Once the worst of a storm, snowfall, or rain shower is over, venture out looking for interesting compositions.
Lighting	**Practice Picture:** The diffused light on the landscape and more direct sunlight in the clouds made for an interesting contrast.
	On Your Own: Although you can work with the light on hand, if it's not actually raining or snowing you can use reflectors to bounce light into areas that use a little extra illumination. Fill flash, if used in moderation, can also help provide a little extra snap.

Lens	**Practice Picture:** Zoom lens at the equivalent of 38mm.
	On Your Own: Use the same lenses you work with for landscape photography; wide-angles for the big picture, and longer lenses and zooms to capture details. Close-up photos of ice or icicles can benefit from a macro lens, but many zoom lenses get you down to the roughly 1- to 2-foot distance you need for photos of this type.
Camera Settings	**Practice Picture:** RAW capture. Aperture-priority AE. Saturation set to Enhanced.
	On Your Own: Use Aperture-priority AE mode to control depth of field for close-ups. In dim light, switch to Shutter-priority so you can be certain that you're using a high enough shutter speed to prevent blur from camera shake.
Exposure	**Practice Picture:** ISO 400, f/11, 1/500 second.
	On Your Own: If the background is distracting, as in this case, use the widest aperture possible to blur the background. ISO 200 or 400 should be enough for good exposures, but on very stormy days you may have to jump up to ISO 800.
Accessories	If you have objects in the foreground, silver reflectors are useful for close-ups on overcast days even though lighting is already fairly diffuse. Bouncing a little extra light onto your subject from a silver reflector can add a little contrast.

Weather photography tips

✦ You might find a circular polarizer useful for cutting down on atmospheric haze and improving contrast. Polarizers always work best when the camera is pointed at right angles to the sun.

✦ Graduated gray or colored filters can darken the sky to improve the rendition of the foreground.

✦ Bad weather often calls for a tripod or monopod to steady your camera.

✦ When shooting lightning pictures, take a few with the shutter open long enough to capture two or three bursts in one photo, for a particularly dramatic effect.

Backing Up and Sharing Your Images

O
ne of the best things about travel is the chance to get away from it all — meaning a temporary replacement of the elements of your everyday life with new sights, sounds, foods, customs, people, and surroundings. Getting away from it all also means new photographic opportunities. Whether you're just traveling across your home state or province, across the country, or even across an ocean, what is commonplace at your destination can present new and exciting things to photograph.

Getting away from it all also means that you'll want to share your new experiences with your friends, family, and colleagues back home. "Having a wonderful time; wish you were here!" is never truer than when you've got some great photos to show to others. Fortunately, sharing your images has never been easier, and you don't even have to wait until you get home.

Before digital cameras, even the traveler couldn't enjoy photographs that had been taken until returning home and dropping rolls of film off at the lab. The only options were to have the film processed while on the trip (practical only either if you planned to remain in the same location for awhile, or were willing to spend some valuable travel time at a one-hour photo retailer) or to use a film processing mailer to send your film on ahead for (with any luck) processing and delivery to your home by the time you got back. These solutions required extra steps or extra risk for your photos.

Today, you can review your images on your camera's LCD seconds after you take them. Carry along the AV cable furnished with your camera, and you might even be able to figure out how to link up with your hotel TV and view those pictures every evening on a bigger screen.

Of course, digital pictures are so easy to take and so easy to review, and cost you nothing in terms of film and processing (you pay to print only the shots you really want). So, you end up taking many more photos than you did in your film days. People who thought taking 10 to 15 rolls of film along on a week-long vacation was a lot (that's 250 to 400 photos or more), now may find themselves snapping 100 digital pictures a day — or more!

This chapter helps you plan for the inevitable moment on your trip when you realize that you've taken many more great pictures than you expected, and now are wondering what to do with all these photos.

Backing Up Your Photos on the Road

Every silver lining has its cloud. The ability to take hundreds of pictures in a day also means that your memory cards fill up rather quickly. An embarrassment of photographic riches may add up to storage poverty. When you're near your home base, it's easy to download any pictures you've taken in a day to your computer, erase your memory cards, and begin shooting again. But when you travel, your home or office computer can't go with you — unless it happens to be a laptop.

Your alternatives are to buy enough blank memory cards to last for your entire trip

(which may require you to curtail your shooting at the end of the journey if your cards fill up faster than you expect), or find a way to copy your photos to other media. This section helps you plan ahead.

Portable/Personal storage devices

The portable/personal storage device (commonly known as a PSD) provides you with a way to copy your travel photos to media such as CDs, DVDs or a transportable hard drive. Once you make a copy, you can safely erase your memory cards and reuse them. You must then be very, very careful of the hard drive or optical media that now contains your photos, because if it is lost or damaged, your precious images are lost, too. For that reason, many traveling photographers are reluctant to use portable hard drives — they have been known to fail. Optical media fail, too, but, at least, you can make several copies of each backup to reduce your chances of losing any pictures.

There are other advantages and disadvantages of each of the most popular personal storage devices. The next sections cover some of these devices and give you practical information to consider when making your choice.

Portable CD/DVD burners

A transportable CD or DVD burner can be a relatively inexpensive backup method for your travel pictures. For maximum flexibility, choose a model that is battery powered and includes a card reader. All you need to do is insert your memory card in the CD burner's slot and make one or several copies of your photographs. If your burner has a Verify function for the copy cycle, use it to confirm that your images have been duplicated

successfully. You might want to make two or three copies, and mail one of them home. Divide the other copies among the luggage of several travel companions if you can. Then, if something bad befalls your luggage, you still have at least one copy of your images.

Here are some things to consider:

✦ **Large size.** Even the most compact portable disc burner can be quite a bit larger than hard drive-based alternatives. Make sure you have enough room to tote around the drive and its AC adapter/charger (if provided).

✦ **No review.** Once the images have been stored on the CD or DVD, you may have no easy way of reviewing them, as the burner device won't have an LCD screen to display your photos. However, your CDs or DVDs can be viewed on any computer with a CD/DVD drive. And, you might even be able to connect the burner to a computer somewhere as you travel.

✦ **Limited capacity.** CDs hold about 700 megabytes of information — or about 70 percent of the capacity of a 1GB memory card. If your digital camera has a resolution of 6 megapixels or more, you might find that you need quite a large number of CDs to store all the photos you shoot. Multiply the number of CDs by the number of backup copies of each disc that you plan to make. If you have a high-resolution digital camera you might want to consider a DVD burner instead.

✦ **Time consuming.** Burning CDs or DVDs takes time — count on spending half an hour or more to set

everything up and make a copy or two — and is something you'll probably want to do in your hotel room rather than in the field.

Portable music players

Your Apple iPod or other MP3 player might be usable as a PSD. Indeed, adapters to link music players to memory cards are readily available. The combination is tempting. If you plan on taking your MP3 player with you anyway, pressing it into double duty for picture storage means one less device to carry around. Plus, you can listen to music. However, there are some drawbacks to consider:

✦ **Hard drive players only.** MP3 players that use solid-state memory are usually limited to about 6GB or less of storage. That's plenty for storing tunes, but insufficient when archiving images, unless your digital camera has 4 megapixels or less of resolution, and you don't plan to take many pictures. You need to use a hard drive-based MP3 player with 20 to 60GB of storage.

✦ **No review.** Not all MP3 players have a color LCD capable of displaying your images; nor do these LCDs always have sufficient resolution to give you a good look at your photos.

✦ **Slow transfer.** Those who use iPods and similar devices for picture storage report that transfer from the memory card to the MP3 player can be excruciatingly slow and uses an alarming amount of battery power. Unless you can transfer your photos in your hotel room at night, have an AC adapter, and a few hours to spare, you

might find storing your images on an MP3 player is clumsy.

✦ **Tunes or photos?** The more songs you have stored on your MP3 player, the less room you have for photos. And vice versa. Sometime during your trip you might have to jettison some of your tunes to make room for more pictures.

7.1. In a pinch, a portable music player can double as a photo storage device.

Portable hard drives

If you're looking for the most compact PSD with the highest capacity, fastest transfer speeds, reasonable security, and the possibility (with some models) of reviewing your photos after you offload them from your memory cards, a hard drive-based solution may be your best choice. These range from very economical (I paid $135 for my CompactDrive PD70X device (which came as a shell, with no hard drive inside), plus $70 for a notebook-sized 2.5-inch 60GB hard drive I installed myself inside the unit) to very expensive (Epson asks $699 for its P-4000 multimedia device). All have the

same weakness as MP3 players used for photo storage: hard drives eventually fail, even though that failure can take many months or years to occur.

7.2. Portable hard drives are compact but may not provide picture review capabilities.

Here are some things to think about:

✦ **Small size.** Although larger than even the most humongous MP3 player, portable hard drives have the footprint of a 3×5 index card, are less than 2 inches thick, and can fit right in your camera bag. Because they have a built-in card reader, they're practical for use in the field, so you don't have to wait until you have time to go back to your hotel room if your memory cards fill unexpectedly.

✦ **Fast transfer speeds.** I took my PD70X on a recent trip to Spain, and found it could transfer a 1GB memory card in about two minutes and a 4GB card in less than eight minutes. That's fast enough for use in the field, too. However, not all portable hard drives are this fast, and using the system's copy verification feature to make sure your files are duplicated correctly can double the transfer time.

✦ **Easy computer interfacing.** Portable hard drives use a USB interface, so you can connect them to a computer and use them as if they are just another hard drive.

✦ **Efficient use of batteries.** I regularly transfer 30GB worth of photos on one set of 2500 mAh rechargeable NiMH AA batteries. The AC adapter might be needed only for continuous use (as when you connect the portable hard drive to a computer).

✦ **Review, maybe.** The most compact portable hard drives have a status LCD that displays the device's functions and prompts, but lack a color LCD for reviewing pictures. You'll find such an LCD— up to 3.8 inches in size—on more expensive units, particularly those that are advertised as multimedia units that can review photos, show videos, and play music.

✦ **File compatibility?** If you have an advanced digital camera and shoot in formats like RAW or TIFF, make sure that your portable hard drive device with review capabilities can play back these file formats, too. All units with a color screen can show JPEG files; RAW and TIFF might be problematic.

Laptop computer

If you take your laptop computer with you (say, for business), or you feel you have unlimited space to pack stuff (you're traveling by van or motor home), a laptop computer can be the ultimate image transfer solution. That's especially true if your laptop has wireless Internet capabilities, and you can find a hot spot or two on your journey.

A laptop allows you to copy files to your hard drive for review on the portable computer's large screen. If your laptop has a CD or DVD burner, you can make backup copies. WiFi Internet access makes it easy to upload your photos to the Web or to send them by e-mail (which is discussed in the sections that follow).

For most of us, getting away from it all includes escape from the pervasive personal computer in breaking away from daily hustle-bustle, but if a laptop is part of your travels, you might as well take advantage of its capabilities.

Entrepreneurs to the rescue

Although you may be new to the problem of backing up digital photos while traveling, you're not the first person to encounter this situation. And, as you might expect, enterprising and imaginative folks who cater to the tourist trade have come up with lots of inexpensive solutions. Souvenir shops may be able to create backups for you; Internet cafés offer a variety of services, and public libraries can prove to be a valuable Internet lifeline for those on the move. This section outlines some of the alternatives to taking your own storage devices along.

CD/DVD burning services

If you never needed to find a third party willing to burn a CD or DVD for you, you'll be shocked to discover just how pervasive they are. In North America, many camera stores and quite a few retailers that have an in-store print-it-yourself kiosk offer this service. Just relinquish custody of your memory card, and wait a few minutes while a CD or DVD is burned for you. With many kiosk operations, you can perform the whole chore yourself, so your precious memory card never needs to leave your custody.

Overseas, camera stores are a good bet, but I've been surprised at how many souvenir shops now have this capability. In the smaller shops, it's more likely that only CD burning is offered, as DVD production is still a bit exotic for retailers who specialize in T-shirts, ceramics, and handcrafts. Even so, everywhere you go you'll probably be able to find a store equipped to copy your photos to a CD. Most accommodate CompactFlash and SD cards; not all can handle xD media or Sony Memory Sticks.

Public libraries

The public library system in the United States is especially good, both because these resources are very public (and free), and because so many have branched out into computer and audiovisual functions. An increasing number of libraries have large banks of computers available for public use. You may be able to get reciprocal services using your hometown library card or sign up for temporary use, perhaps for a small fee.

The library's computer might not have a card reader, but it will have a USB connection you can use if you're clever enough to carry along your own compact media reader. You may be able to burn CDs or upload your photos to the Internet (as described later in this chapter) using a fast broadband connection. Available services vary widely. If a public library at your destination doesn't offer what you need, you just might be able to get access at the library of a college or university. Your odds improve if the institution is a state school, you happen to make friends with a local student, or you are a card-carrying student or alumni yourself.

Internet cafés

The Internet café is a resource that can be a lifesaver when you travel and need to make contact back home via e-mail, you want to monitor Web sites or use services such as on-line bill pay or banking, or you need to upload your photos for backup or transfer.

7.3. No translation needed? But if so, "Digital camera cards unloaded to CD" is close enough.

You should realize that the café part of the equation doesn't often apply. I've frequented Internet access locations that served no food or beverages at all. However, you'll also find Internet cafés that offer a full complement of things to eat or drink so you can relax as you work. Others offer Internet services only as a sideline; they have a few computer terminals as a lure to attract paying customers for their food and drink services.

In the United States, Internet cafés can be tricky to find outside of larger cities. Just about everyone has his or her own computer in the home, office, or school. There is a great deal of competition from public libraries, which offer Internet access for little or no money, making it hard for a money-making business to contend with. I often see Internet cafés open, then close down a few months later because the operator couldn't make a go of it. The most successful seem to treat these businesses as a kind of amusement arcade, and get much of their business from young people who want to cruise the Internet outside of their home or school, often while hanging with their friends.

While you often find Internet-access kiosks in places frequented by travelers in the United States, such as airports and train stations, they usually provide only limited services.

Overseas, in many tourist destinations, it's hard to get away from stands, kiosks, and other locations hoping to sell you Internet services. Kiosks, in particular, are as common as pay phones and ATMs. I've picked up my e-mail in the lobby of a restaurant using one of those stand-up Internet machines that lack a real keyboard, expecting you to tap out your e-mail on a pressure-sensitive pad.

If you want to sit down at a real computer, you'll usually be able to do that, even in relatively small towns in many foreign countries. In one tiny hamlet, I found a storefront across from the post office that had four booths for making long-distance phone calls, and two carrels with Windows PCs and Internet access. Needless to say, at certain times of day there was always one or two people waiting to use the computers, and the store owner was quick to shoo lingerers off the computers after 15 minutes if others were in line.

In contrast, larger towns have full-blown Internet parlors, sometimes on the second floor over another business where the cheaper rent allows them to present a full range of services and an array of dozens of terminals. The operators of these locations are more likely to speak English, reducing the challenge of actually gaining access to a computer.

The main thing to keep in mind when patronizing an Internet café is that not all of them have a fast broadband connection at a price you can afford. While dial-up lines are fine for exchanging e-mail, they aren't practical for uploading digital photographs to the Web. You'll also want to make sure the computers have card readers or a USB port that you are permitted to use with your own card reader.

Tip *Computers running Windows XP or Mac OS X don't require any special software to recognize a card reader; just plug it in and you're ready to go.*

Internet café services can be purchased by the hour or portion thereof. You generally are given a user name and password, and can log on using any of the computers in

the café. The system tracks your usage and warns you when your time is up. You can log off early and return to the same café at a later date and use up the rest of your time. The cost is so little that it usually makes sense to purchase at least an hour or two of time, or more if you plan on remaining in the same city for a few days. Buying extra time relieves you of the reminders that start when you have 15 minutes or less to go.

Sharing Images While Traveling

If you have access to a computer while traveling, you have several ways of backing up your photos and sharing them using the Internet. You can send them by e-mail, upload them to your own personal Web space, or deposit your images in a public gallery for viewing by anyone who has access to that Web space and has been given the right password if you choose to protect your photos from the general public (or vice versa).

E-mailing photos

Even if you have a broadband connection while you travel, your recipients might not have such access, so it's a good idea to reduce the size of your photos before you send them. Some digital cameras have an e-mail option that can create an alternate image file that uses less resolution or more compression. Use these squeezed versions instead of your full-resolution photos. Your friends and family will thank you for it. If your camera doesn't offer that option, consider shooting a few pictures at a lower resolution as you travel, specifically for e-mailing.

You can also post your photos on a Web site, and then e-mail a hot link that can be clicked to take the recipient directly to your photos at their Internet location.

Note *A hot link is a clickable Web address link that takes you directly to the address of the link you've clicked. You can see an example in the e-mail message pictured in figure 7.4.*

Many e-mail programs create such a hot link for you. For example, if you type anything that begins with http:// into recent versions of Outlook, Outlook Express, or America Online's e-mail system, the e-mail software automatically converts the address into a hot link, colors it blue, and supplies an underline that lets the recipient know the link is live. With some e-mail software, you may have to make sure the Rich Text (HTML) option is turned on. If your software is set to create messages only in Plain Text, the hot links may not be created automatically.

The recipient must also have the HTML option active for your link to be hot when the message is received. If not, the recipient can still jump to your Web page by highlighting the link, copying it (usually by pressing Ctrl+C, or ⌘+C on a Mac), and then pasting the link into a browser's address bar (press Ctrl+V, or ⌘+V on a Mac). Although many folks who send and receive e-mail already know how to copy and paste links, you might want to include instructions on how to do this in your e-mail message.

Using your own Web space

You might actually have your own Web space where photos can be stored and shared and not even know it. Your ISP may

7.4. E-mail only a link to your photos that are stored on your Web page.

provide a certain amount of space. For example, America Online offers several megabytes of space per screen name. Visit your ISP's Web page to see if free storage is provided. Bundled with the space might even be online tools to help you set up your own pages and galleries.

You can also purchase your own Web storage space from a hosting service, which is a good idea if you want to use your own domain name, such as www.myfinephotos.com. Domain registration can cost less than $10 a year, and hosting services can cost $10 or less per month.

Once you're set up, all you need to do is upload the photos to your Web space (many hosting services have a Web-based upload page you can access so you don't need a special program to upload your pictures). Then distribute the URLs of the photos. If you want to get fancier and have more time to spend with a PC during your trip, you can prepare actual Web pages.

Using a sharing system

You can find an online photo sharing service that costs little or nothing at www.click herefree.com. You can also use America Online's Your Pictures service, or commercial enterprises that give you free photo sharing because they want to sell you prints or T-shirts and coffee mugs with your photos on them. These include Kodak's EasyShare gallery (www.kodak.com), Yahoo! Photos (www.photos.yahoo.com), Snapfish (www.snapfish.com), and Shutterfly (www.shutterfly.com).

Other options include services that offer more sophisticated galleries and less emphasis on the coffee mugs. They might still be free, but will force you to look at ads while you browse through images. To find these types of services, try searching Google for Online Galleries.

If you're willing to pay something to store and display your pictures, you might be even better off with services like those

7.5. Your own Web space can host image galleries of your travel photos.

provided by SmugMug (www.smugmug.com) and PBase (www.pbase.com). For a reasonable fee, you get photo sharing without the annoyances that totally free services are saddled with.

SmugMug offers three levels of service, all with unlimited storage space. Your options include Standard, Power User, and Pro. As of the book's writing, you could get Standard services for less than $40 a year, which allows you to track visits to your gallery, password-protect your images, organize your photos by keyword tags, and convert your images to prints and gifts. The Power

User service lets you add video clips, choose your own colors and fonts for your gallery, and allows much higher levels of traffic to your gallery, just in case you become hugely popular. The Pro level galleries let you sell your prints through SmugMug and even make a profit from your work.

PBase offers similar features for less than $30 a year for 300MB of photo storage and around $60 annually for 900MB of storage. You can add additional storage in 300MB increments. Mac users can join .Mac, which provides e-mail Web storage and sharing for a modest cost.

Appendixes

Recommended Resources

This appendix offers suggestions of various Web sites, magazines, and books that I believe are good resources for digital photographers. I hope you will find them to be good resources as well.

Web Sites

What follows is a selection of Web sites that will help you learn more about photography, travel, or posting your images online for browsing over the Internet. Many of the best sites are related to print magazines of the same name.

www.pbase.com

This is one of the best hosting sites for serious photographers. It goes well beyond the album sites to provide true online photo galleries—and a lot more. There's a search engine to enable visitors to search for photographs by using specific keywords. The site makes it easy to upload batches of photos. You can link galleries that you create. So if you start a gallery showing off your 2006 vacation photos, you can subdivide it into Spain, France, Italy, or other appropriate categories. PBase is even a terrific information resource. It publishes a magazine compiled entirely from the efforts of members. The premiere issue highlighted the work of two photographers and provided some useful tips on sensor cleaning. Of course, something this good isn't free, but the fees are reasonable, with as much as 900MB of storage available for $60 a year.

www.smugmug.com

This is another hosting site with a modest fee ($39.95 per year for the standard subscription), but with claimed *unlimited* photo storage. If you plan to shoot a lot of pictures on your trip, have access to a fast broadband connection as you travel, and want to upload all your photos, this service is the ticket.

www.shutterbug.net

It's an online adjunct to *Shutterbug* magazine, and as such covers digital photography in depth as well as recent and classic film cameras, photo techniques, and other topics of interest. Shutterbug's strength lies in its forums, which, like the magazine and Web site, span a broad range of interests.

www.popphoto.com

Popular Photography & Imaging magazine has been the most authoritative resource for serious amateur photographers for longer than most of us have been alive. The addition of a Web site as a supplement to the magazine's coverage and increasing emphasis on digital photography prove that venerable doesn't have to equal stodgy or old-fashioned. Pop Photo remains as up to date as the latest digital camera, and most of the time, is several steps ahead of the technology in its predictions.

www.luminous-landscape.com

This site has everything you'd want to know about nature photography, but goes far beyond that. Travel photographers can find lists of workshops occurring around the world. (China, Africa, Antarctica, Ireland, and Iceland are just a few destinations where these workshops have been held in the past.) There are descriptions of prime shooting locations for nature photography that help you find new places to take photos.

www.bytephoto.com

This site includes lots of features on its own, but is especially strong as a portal to other sites. For example, BytePhoto offers online galleries, but also gives you links to other interesting pages on external sites, a Google search box for combing the Net, and a ton of ads with interesting offers you might want to jump to. BytePhoto offers news, reviews (not especially great, but interesting), and photo contests.

www.fredmiranda.com

This gorgeous site is bursting with valuable information on a variety of digital photography topics, all arranged logically and easy to access. Lots of digital photographers agree: On a recent night when I logged in, nearly 1,500 *other* photographers were also using the site at that exact moment!

Usenet Newsgroups

Newsgroups aren't a Web site, although you can access them from `http://groups. google.com` using your Web browser. Newsgroups are online forums full of interesting discussions. Posts range far and wide, and you're likely to see hundreds of different topics and comments in a particular group on virtually anything — in a single day. One key strength of Usenet is this diversity: You're bound to stumble across information you'd never pick up anywhere else in a refreshing, serendipitous way. The most common way to access newsgroups is through a special program, or *client,* called a newsreader. Among the most popular newsreaders are Free Agent and the newsreader built into Outlook Express. However, you can also search through newsgroup postings with a Web browser by accessing Google Groups. After you launch your newsreader, you need to tell it which news server to use, connect to that server, and download a list of groups available from that source. Search among the groups to find those that specialize in travel topics or those related to the kind of photography you like the most.

Magazines

It's difficult to recommend specific magazines, because so many of them have bitten the dust recently, including the late, lamented *PhotoGraphic* and *eDigital Photo*. You often can tell that a magazine isn't long for this world when you receive your thin latest issue and there is more editorial content than ads, and your mailbox has offers to renew for as many years as you like for $5 a year.

However, magazines remain one of the most useful resources for travel photography, because you can linger over the great photos, tote a copy of the magazine in your camera bag for reading during idle moments on your trip, and tear out useful articles for quick reference that's even more convenient than your browser's bookmarks. Virtually all have Web sites you can use to sign up for a subscription to the print magazine. Among the magazines you can expect to remain viable for quite a while longer are:

Arthur Frommer's Budget Travel (www.budgettravelonline.com)

From Frommer's, this magazine is your best resource for travel and photography tips when you don't want to spend an arm and a leg.

National Geographic Traveler (www.nationalgeographic.com/traveler)

When it comes to travel photography and destination information, National Geographic is in a class by itself.

Popular Photography & Imaging (www.popphoto.com)

I love the print version of this magazine, although I might be biased because I write articles for it. There's lots of general photographic information and tips, along with frequent features on travel photography.

Shutterbug (www.shutterbug.com)

The magazine covers digital photography, but has lots of general photographic information for those who use film cameras. This is an especially good resource for information on equipment and tools.

Books

This book is compact, concise, and has most of the information you need to take with you in the field. However, there is room for additional knowledge right there in your head, and you can get that from one of these recommended books. All are available from Wiley Publishing, Inc.

Digital Photography All-in-One Desk Reference For Dummies

This huge compendium has chapters on travel, close-ups, action photography, portraiture, and other key topics, along with in-depth information on choosing a digital camera, working with image editors, and so forth. I can promise you that I read every single word in this book, and approve of its contents 100 percent.

Digital Photography For Dummies

This is the classic introduction to digital photography, now in its 5th edition, especially suitable for beginners.

Digital SLR Cameras & Photography For Dummies

A more advanced guidebook for those who use digital SLR cameras and want to learn how to use their special features, interchangeable lenses, and other goodies.

Digital Field Guides

Wiley offers Digital Field Guides written for specific camera models, such as the Canon EOS Digital Rebel, Nikon D50, Nikon D70s, and Nikon D200. All are compact and make good companions to this book for take-along information that you'll find handy as you travel.

Frommer's Travel Guides

There are a ton of these, all aimed at travelers who want to get the most from their journeys, both in terms of enjoyment and in efficient expenditure of their cash. You'll find individual guides for virtually any destination, from Aruba to Vancouver.

Glossary

ambient lighting Diffuse non-directional lighting that doesn't appear to come from a specific source, but rather bounces off walls, ceilings, and other objects in the scene when a picture is taken.

angle-of-view The area of a scene that a lens can capture, determined by the focal length of the lens. Lenses with a shorter focal length have a wider angle of view than lenses with a longer focal length.

anti-alias A process that smoothes the look of rough edges in images (called *jaggies* or *staircasing*) by adding partially transparent pixels along the boundaries of diagonal lines that are merged into a smoother line by our eyes. See also *jaggies*.

aperture-preferred A camera setting that allows you to specify the lens opening or f-stop that you want to use, with the camera selecting the required shutter speed automatically based on its light-meter reading. See also *shutter-preferred*.

autofocus A camera setting that allows a camera to choose the correct focus distance for you, usually based on the contrast of an image (the image will be at maximum contrast when in sharp focus) or a mechanism such as an infrared sensor that measures the actual distance to the subject. Cameras can be set for single autofocus (the lens is not focused until the shutter release is partially depressed) or continuous autofocus (the lens refocuses constantly as you frame and reframe the image).

autofocus assist lamp A light source built into a digital camera that provides extra illumination that the autofocus system can use to focus dimly lit subjects.

averaging meter A light-measuring device that calculates exposure based on the overall brightness of the entire image area. Averaging tends to produce the best exposure when a scene is evenly lit or contains equal amounts of bright and dark areas that contain detail. A digital camera uses much

more sophisticated exposure measuring systems based in center-weighting, spot-reading, or calculating exposure from a matrix of many different picture areas.

backlighting A lighting effect produced when the main light source is located behind the subject. Backlighting can be used to create a silhouette effect or to illuminate translucent objects.

barrel distortion A lens defect, most often found in wide-angle lenses, that causes straight lines at the top or side edges of an image to bow outward into a barrel shape.

blur To soften an image or part of an image by throwing it out of focus, or by allowing it to become soft due to subject or camera motion.

bounce lighting Light bounced off a reflector, including ceiling and walls, to provide a soft, natural-looking light.

bracketing Taking a series of photographs of the same subject at different settings, including exposure, color, and white balance, to help ensure that one setting will be the correct one. Some digital cameras allow you to choose the order in which bracketed settings are applied.

buffer The digital camera's internal memory, which stores an image immediately after it is taken until the image can be written to the camera's nonvolatile (semipermanent) memory or a memory card.

burst mode The digital camera's equivalent of the film camera's "motor drive," used to take multiple shots within a short period of time.

Camera Raw A plug-in included with Photoshop and Photoshop Elements that can manipulate the unprocessed images captured by digital cameras, such as a digital camera's NEF files.

camera shake Movement of the camera, aggravated by slower shutter speeds, which produces a blurred image.

center-weighted meter A light-measuring device that emphasizes the area in the middle of the frame when calculating the correct exposure for an image. See also *averaging meter* and *spot meter*.

close-up lens A lens add-on that allows you to take pictures at a distance that is less than the closest-focusing distance of the lens alone.

color correction Changing the relative amounts of color in an image to produce a desired effect, typically a more accurate representation of those colors. Color correction can fix faulty color balance in the original image or compensate for the deficiencies of the inks used to reproduce the image.

compression Reducing the size of a file by encoding using fewer bits of information to represent the original. Some compression schemes, such as JPEG, operate by discarding some image information, while others, such as TIFF, preserve all the detail in the original, discarding only redundant data.

continuous autofocus An automatic focusing setting (AF-C) in which the camera constantly refocuses the image as you frame the picture. This setting is often the best choice for moving subjects.

contrast The range between the lightest and darkest tones in an image. A high-contrast image is one in which the shades fall at the extremes of the range between

white and black. In a low-contrast image, the tones are closer together.

dedicated flash An electronic flash unit designed to work with the automatic exposure features of a specific camera.

depth of field A distance range in a photograph in which all included portions of an image are at least acceptably sharp. With most digital cameras, you can see the available depth of field at the taking aperture by pressing the depth-of-field preview button, or estimate the range by viewing the depth-of-field scale found on many lenses.

diffuse lighting Soft, low-contrast lighting.

equivalent focal length A digital camera lens' focal length translated into the corresponding values for a 35mm film camera. This value can be calculated for lenses used by multiplying by 1.3, 1.5, 1.6, or some other factor appropriate to a particular camera, based on its sensor size.

exposure The amount of light allowed to reach the film or sensor, determined by the intensity of the light, the amount admitted by the iris of the lens, and the length of time determined by the shutter speed.

exposure program An automatic setting in a digital camera that provides the optimum combination of shutter speed and f-stop at a given level of illumination. For example, a digital camera's sports exposure program uses a faster, action-stopping shutter speed and larger lens opening instead of the smaller, depth-of-field-enhancing lens opening and slower shutter speed that might be favored by its close-up mode at exactly the same light level.

exposure values (EV) EV settings are a way of adding or decreasing exposure without the need to reference f-stops or shutter speeds. For example, if you tell your camera to add +1EV, it will provide twice as much exposure, either by using a larger f-stop, slower shutter speed, or both.

fill lighting In photography, lighting used to illuminate shadows. Reflectors or additional incandescent lighting or electronic flash can be used to brighten shadows. One common technique outdoors is to use the camera's flash as a fill.

focal length The distance between the film or sensor and the optical center of the lens when the lens is focused on infinity, usually measured in millimeters.

front-curtain sync The default kind of electronic flash synchronization technique, originally associated with focal plane shutters, which consists of a traveling set of curtains, including a front curtain (which opens to reveal the film or sensor) and a rear curtain (which follows at a distance determined by shutter speed to conceal the film or sensor at the conclusion of the exposure). Front-curtain sync causes the flash to fire at the beginning of the period when the shutter is completely open. With slow shutter speeds, this feature can create a blur effect from the ambient light, showing as patterns that follow a moving subject with subject shown sharply frozen at the beginning of the blur trail. See also *rear-curtain sync.*

front lighting Illumination that comes from the direction of the camera. See also *backlighting* and *sidelighting.*

f-stop The relative size of the lens aperture, which helps determine both exposure and

depth of field. The larger the f-stop number, the smaller the aperture.

graduated filter A lens attachment with variable density or color from one edge to another, often useful for landscape photography. A graduated neutral density filter, for example, can be oriented so the neutral density portion is concentrated at the top of the lens's view with the less dense or clear portion at the bottom, thus reducing the amount of light from a very bright sky while not interfering with the exposure of the landscape in the foreground. Graduated filters can also be split into several color sections to provide a color gradient between portions of the image.

high contrast A wide range of density in a print, negative, or other image.

highlights The brightest parts of an image containing detail.

histogram A kind of chart showing the relationship of tones in an image using a series of 256 vertical bars, one for each brightness level, which can be used to adjust your camera for optimum exposure.

hot shoe A mount on top of a camera used to hold an electronic flash. The hot shoe provides an electrical connection between the flash and the camera.

hyperfocal distance A point of focus where everything from half that distance to infinity appears to be acceptably sharp. For example, if your lens has a hyperfocal distance of 4 feet, if the photographer sets this value on the lens, everything from 2 feet to infinity would be sharp and suitable for impromptu grab shots. The hyperfocal distance varies by the lens and the aperture in use.

image stabilization A technology that compensates for camera shake, usually by adjusting the position of the camera sensor or lens elements in response to movements of the camera. Also called vibration reduction.

incident light Light falling on a surface.

interpolation A technique digital cameras, scanners, and image editors use to create new pixels required whenever you resize or change the resolution of an image based on the values of surrounding pixels. Devices such as scanners and digital cameras can also use interpolation to create pixels in addition to those actually captured, thereby increasing the apparent resolution or color information in an image.

jaggies Staircasing effect of lines that are not perfectly horizontal or vertical. This is caused by pixels that are too large to represent the line accurately. See also *anti-alias*.

JPEG (Joint Photographic Experts Group) A file format that supports 24-bit color and reduces file sizes by selectively discarding image data. Digital cameras generally use JPEG compression to pack more images onto memory cards. You can select how much compression is used (and therefore how much information is thrown away) by selecting from among the Standard, Fine, Super Fine, or other quality settings offered by your camera. See also *RAW* and *TIFF*.

lag time The interval between when the shutter button is pressed and when the picture is actually taken. During that span, the camera may be automatically focusing and calculating exposure. With digital SLR cameras, lag time is generally very short; with nonSLR cameras, the elapsed time easily can be one second or more.

latitude The range of camera exposures that produces acceptable images with a particular digital sensor or film.

lossless compression An image-compression scheme, such as TIFF, that preserves all image detail. When the image is decompressed, it is identical to the original version.

lossy compression An image-compression scheme, such as JPEG, that creates smaller files by discarding image information, which can affect image quality.

macro lens A lens that provides continuous focusing from infinity to extreme close-ups, often to a reproduction ratio of 1:2 (half life-size) or 1:1 (life-size).

matrix metering A system of exposure calculation that looks at many different segments of an image to determine the brightest and darkest portions, and then compares the scene with a database to ensure optimum exposure.

midtones Parts of an image with tones of an intermediate value, usually in the 25 to 75 percent range. Many image-editing features allow you to manipulate midtones independently from the highlights and shadows.

neutral density filter A gray camera filter that reduces the amount of light entering the camera without affecting the colors.

noise In an image, pixels with randomly distributed color values. Noise in digital photographs tends to be the product of low light conditions and long exposures, particularly when you have set your camera to a higher ISO rating than normal.

noise reduction A technology used to cut down on the amount of random information in a digital picture, usually caused by long exposures at increased sensitivity ratings. Noise reduction involves the camera automatically taking a second blank/dark exposure at the same settings that contains only noise, and then using the blank photo's information to cancel out the noise in the original picture. The process is very quick, but it doubles the amount of time required to take the photo.

overexposure A condition in which too much light reaches the film or sensor, producing a dense negative or a very bright/light print, slide, or digital image.

polarizing filter A filter that forces light, which normally vibrates in all directions, to vibrate only in a single plane, reducing or removing the specular reflections from the surface of objects.

RAW An image file format that includes all the unprocessed information captured by the camera. RAW files are very large compared to JPEG files, and must be processed by a special program such as Adobe's Camera Raw filter after being downloaded from the camera.

rear-curtain sync Rear-curtain sync causes the flash to fire at the end of the exposure, an instant before the second or rear curtain of the focal plane shutter begins to move. With slow shutter speeds, this feature can create a blur effect from the ambient light, showing as patterns that follow a moving subject with the subject shown sharply frozen at the end of the blur trail. If you were shooting a photo of The Flash, the superhero would appear sharp, with a ghostly trail behind him. See also *front-curtain sync*.

red eye An effect from flash photography that appears to make a person's eyes glow red, or an animal's yellow or green. It's caused by light bouncing from the retina of the eye and is most pronounced in dim illumination (when the irises are wide open) and when the electronic flash is close to the lens and therefore prone to reflect directly back. Image editors can fix red eye through cloning other pixels over the offending red or orange ones.

saturation The purity of color; the amount by which a pure color is diluted with white or gray.

selective focus Choosing a lens opening that produces a shallow depth of field. Usually this is used to isolate a subject by causing most other elements in the scene to be blurred.

self-timer Mechanism delaying the opening of the shutter for some seconds after the release has been operated.

sensitivity A measure of the degree of response of a film or sensor to light, measured using the ISO setting.

shadow The darkest part of an image, represented on a digital image by pixels with low numeric values.

sharpening Increasing the apparent sharpness of an image by boosting the contrast between adjacent pixels that form an edge.

shutter In a conventional film camera, the shutter is a mechanism consisting of blades, a curtain, plate, or some other movable cover that controls the time during which light reaches the film. Digital cameras may use actual mechanical shutters for the slower shutter speeds (less than 1/500 second) and an electronic shutter for higher speeds.

shutter-preferred An exposure mode in which you set the shutter speed and the camera determines the appropriate f-stop. See also *aperture-preferred*.

sidelighting Applying illumination from the left or right sides of the camera. See also *backlighting* and *frontlighting*.

slave unit An accessory flash unit that supplements the main flash, usually triggered electronically when the slave senses the light output by the main unit or through radio waves.

slow sync An electronic flash synchronizing method that uses a slow shutter speed to record ambient light by the camera in addition to the electronic flash illumination, so that the background receives more exposure for a more realistic effect.

spot meter An exposure system that concentrates on a small area in the image. See also *center-weighted meter* and *averaging meter*.

TIFF (Tagged Image File Format) This universal file format can be read by most computers. It is commonly used for images and supports 16.8 million colors. It also offers lossless compression to preserve all original file information.

time exposure A picture taken by leaving the shutter open for a long period, usually more than 1 second. The camera is generally locked down with a tripod to prevent blur during the long exposure.

TTL (through the lens) A system of providing viewing and exposure calculation through the actual lens taking the picture.

tungsten light Light from ordinary room lamps and ceiling fixtures, as opposed to fluorescent illumination.

underexposure A condition in which too little light reaches the film or sensor, producing a thin negative, a dark slide, a muddy-looking print, or a dark digital image.

unsharp masking The process for increasing the contrast between adjacent pixels in an image, increasing sharpness, especially around edges.

white balance The adjustment of a digital camera to the color temperature of the light source. Interior illumination is relatively red; outdoor light is relatively blue. Digital cameras often set correct white balance automatically or let you do it through menus. Image editors can often do some color correction of images that were exposed using the wrong white balance setting.

Index

Continued